AN AMERICAN BESTIARY

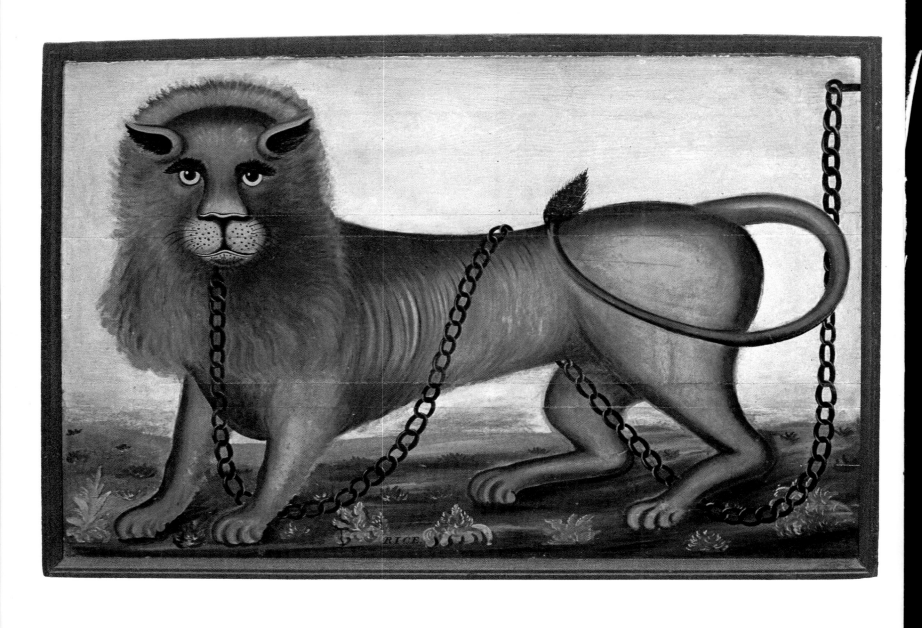

AN AMERICAN BESTIARY

Mary Sayre Haverstock

Harry N. Abrams, Inc., Publishers, New York

Frontispiece

William Rice. Tavern Sign. *c. 1818. Oil on wood, 49½ × 74¾". Wadsworth Atheneum, Hartford, Conn.*

In the early nineteenth century, proprietors of inns and taverns commonly maintained exotic beasts on the premises for the amusement of the patrons. A large and handsome example of the sign painter's art, this lion marked the Goodwin Tavern on Albany Street in Hartford, Connecticut.

Editor: Reginald Gay
Designer: Norma Levarie

Library of Congress Cataloging in Publication Data

Haverstock, Mary Sayre.
 An American bestiary.

 Bibliography: p.
 Includes index.
 1. Art, American. 2. Animals in art.
I. Title.
N6505.H36 760'.0973 78–27333
ISBN 0–8109–0682–1

Library of Congress Catalog Card Number: 78–27333

Published in 1979 by Harry N. Abrams, B.V., The Netherlands
All rights reserved. No part of the contents of this book may be
reproduced without the written permission of the publishers

Printed and bound in Japan

To Nathan Alfred Haverstock

Dum iuga montis aper, fluvios dum piscis amabit,
dumque thymo pascentur apes, dum rore cicadae . . .

CONTENTS

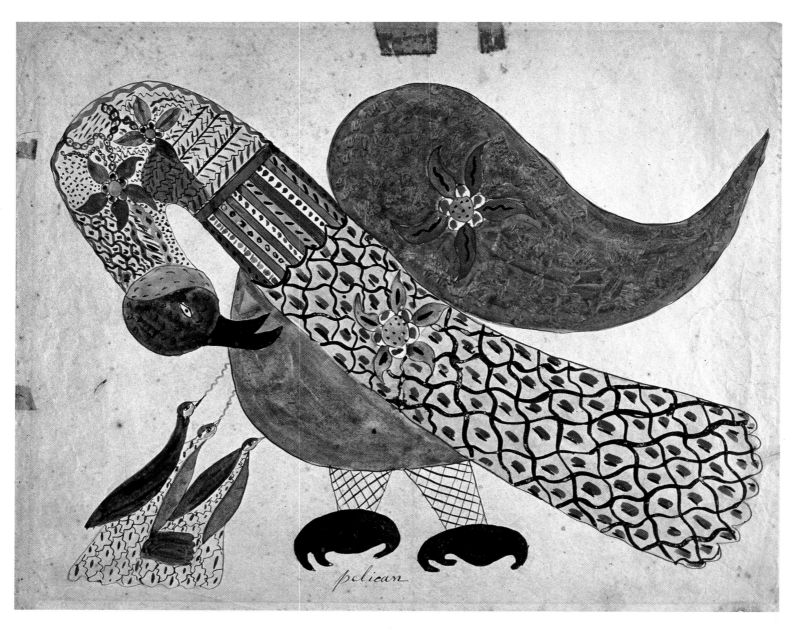

Mary Ann Willson. Pelican. c. 1820. Ink and watercolor, 12⅞ × 16″. Museum of Art, Rhode Island School of Design, Providence. Jesse Metcalf Fund

In the Middle Ages the female pelican, piercing her breast to nourish her young, symbolized Christ bleeding on the cross. In heraldry the motif became known as pelican-in-her-piety. Mary Ann Willson's American folk art version adheres closely to the medieval tradition: the theme was popular in bestiaries, and the twelfth-century cathedral at Le Mans has the same figure worked in stained glass.

Jonathan Fisher, a versatile Maine parson, wrote and illustrated what may be the only true American bestiary, Scripture Animals. *He delighted in nature six days a week and sermonized against human depravity on the seventh, and his 1834 compendium of animal lore drew equally on his keen observations of nature and his vast knowledge of the Bible. In the Old Testament the cormorant inhabited lonely places and thus, for Fisher, exemplified lonely states of mind.*

8

An American Bestiary

The bestiaries of medieval Europe were special guide books to the animal kingdom, compounded equally of fact, rumor, and faith. For the uneducated, who could not read Latin, there were marvelous illustrations showing the diverse animals of the world, both familiar and strange, in characteristic attitudes. For the educated the bestiary presumed to describe each creature's anatomy, habitat, and personality structure, and appended to the description was a didactic discourse pointing out the human traits the animal exemplified. The crocodile, which according to the medieval observer spent its nights in the water and its days on land, was depicted as the archetypal hypocrite, parading the appearance of virtue and holiness by day but after sunset wallowing in the clandestine corruption of luxury.

The vices of greed, sloth, pride, anger, lust, arrogance—indeed the whole roster of the deadly sins—all found animal analogies in the bestiaries. Some creatures, on the other hand, were cited as examples of virtue: the crow, who laid in food for its young and did not early wean them, gave better care to its offspring than the human mother, and the goat, not only far-sighted but uncannily discriminating as well, could distinguish good from evil even from the mountaintop and thus symbolized the Saviour.

The medieval bestiarists were keenly aware of man's insatiable curiosity about animals and counted on it to hold the reader's attention while they administered a strong dose of spiritual tonic. Although the bestiaries were fanciful and entertaining, their intent was clearly to point the way to salvation. Their laudatory efforts notwithstanding, the bestial vices of the Middle Ages are still with us,

Jonathan Fisher. Cormorant. *1834. Woodcut.*
From Scripture Animals *by Jonathan Fisher.*
Rare Book Division, New York Public Library.
Astor, Lenox and Tilden Foundations

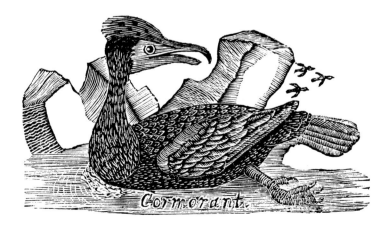

9

and this modern bestiary refrains from invoking them—except to mention that when man and beast are compared today, the fox no longer appears any more greedy or deceitful than his two-legged brother.

This is a different kind of bestiary: animals are presented not as prime examples of piety or of waywardness but instead as samples of some of the most enchanting painting, drawing, and print-making that America has produced. Largely ignored by art historians, animal painting is actually a microcosm of American art as a whole. Birds, beasts, and fish abound in every mode of painting from the naive to the sophisticated, from the conservative to the avant-garde. Some are dark and mysterious and steeped in psychological significance, while others are as sharp and explicit as photographs. All of them contribute to an understanding of both American art and America's constantly changing perceptions of the animal kingdom.

Art historians are known to leap from masterpiece to masterpiece like fishermen working a stream: the footing is better on the bigger rocks. Although many of the creatures in this artistic ark are indeed masterpieces, the reader will not be obliged to tiptoe or whisper in their presence. For the most part these works were meant to be ingratiating or amusing or enlightening. Again and again they provide a refreshing glimpse of the artist's unpretentious side, as if animals had a way of banishing self-consciousness, stridency, cynicism, and gloom. Whenever a Winslow Homer or a John Singer Sargent sojourned in the animal kingdom, he seemed more at ease than when he tackled the mighty elements or copied the countenances of the aristocracy.

What these pictures reveal about American artists and the periods in which they painted is all the more valuable because of this lack of ostentation. Because traditionally much of art history has been based on masterpieces, we expect, for example, only the grandiose from Frederic Edwin Church; yet he was capable of painting a little Persian kitten with candor, intimacy, and charm. Those who consider Paul Revere the most inspired designer of his time may be surprised to learn that he copied animals from English engravings. Albert Bierstadt, Albert Pinkham Ryder, Thomas Eakins, Robert Rauschenberg, Andrew Wyeth—virtually all of the country's most respected artists—painted animals at one time or another, and the result was almost always something quite different from the artist's best-known work.

If America's great masters gave their private selves away in their animal pictures, perhaps still more illuminating are the animals limned by the legions of anonymous and untutored or self-taught

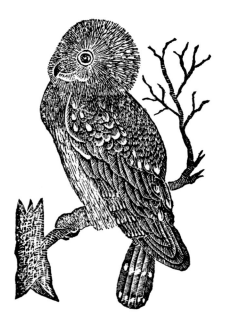

Jonathan Fisher. Owl. 1834. Woodcut. From
Scripture Animals *by Jonathan Fisher. Rare*
Book Division, New York Public Library. Astor,
Lenox and Tilden Foundations

Although Leviticus describes moles as "unclean . . . among all that creep,"
Reverend Fisher observed that "they are usually plump and fat, and this
indicates that they enjoy their mode of living, as well as those animals that
bask in the sunshine." The little brown owl he found not in the Bible but in
his home parish of Blue Hill, Maine, where its "sudden screams . . . are
no very pleasant sounds to those who are travelling alone through the woods
by night, as I have found by experience."

artists who left a vast legacy of undocumented but affectionate portraits of their beloved dogs, cats, puppies, and kittens, as well as horses, cows, and other livestock. Today these are valuable fragments of social history. They disclose a great deal about our changing attitudes toward nature, and through them we become witnesses to the continuing American dialogue between man and beast.

Few countries, even in this industrialized age, can boast a more diverse and numerous animal population than the United States. Certainly no other country has allowed birds, beasts, and fish a freer access to its language, literature, commerce, politics, and art. A quick trip through any of the new dictionaries reveals the extent to which the American vernacular has been taken over by the animal kingdom: for all our advanced technology, we are still speaking of ourselves as a nation of eager beavers, culture vultures, stool pigeons, old coots, cool cats, loan sharks, cold fish, legal eagles, nags, buck privates, cat burglars, snakes in the grass, and pussycats. Furthermore, Wall Street is set aside for bulls and bears, while Madison Avenue has become a preserve for a whole menagerie of other furred and feathered emblems of the American corporate heraldry. Even our beloved automobiles and athletic teams have animal names; that cars and football should be so honored is perhaps middle-class America's greatest compliment to the animal kingdom.

It is not surprising that our imagery is overrun with animals: the history and ecology of the United States preordained that we would have to make room for beasts even as they were making room for us.

At first the early settlers in the New World were willing to go much further than simple coexistence. From the outset the wild beasts of America were welcomed, from improvised Yankee pulpits, as charter members and full participants in the great American experiment. Promotional literature for the early colonies, such as one tract published in 1609 to urge investment in Virginia, pointed out that ever since the expulsion of Adam and Eve the earth had been "possessed and wrongfully usurped by wild beasts, and unreasonable creatures." But the New World offered one last chance: here one could make a new start, and according to the American dream this land was potentially a new Garden of Eden where man and beast would at last be living and toiling together and caring for one another as presumably God had intended from the beginning. The Reverend Jonathan Fisher, author and illustrator of his own 1834 bestiary, *Scripture Animals,* had preached to his Maine congregation in 1832: "His generous benevolence calls loudly upon man to feel an in-

Jonathan Fisher. Mole. *1834. Woodcut. From* Scripture Animals *by Jonathan Fisher. Rare Book Division, New York Public Library. Astor, Lenox and Tilden Foundations*

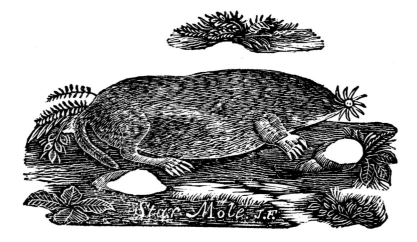

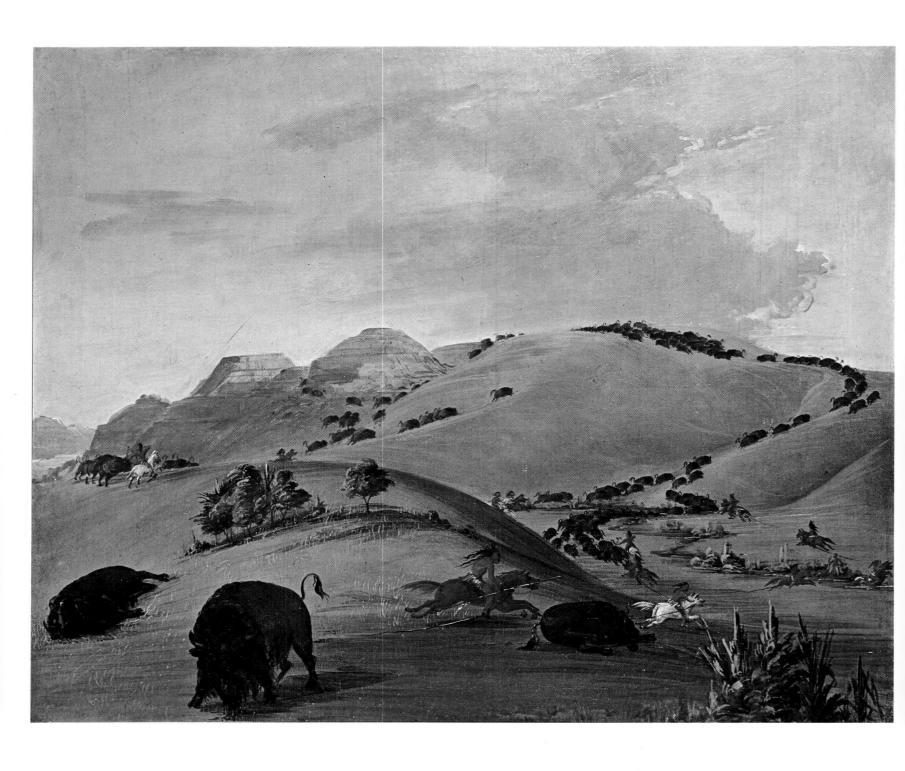

George Catlin. Buffalo Chase, Mouth of Yellowstone. *1832. Oil, 24 × 29″. National Collection of Fine Arts, Smithsonian Institution, Washington, D.C.*

George Catlin, who foresaw a tragic future for the American bison, made a vigorous attempt to keep a record of the animal, which he painted from every angle and at every stage of its life cycle. The oil sketches for his popular traveling Indian Gallery were powerful statements in support of the buffalo's preservation.

terest in the happiness of all living creatures. For if the happiness of the animals is not beneath the notice and care of God, surely man ought not to be too proud or too indifferent to notice and care for them."

In the following decade the painter George Catlin, who certainly could not have heard of Reverend Fisher, urged an even more protective stance toward animal life in his best-selling book *Letters and Notes on the Manners, Customs, and Condition of the North American Indians* (London, 1841). Catlin envisioned a "magnificent park, where the world could see for ages to come, the native Indian in his classic attire, galloping his wild horse amid the fleeting herds of elks and buffalos . . . in all the wild and freshness of their nature's beauty."

Wishing and preaching would not suffice. By the time Catlin's dream of a national park system was fulfilled, the Indians had long since shed their "classic attire" and the "fleeting herds" were little more than a memory. Even while many of the animals in American art were standing for their portraits, their future was already much in doubt. In fact, many of the creatures chronicled by American artists have apparently disappeared for good. It would be hard to imagine Pennsylvania German decoration without its ubiquitous pair of Carolina parakeets, facing each other across the hearts and tulips with characteristic lopsided symmetry, but this bird, America's only native parrot, spoke its last in 1914, victim of a concerted campaign by the American farmers in a zealous campaign to protect their cornfields.

The Audubons, over a century ago noting the scarcity of the black-footed ferret, could never in their most pessimistic thoughts have foreseen a Department of Agriculture that would allow the ferret's last descendants to be poisoned in an attempt to eradicate the prairie dog.

Except for John James Audubon and the far-sighted Catlin, few artists were aware that their sketches of some species might be the last, though many may have suspected it. In 1888 Albert Bierstadt unveiled a moving requiem for the American bison in his painting *The Last of the Buffalo*, in which, he told the New York *World*, he "endeavoured to show the buffalo in all his aspects and depict the cruel slaughter of a noble animal now almost extinct." This celebrated painting did little to set the record straight, since it explicitly accused the American Indian of being responsible for the bison's demise. The real culprits were the fur traders who made the carnage profitable.

If this were a bestiary in the strictest sense, Alexander Pope's *Trumpeter Swan* would be its frontispiece. It is included here for its beauty as a painting rather than for its poignant moral, yet without human avarice and arrogance this magnificent bird would not have been brought down and its descendants might not now be in retreat.

In this bestiary man will at times unavoidably perform in roles formerly reserved for the most brutish of beasts. And the animal will often play the innocent. But there are many interesting questions pertaining to American animal painting quite apart from those of today's bungled ecology. Why, for instance, are certain animals especially popular in some periods and not in others? Claus

Alexander Pope's splendid trumpeter swan (life-size in the original painting) carries a double meaning today. Taken purely as an object of beauty, it is a masterpiece of magic realism; as a document in the sad history of American wildlife, it is a tragedy in one act. Few of these huge, glorious birds remain, and there may come a time when the only memento of their passing will be this extraordinarily handsome portrait of one slain specimen.

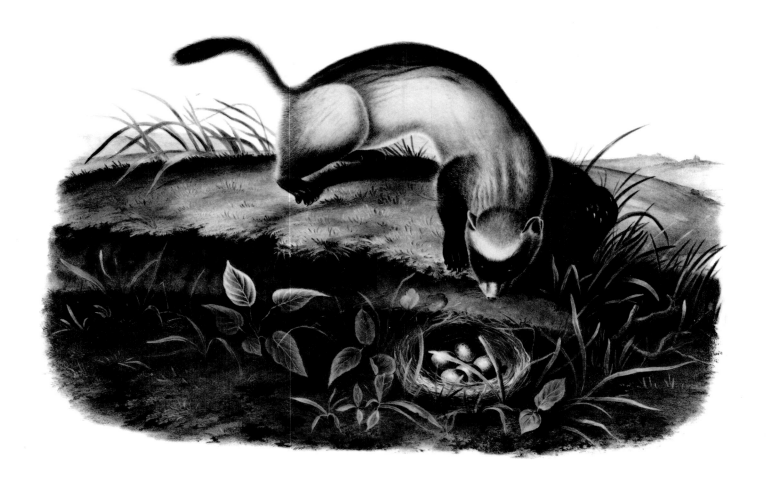

The black-footed ferret was scarce even when the European settlers arrived in the New World. Its range coincides with that of the prairie dog, which constitutes most of its diet. As the unintentioned victim of the ranchers' campaign to exterminate the prairie dog by poisoning, the ferret is now itself close to extinction.

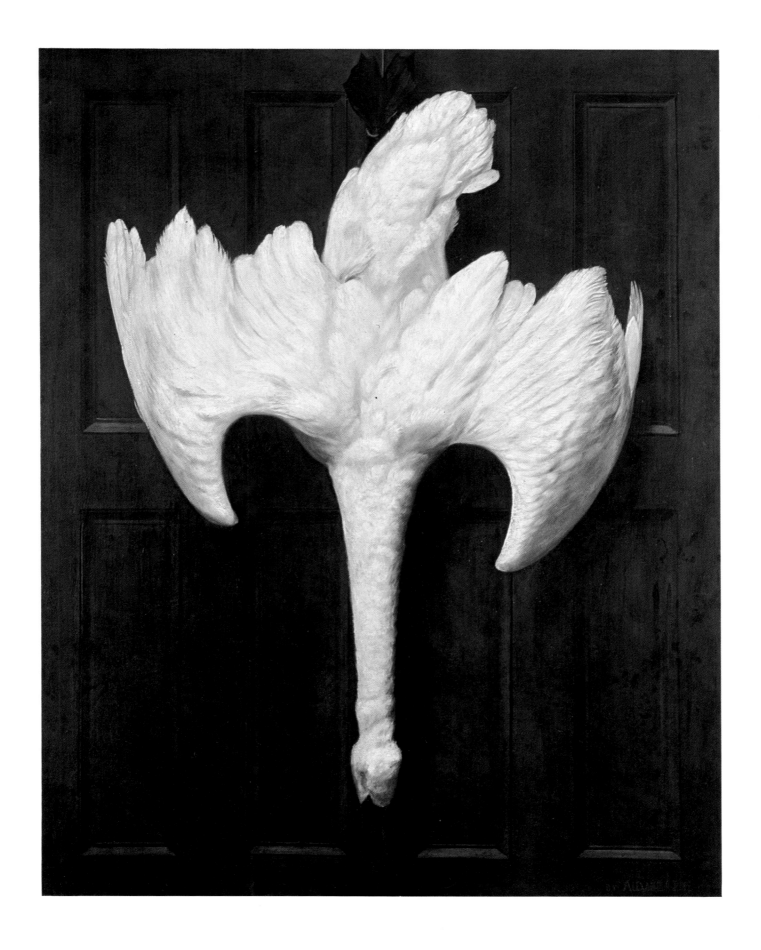

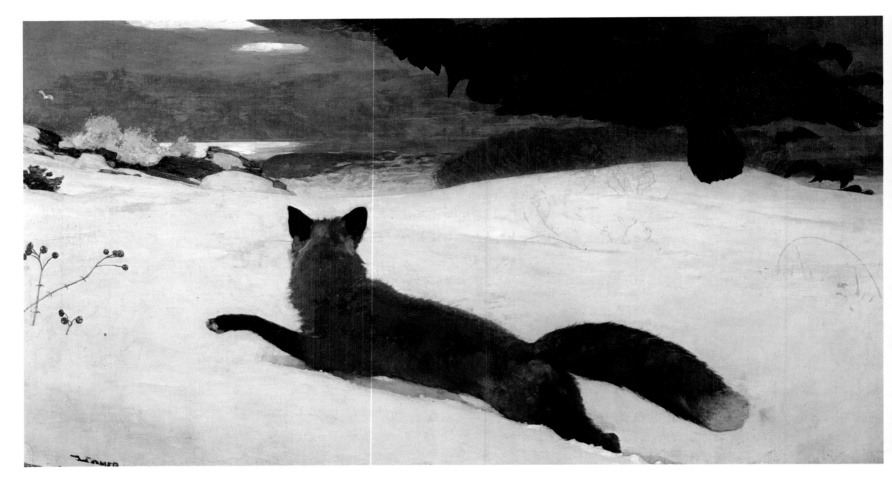

Winslow Homer. The Fox Hunt. *1893. Oil, 38 × 68½". Pennsylvania Academy of the Fine Arts, Philadelphia*

In a powerful and haunting composition reminiscent of Japanese woodblocks, Winslow Homer depicts life at its lowest ebb, at a moment of great solitude. Deep snows have imprisoned the fox as inexorably as any steel trap; the starved crows are hovering above their prey, ready to attack. Medieval bestiarists often described a similar situation, but with a different denouement: the clever fox, pretending to be in great distress, deliberately lures the birds in for the kill, and at the last moment he becomes the assailant, not the victim.

Jackson Pollock. The She-Wolf. *1943. Oil, gouache, and plaster on canvas, 41⅞ × 67". Museum of Modern Art, New York*

In one of his last figurative paintings Jackson Pollock made use of an age-old fertility motif, which may have been evoked during psychotherapy sessions with a disciple of Carl Jung. Unquestionably the image had a profound meaning for the artist: when queried about it in 1944 by art dealer and critic Sidney Janis, Pollock was flatly noncommittal. "She-Wolf," he said, "came into existence because I had to paint it. Any attempt on my part to say something about it, to attempt an explanation of the inexplicable, could only destroy it."

Virch, a former curator at the Metropolitan Museum of Art, raised the intriguing question in his catalog for a 1968 exhibition, "The Artist and the Animal," presented at the Knoedler gallery in New York. For some mysterious reason, he noted, there "seems to be a recurrence of cattle painting during the second half of each succeeding century." Why this might be true—and the chronology of cow pictures in American art suggests that it is indeed true—may be that the waning of a century, like the waning of a year, encourages man to be more appreciative of the fruits of his husbandry. On the other hand, it may indicate something totally different. It may be related to economic cycles: periods of lavish interior decoration, for instance, have usually been congenial for cows in art.

Whether by coincidence or design, animals have been present at many of the important moments in American painting. Winslow Homer chose the red fox as the subject of his largest and most enigmatic canvas. John Singleton Copley based his most dramatic and talked-about historical scene on a man-eating fish—*Watson and the Shark* painted in England in 1778. And toward the end of World War II, when Jackson Pollock initiated the disintegration of figurative painting—an action that would lead to the abstract expressionist style—he turned to the female wolf. In Pollock the symbolism of the medieval Christian bestiary had largely been replaced by that of modern psychoanalysis.

There is no lack of significance in the abundant drawings and paintings of animals in American art—social, ecological, and artistic meaning that intersects virtually every aspect of American cultural history. Yet these pictures can be appreciated without footnotes, for they serve also as tangible evidence of qualities for which Americans are widely admired but which they seldom admit to: simplicity of spirit, keenness of observation, and respect for life.

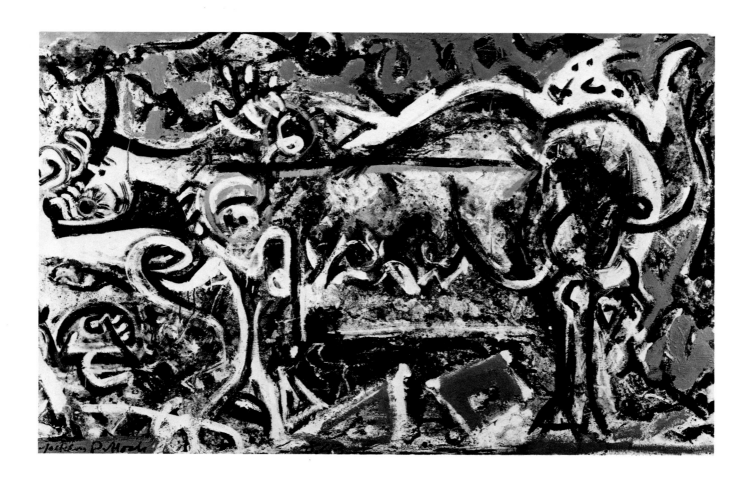

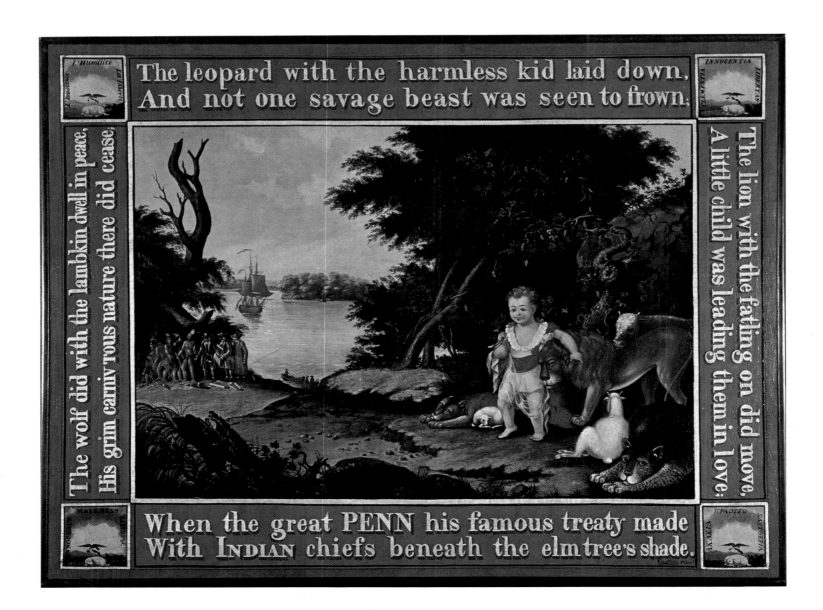

The leopard with the harmless kid laid down,
And not one savage beast was seen to frown.

The wolf did with the lambkin dwell in peace,
His grim carniv'rous nature there did cease.

The lion with the fatling on did move,
A little child was leading them in love;

When the great PENN his famous treaty made
With INDIAN chiefs beneath the elm tree's shade.

Edward Hicks. The Peaceable Kingdom. *c. 1830–35. Oil, 17½ × 23½". Museum of Fine Arts, Houston. Bayou Bend Collection*

When in the 1830s Edward Hicks began his series of paintings of the peaceable kingdom, his message was more moral than zoological. His many versions of Isaiah 11: 6–8, in which the lion lies down with the lamb, were set not on a remote holy mountain but squarely back home in Pennsylvania. By means of handsome gilt lettering, which he learned as a sign painter, Hicks ingenuously made it clear that Isaiah's prophecy had been fulfilled in Pennsylvania by William Penn's "holy experiment."

America: Peaceable Kingdom or Howling Wilderness?

The first Europeans arriving on the shores of the North American continent were staggered by the endless wilderness teeming as it was with birds and animals of every imaginable appearance and temperament. Jean Ribaut, leader of a French expedition to Florida, with wonderful enthusiasm reported his first glimpse of the Florida coast in his book *The Whole & True Discoverye of Terra Florida* printed in London in 1563: "The sight of the faire medowes is a pleasure not able to be expressed with tonge; full of herons, corleux, bitters, mallardes, egertes, woodkockes, and of all other kinde of smale birdes, with hartes, hyndes, buckes, wild swyne, and sondery other wild beastes as we perceved . . . there and also afterwardes in other places by ther crye and brayeng which we herde in the night tyme. Also there be cunys, hares, guynia cockes in mervelus number . . . and to be shorte it is a thinge inspeakable, the comodities that be sene there and shalbe founde more and more in this incomperable lande, never as yet broken with plowe irons, bringing fourthe all things according to his first nature, whereof the eternall God endued yt."

Ever since those first encounters beasts have been exerting a strange spell on Americans. Their hold on American artists has been especially strong, leading them literally into the wilderness as wilderness remained and, when that was gone, drawing them into the wilderness of the mind to meet the beasts within.

Deeply entrenched in the American psyche, there seems to be an abiding belief that all creatures, including man, were put on earth to live together in harmony and mutual respect. This might be called the peaceable kingdom view of nature; it underlies the joyous all's-right-with-the-world spirit of much of American animal art, and in a way it forms the ideological basis for today's belated effort to salvage the balance of nature. But opposed to this trusting view of man and nature, there is a darker outlook as well. Apparently for every artist, naturalist, or conservationist who ever delighted in the give-and-take between beast and man there were others to whom America represented a threatening, howling wilderness waiting to be subdued by man.

The nation is still very much divided. Throughout the four centuries of American art there has been little agreement about man's place in nature; science, philosophy, and religion all have different interpretations of man's role in the universe. The ambivalence early asserted itself in the American attitude toward animals and nature and this ambivalence persists today. On Capitol Hill

during the hearings that determine public land policies, representatives and senators fight over questions the Pilgrim Fathers never foresaw. Should the public have a wildlife refuge or a jet airport? A fish-filled unpolluted river or an atomic power plant? A national forest or a strip mine? These are not merely political issues; they reflect an unresolved conflict that has been present from the outset.

At issue is the idea that nature in its wild state is fundamentally inimical to human progress. Even today millions rigidly cherish this notion: they see the wilderness not as a peaceable kingdom but as a place of fear and foreboding. This howling wilderness syndrome, vigorously reinforced by the early Puritan preachers, accounts for the menacing quality found in many depictions of animals in American art, and on a more sociological level it must also be a potent force, for it brings thousands of men out in camouflage suits every deer-hunting season.

Like many inconsistencies in the American world view, our persistent uncertainty toward nature can be traced to an incongruity in Holy Scripture. According to Isaiah, man and beast would one day dwell together harmoniously as God had intended. Yet by the account in Genesis God's motive for creating animals and placing them on earth was to allow man dominion over them. Animals were to be at the service of mankind. The view of Isaiah implies a trust in nature—a symbiotic code of behavior for all creatures. According to Genesis, though, there is a deep conflict of interest between beast and man whereby man's will must prevail.

There was ample basis for a terror of the howling wilderness in early times. Just beyond every village perimeter the threat of danger from wild animals was a very real one: besides the marauding wolf, deadly snakes and numerous wild members of the cat family were lying in wait, while alligators threatened to the south and bears in the immediate west. The sea contained sharks as well as cod, and in the general imagination terrible monsters lurked dangerously close to the shore.

Many of the predatory creatures encountered in the New World were unfamiliar to European immigrants. Their danger was still largely unmeasured, and it was easy to credit them with unnatural abilities and powers. When theologians, such as Reverend Michael Wigglesworth, declared that the seventeenth-century New England woods were inhabited by "hellish fiends," there were few who were qualified to contradict. Since the early inhabitants of New England were obsessed with the vagaries of Satan and his attendants, it is understandable that they associated the native animals with savagery and evil intentions.

One way to resolve this anxiety was to laugh at it. When pioneers left the relative safety of the eastern settlements, they sent back tales of a still more savage wilderness; yet they minimized the dangers they faced by bragging of their herculean exploits. The blithely exaggerated adventures of

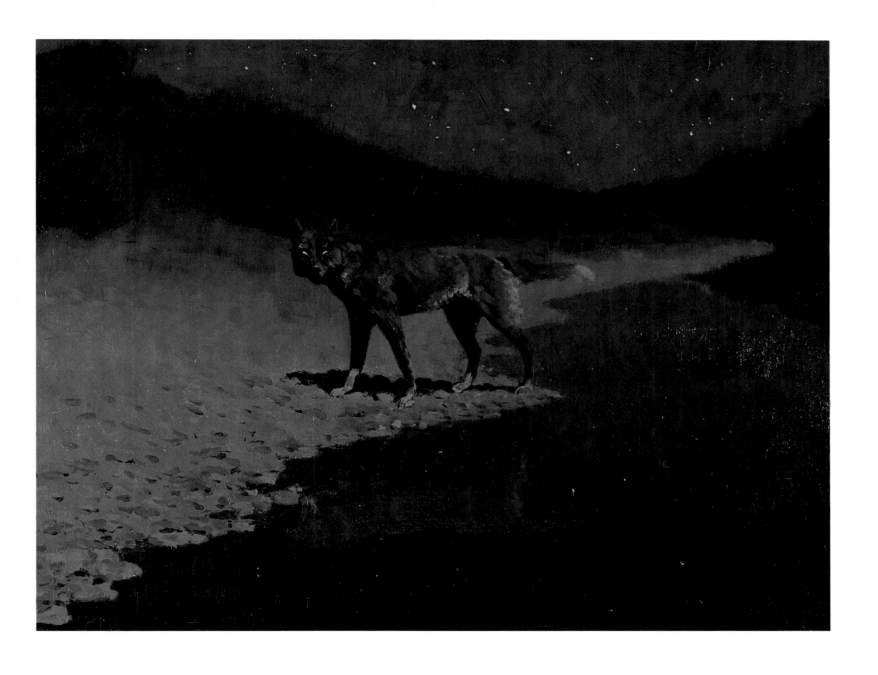

Frederic Remington. Moonlight, Wolf. c. 1907. Oil, 20 × 26". Addison Gallery of American Art, Phillips Academy, Andover, Mass.

Once thought to be America's meanest and most ineradicable predator, the slant-eyed wolf—guarding his lonely terrain in Remington's eerie portrait—has all but disappeared, to the everlasting relief of farmers and stockmen. Its near-extermination was a legend in itself, with the country's best hunters pitting their guns and wits against the wolf's treacherous intelligence.

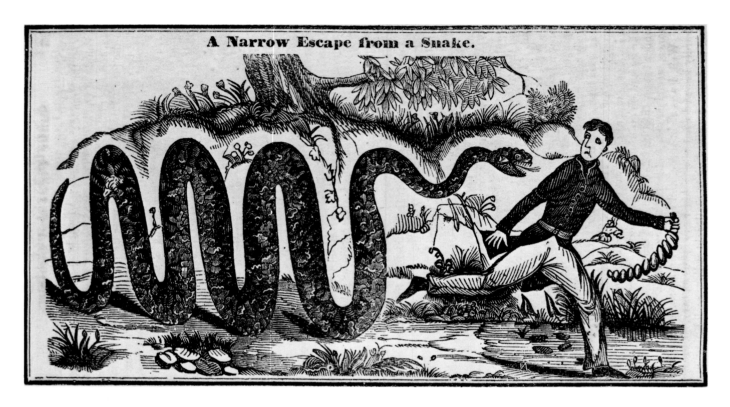

Artist unknown. A Narrow Escape from a Snake. *1838. Woodcut. From* Davy Crockett's Almanack of Wild Sports in the West, Life in the Backwoods, Sketches of Texas, and Rows on the Mississippi *(Vol. 1, No. 4). Rare Book and Special Collections, Library of Congress, Washington, D.C.*

In the tall tales of the almanacs the doughty hero was attacked by a different savage beast in almost every paragraph. In this typical report from the frontier, the snake roared with "squalling and rattling" and the hero "trimbled all over." The snake "began to stretch his head out, and draw it back; and then such a hissing you never did hear. . . . I don't care what people say, I won't believe that snakes have bones in 'em. . . . I streaked it; the faster I run, the more noise I made, and looking behind, I saw him rolling on."

Artist unknown. A Tongariferous Fight with an Alligator. *1837. Woodcut. From* Davy Crockett's Almanack of Wild Sports in the West, Life in the Backwoods, Sketches of Texas, and Rows on the Mississippi *(Vol. 1, No. 3). Rare Book and Special Collections, Library of Congress, Washington, D.C.*

The heroic death of Davy Crockett at the Alamo in 1836 did not put an end to America's infatuation with adventurous exploits. Almanacs full of far-fetched yarns were extremely popular in the nineteenth century, with illustrations in keeping with the rambunctious spirit of the frontier.

Daniel Boone and Davy Crockett were immensely popular back East, where readers of the almanacs must have been greatly reassured to find out that beyond the Appalachians there were men capable of fending off whole families of grizzly bears or ingeniously outwitting ravenous twenty-foot serpents. Obviously these were tall tales, yet they may have provided some relief to those who nurtured fears of resettling and convinced them that they should stay put and tend their gardens at home.

The Bible itself was unequivocal on the subject: "The wolf also shall dwell with the lamb, and the leopard shall lie down with the kid; and the calf and the young lion and the fatling together; and a little child shall lead them" (Isaiah 11:6). In that ingratiating piece of Scripture the prophet spoke allegorically of a day when enemies would cease to hate one another and there would be an end to war. The little child has been interpreted as a prophecy of the Messiah, but perhaps the child figure represented simply the lost innocence of humanity. The scene described by Isaiah was the inspiration for many American artists, and the one who was most profoundly affected by it was the Pennsylvania Quaker preacher Edward Hicks.

In Hicks's vision the great convocation of creatures was not called forth on an Old Testament mountaintop but right on the banks of the Delaware River. As if to dispel doubts about his meaning, Hicks usually placed on the left of his canvases a vignette depicting William Penn holding his celebrated colloquy with the Indians. Therein the white man had made a peaceful bargain to share at least a small portion of the earth with beings who perhaps had a more legitimate claim to it.

Hicks wanted to do no more than was expected of him as a simple country preacher: to bring the

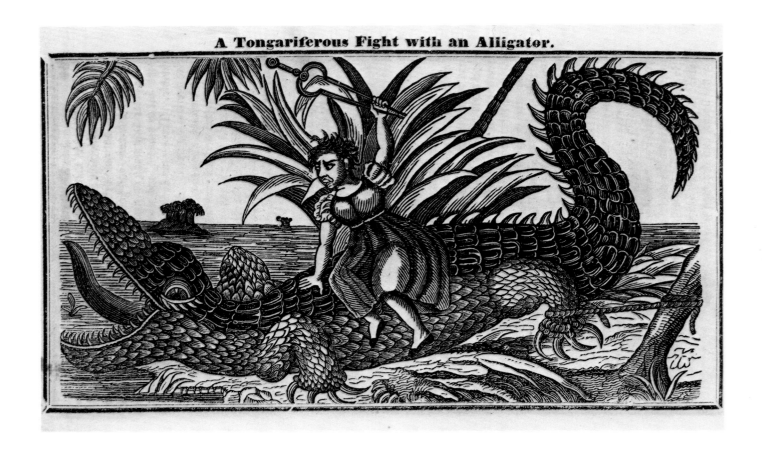

A Tongariferous Fight with an Alligator.

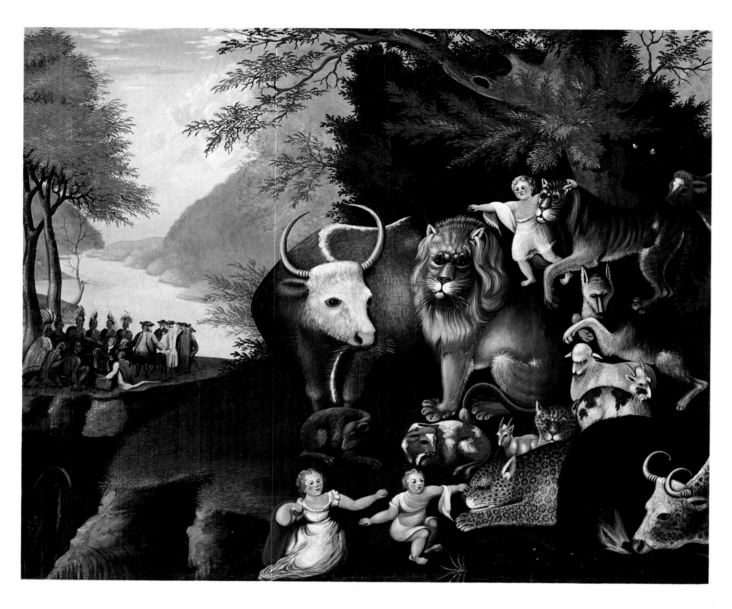

Edward Hicks. The Peaceable Kingdom. *c. 1830. Oil, 30 × 35⅞". Collection, Edgar William and Bernice Chrysler Garbisch, New York and Cambridge, Md.*

In some later versions of Edward Hicks's kingdom animals filled the canvases to overflowing, yet even in small gatherings his beasts were eloquent testimony to his vision of peace on earth. Close by the Delaware River, William Penn was often pictured in earnest colloquy with fellow Quakers or engaged in friendly dialogue with the Indians. No one expressed America's optimism and faith better than Hicks. In his scores of paintings of The Peaceable Kingdom *the animals mentioned by Isaiah are all present—lion, lamb, and fatling—augmented at times by creatures the artist found in his perusal of illustrated zoölogies.*

William Hallowell was a country dentist who did some doctoring on the side. A Quaker like Edward Hicks, he was bemused by the prospect of a peaceable kingdom on earth. His lively array of creatures places an emphasis on cattle, but also comprises sheep, fox, jaguar, bear, and lion as well as three well-nourished man-cubs.

message of God's goodness to the hard-pressed farmers of eastern Pennsylvania. The notion of a truly peaceable kingdom, uniting a dozen or more natural enemies under the clear Pennsylvania sky, may have seemed like naive piety even in its day, but to the artist's friends and neighbors, who paid hard-earned cash for them, these paintings presented a kind of truth they fervently wanted to believe.

On the other hand, the uncanny hand of Satan lay close to the brush of many American artists. *A Minister Extraordinary*, a sinister lithograph published in Hicks's era, shows the animal kingdom coming to the aid of Satan, who places his claim on an unfortunate cleric fallen from grace. It is a hint of how strongly the American artist was both attracted and repelled by certain beastly cravings in the human animal.

Paintings in the howling wilderness tradition progressively described more terrifying scenes. Inevitably the theme would encompass the struggle, on the high seas, of man's chilling pursuit of the

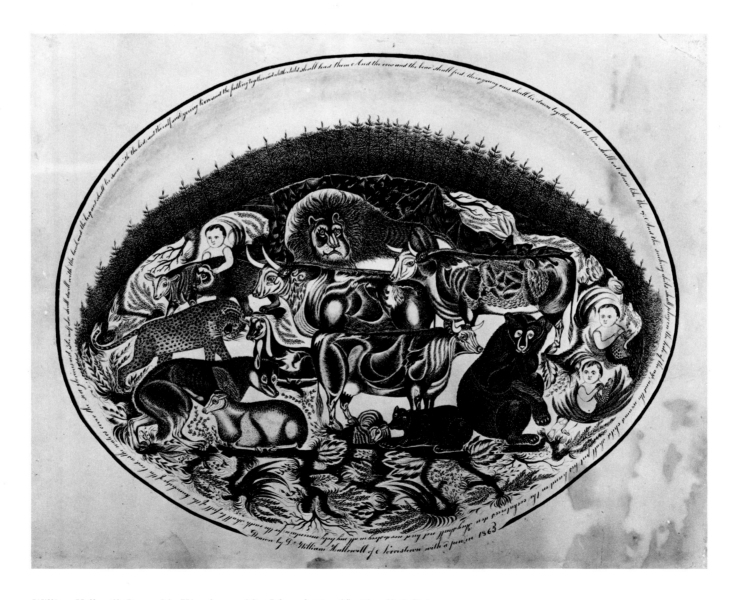

William Hallowell. Peaceable Kingdom. *1865. Ink, 15¾ × 19¾″. New York State Historical Association, Cooperstown*

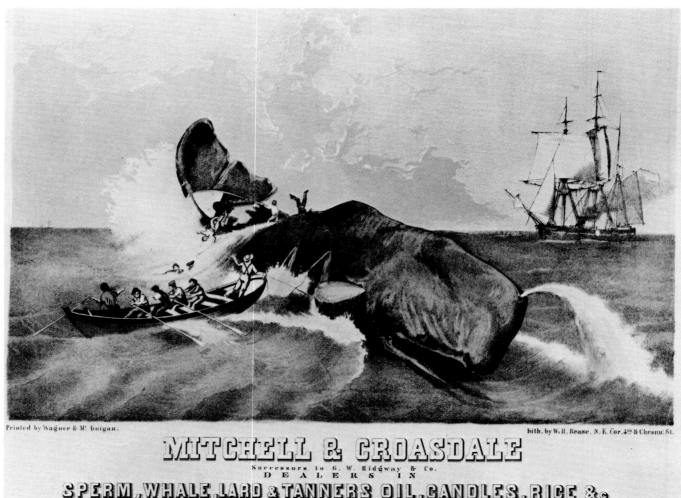

MITCHELL & CROASDALE

Successors to G. W. Ridgway & Co.

D E A L E R S I N

SPERM, WHALE, LARD & TANNERS OIL, CANDLES, RICE &c

N^o 30 Nth WHARVES, ABOVE ARCH ST.

PHILADELPHIA.

whale. To paint such encounters from life entailed more than a little danger for the artist. Herman Melville, who was an experienced seaman, tried to discourage artists from attempting the genre. In the chapter "Of the Monstrous Pictures of Whales" in *Moby Dick*, Melville complained, "They are generally Richard III whales, with dromedary humps, and very savage; breakfasting on three or four sailor tarts, that is whaleboats full of mariners: their deformities floundering in seas of blood and blue paint. . . . There is no earthly way of finding out precisely what the whale really looks like. And the only mode in which you can derive even a tolerable idea of his living contour, is by going a whaling yourself; but by so doing, you run no small risk of being eternally stove and sunk by him."

In the most sophisticated expressions of the eternal conflict between nature and civilization the real adversary in the howling wilderness is not always the beast, but sometimes man's own folly. Perhaps the message of some artists is that despite his superior mental acuity and an arsenal of advanced weapons, there are still some places on earth where man may never be king. In C. S. Raleigh's

W. H. Rease. Advertisement for Whale Oil. *c. 1858. Lithograph, 7¾ × 11¾″.*
Smithsonian Institution, Washington, D.C. Harry T. Peters "America on Stone"
Lithography Collection

*One of the few mammals that can be said to have actual global distribution
is the sperm whale, despite its having been hunted relentlessly in a systematic
way for more than two centuries. In 1858, a peak year, American whaling
vessels brought in no less than 264,164 barrels of precious whale oil.*

Artist unknown. A Minister Extraordinary. *1833. Lithograph, 9⅛ × 16⅛″. Smithsonian
Institution, Washington, D.C. Harry T. Peters "America on Stone" Lithography Collection*

*All the monsters, satanic creatures, and inherent beasts of the Protestant
imagination came out for this allegory of the expulsion of one unfortunate
parson, apparently the victim of a taste for a more fleshly existence than his
sect allowed.*

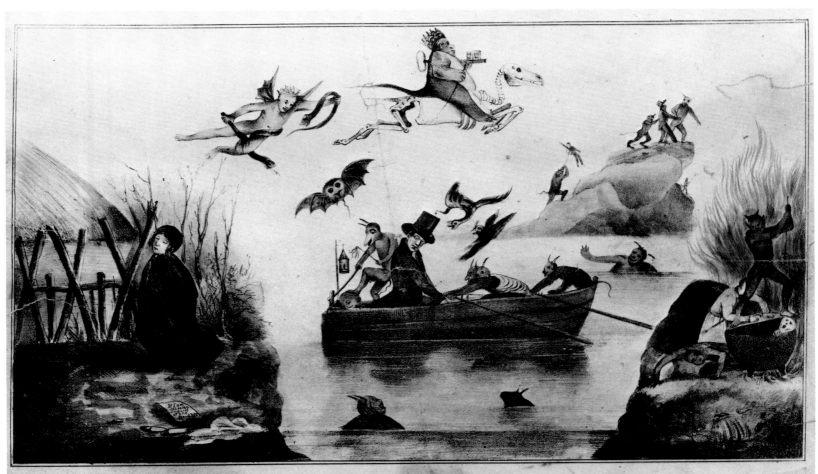

A MINISTER EXTRAORDINARY TAKING PASSAGE & BOUND ON A FOREIGN MISSION
TO THE COURT OF HIS SATANIC MAJESTY!

Entered according to act of congress in the year 1833 by Robinson in the Clerks Office of the District Court of the United States for the southern district of NY
Published by Robinson 52 Courtland St NY.

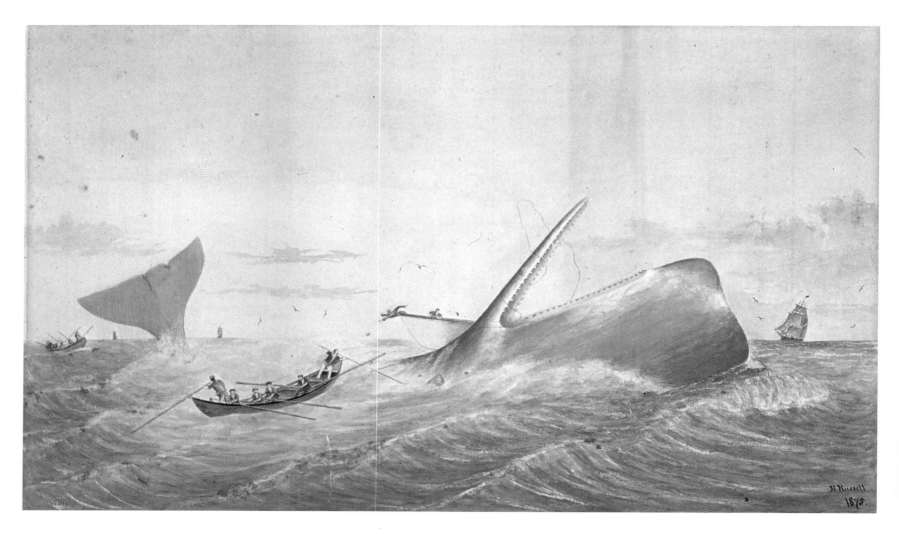

Benjamin Russell. A Sperm Whale Engagement. *1875. Watercolor, 17¼ × 29½″.*
National Museum of History and Technology, Smithsonian Institution, Washington, D.C.

The sperm whale, the leviathan of the ocean, has been called nature's pièce de résistance. The whale has no natural enemy except man. Man's assault on the whale has not always been a one-sided contest: in the majority of nineteenth-century whaling scenes, the whale has the advantage over the flimsy whaleboat and its frail inhabitants.

Charles S. Raleigh. Chilly Observation. *1889. Oil, 30 × 44⅛″. Philadelphia Museum of Art. Edgar William and Bernice Chrysler Garbisch Collection*

The polar bear's reputation for viciousness is almost as exaggerated as that of the grizzly, its southern cousin. If polar bears approached human beings in Raleigh's time, it was probably out of simple curiosity. Raleigh traveled the seven seas as a merchant seaman before he settled in Massachusetts and became a marine painter. Of the 1,100 paintings he claimed to have produced, several depicted polar bears regarding man with a combination of pity and derision.

painting *Chilly Observation* the polar bear is fully in command of his inhospitable, icebound domain. Man is out of his element, so much so that the bear laughs at him. In Frederic Remington's haunting *Moonlight, Wolf* the wolf, with eyes flashing a message no human can intercept, defies anyone to set foot on the desert at night. And in *Afternoon Shadows*, a deeply disturbing animal painting of twentieth-century urban life, Robert Vickrey's disquieting tiger suggests the shapeless phantoms hidden in every child's fantasy, in this instance transposed to an arid jungle of concrete.

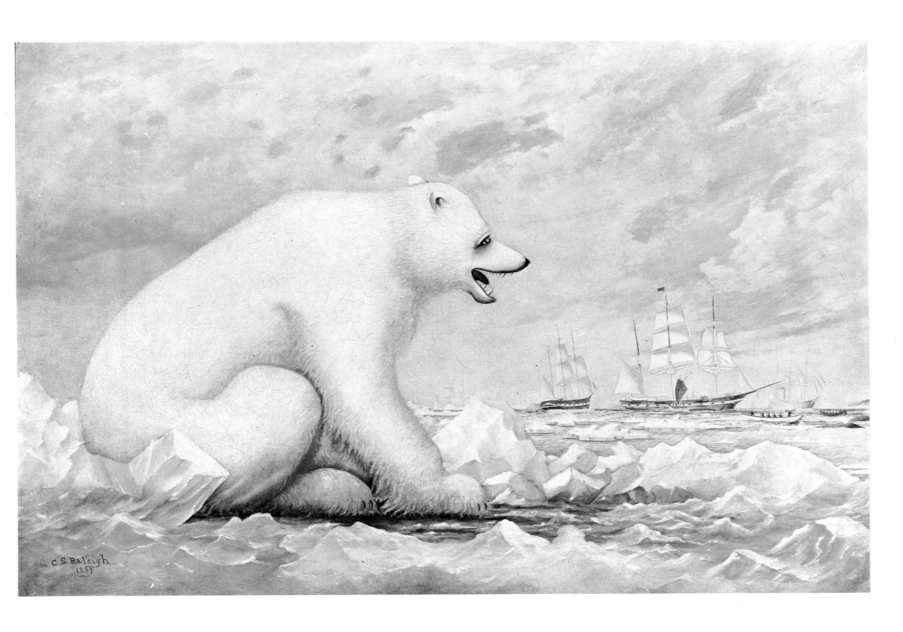

Robert Vickrey. Afternoon Shadows. 1960. Tempera on masonite, 25⅜ × 39⅜". Wichita Art Museum, Wichita, Kans. Gift of John E. and Elsie Naftzger Foundation

In some primitive societies it is considered dangerous to show disrespect to the tiger, because the tiger is believed to be immortal and might some day return to haunt its killer. If a tiger is killed, one must take the precaution of apologizing to its carcass. Vickrey's unsettling animal recalls the ancient taboo, apparently still viable in the asphalt jungle.

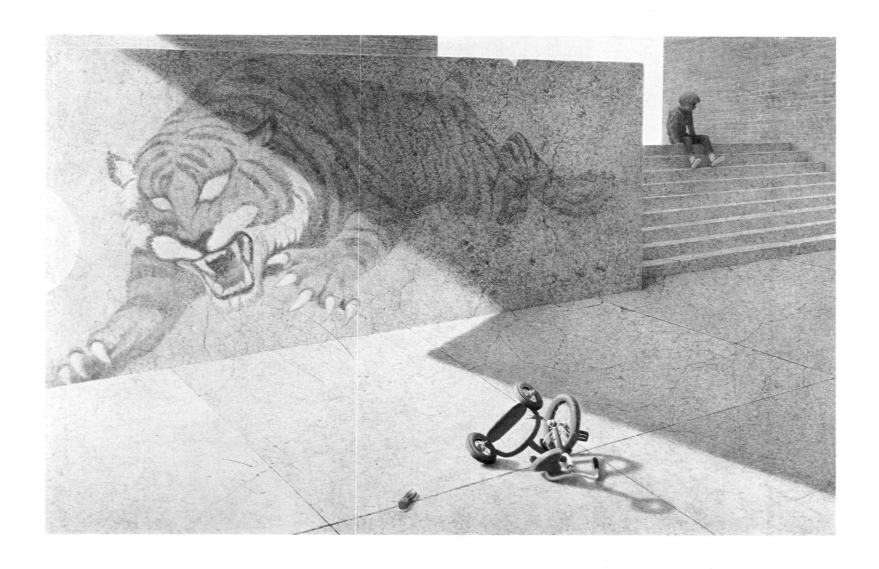

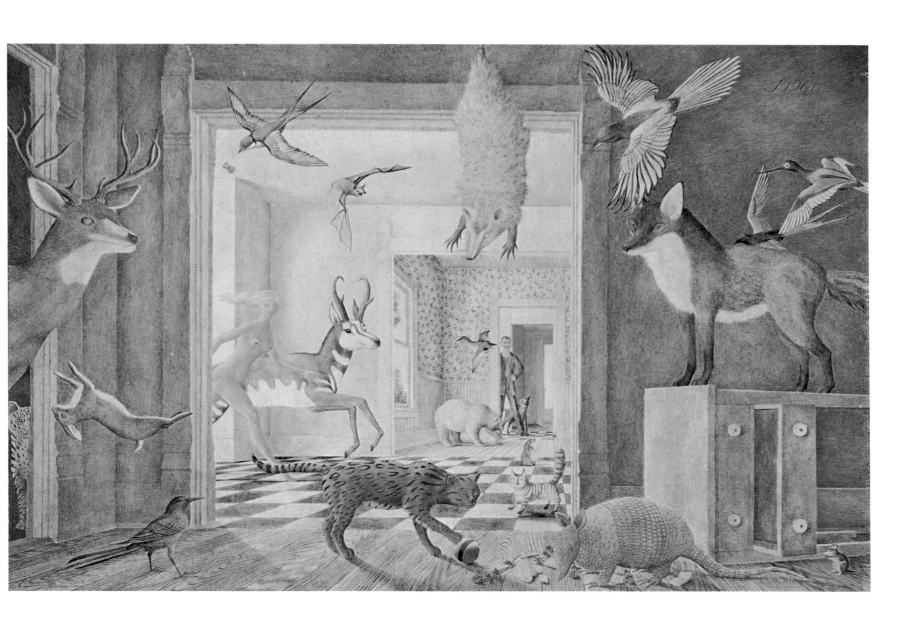

John Wilde. Happy, Crazy, American Animals and a Man and a Lady at My Place. *1961. Oil on board, 12 × 17¾". National Collection of Fine Arts, Smithsonian Institution, Washington, D.C. Gift of S. C. Johnson and Son, Inc.*

Within this highly permissive household can be found some of America's most distinctive beasts. At the left, near the first archway, a barn swallow and bat hover over a pronghorn antelope (a vanishing species) slightly outrunning a naked human female (increasing species). In front of them is a ring-tailed cat and a tiny prairie dog. Past a second archway are a bear and bird, and beyond yet another arch a man and a Doberman pinscher. Closer to view—clockwise—are a floating, or hanging, opossum, a magpie, an avocet with yellow markings, another swallow darting behind a statuesque fox, an armadillo, an ocelot, a grackle, an air-borne rabbit, and a white-tailed deer. Barely visible below the deer lurks a wary jaguar.

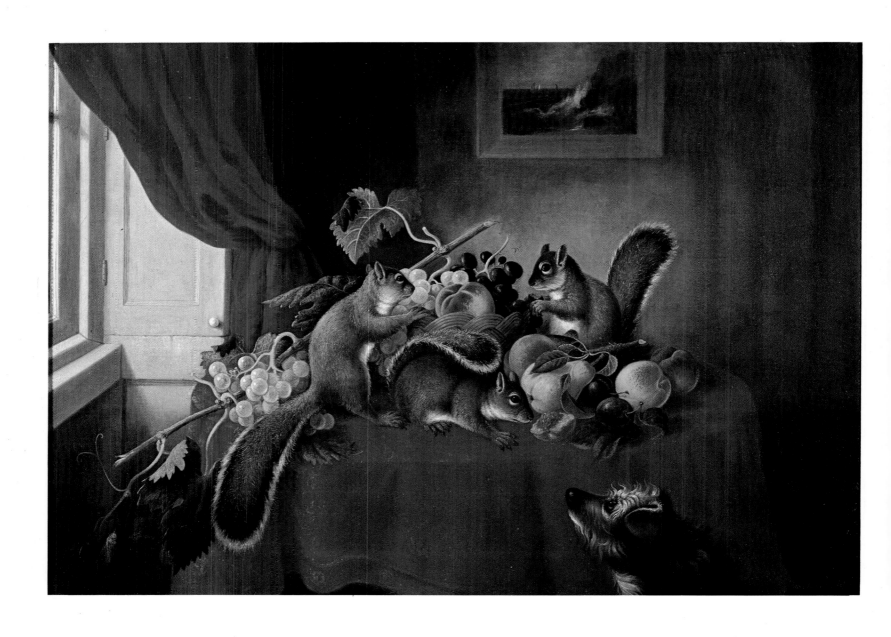

Susan C. Waters. Still Life with Squirrels. *c. 1880. Oil, 29¾ × 42⅛″. Private collection, New York*

A terrier looks on quizzically while squirrels dismantle a late nineteenth century centerpiece. Squirrels will go after almost anything edible—particularly if it belongs to someone else.

Hicks's innocent dream of a peaceable kingdom has retained its freshness for a century and a half, and it continues to be a favorite theme in American art even after many changes. In *Still Life with Squirrels*, one talented nineteenth-century amateur, Mrs. Susan C. Waters, concocted the idea of a world in which human beings would extend the hospitality of their homes to visitors from the forest, sharing with them the homespun amenities of front-parlor American life. Much more recently John Wilde brought the theme up to date with his swinging indoor peaceable kingdom, *Happy, Crazy, American Animals and a Man and a Lady at My Place*.

Of the two persistent views of nature it has been the simple dream of a peaceable kingdom that has been the most durable in American art. But deep in the American consciousness skulks the same fear of the howling wilderness that haunted the Puritan imagination three centuries ago. It lies dormant for long periods but surfaces in times of national stress and uncertainty, creeping unbidden even into the most objective attempts at scientific depiction of the animal kingdom.

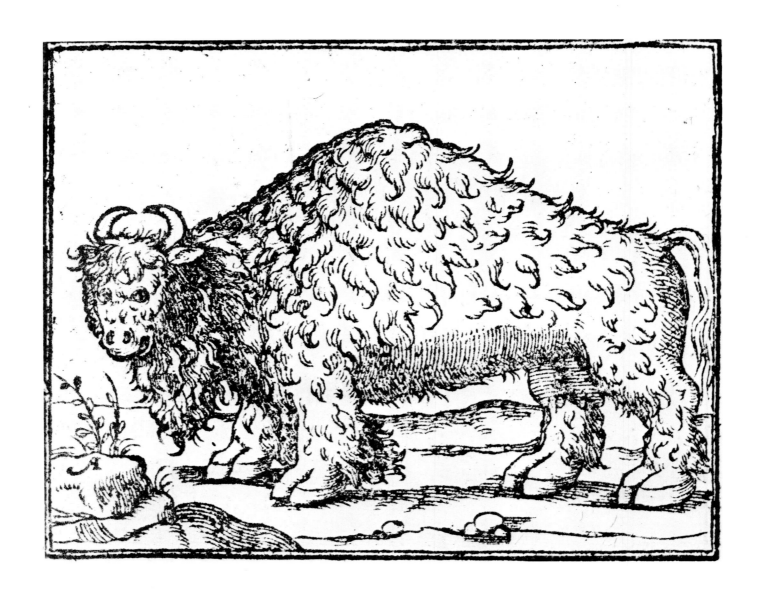

Artist unknown. Bison. *1554. Woodcut. From* La historia general de las Indias *by Francisco López de Gómara. Prints and Photographs Division, Library of Congress, Washington, D.C.*

European voyagers to the New World first encountered the American bison in the most exotic of places—the private menagerie of the Aztec emperor Montezuma. According to a sixteenth-century English translation of López de Gómara's account, Hernán Cortés and his men found this extraordinary beast "a wonderful composition of divers Animals. It has crooked shoulders, with a bunch on its back like a Camel; its Flanks dry; its Tail large, and its Neck covered with Hair like a Lion. It is cloven footed, its Head armed like that of a Bull, which it resembles in Fierceness, with no less Strength and Agility."

Hearsay and Heraldry:
Early American Animals

The first images of American wildlife to reach the European public were fabulous centaurs, dragons, and sea serpents distributed artfully in the margins of early maps. These postmedieval creatures were not substantially different from the fauna attributed at the time to the vast, wild expanses of Africa or Asia. In no way were they serious attempts at realism; instead they were intended as easily understood, convenient symbols for the unknown.

Whether through bravado or naiveté, sixteenth-century navigators ignored the warnings implied by these cartographic monsters. Expedition after expedition set off for the New World, each one adding a contribution to the European's conception of American fauna. Those who backed these expeditions wanted detailed chronicles and maps, and, if possible, paintings and sketches of America's marvels—topographical, botanical, and zoological. Since, with few exceptions, the earliest paintings and engravings depicting the New World were commissioned in Europe after an expedition's return, their scientific veracity was less than perfect. One of the earliest known portraits of the American bison is a woodcut in Francisco López de Gómara's *La historia general de las Indias* published in Spain in the middle of the sixteenth century. It is an excellent example of what happened when an enthusiastic sixteenth-century traveler dictated the details of an unfamiliar animal's anatomy to a gullible artist back home. The depiction must have satisfied the European audience, for it was copied and recopied from London to Utrecht to Antwerp to Frankfurt during the following century.

By the end of the seventeenth century, when Father Louis Hennepin returned from his erratic investigations of the Mississippi, the market for published accounts of the New World had greatly increased. Not only were members of royalty and officialdom eager to expand their knowledge of the unmapped parts of the globe, but there was also a burgeoning leisure class that could afford to collect these exotic accounts. Perhaps it was to please this new audience that Hennepin's London publisher included one or two engraved illustrations as an "ornament to the book," among them the obligatory depiction of the bison. Crowding as much misinformation as possible into one engraving (*The Buffalo*), the artist combined, in a densely wooded setting, an opossum hanging by its tail, a hypothetical but vaguely tropical bird reminiscent of the pelican, and a buffalo so overweight and so badly in need of a haircut that it does not appear to be much of an improvement over the preceding example.

It was the English who finally put an end to generations of misconstrued zoology: they dispatched to the New World a man whose keen powers of observation were combined with enough artistic talent to make his sketches of the flora and fauna reasonably reliable. John White, the first of several

English artist-naturalists commissioned to depict life in the New World, set sail in 1585 with Sir Walter Raleigh. White's work during this expedition to the Carolinas added the authenticity of on-the-spot reporting to several widely read volumes on the New World and earned him the gratitude of London investors and promoters of colonization.

The watercolors that White produced during his brief visit were astonishingly accurate for someone encountering a confusing assortment of foreign animals for the first time. Not unexpectedly he was most accurate when portraying what to him were more familiar-looking species. Thus he could paint a box turtle and a swallowtail butterfly with confidence, but the mighty Florida alligator—through a questionable understatement—emerged looking like an elongated newt or oversized salamander.

Of all the American birds and beasts drawn by Europeans during the age of exploration those of Mark Catesby showed the greatest scientific accuracy as well as the most ambitious sense of design. In the first half of the eighteenth century Catesby was sent twice to America, at the expense of an avid circle of British naturalists who craved specimens of American wildlife as eagerly as today's geologists desire samples of the moon's crust. These dedicated amateurs comprised an informal group of physicians, botanists, and members of the Royal Society. Their first emissary was murdered by Indians in 1710, but so great was their demand for seeds and skins that they determined to try again with young

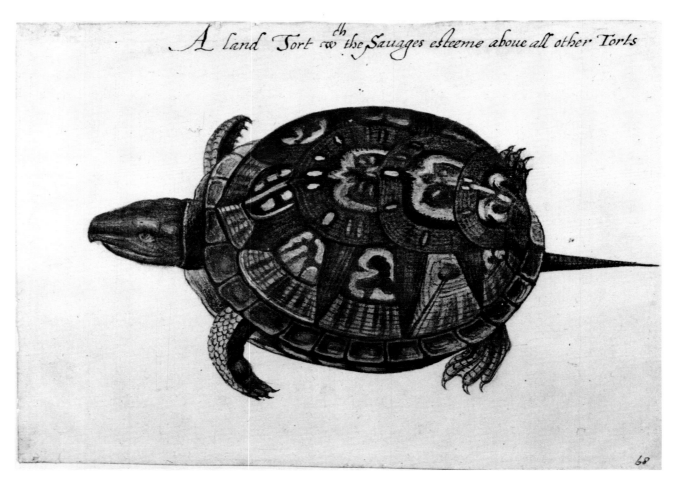

John White. A Land Tort. 1585–86. Watercolor, 5½ × 7¾". Reproduced by courtesy of the trustees of the British Museum, London

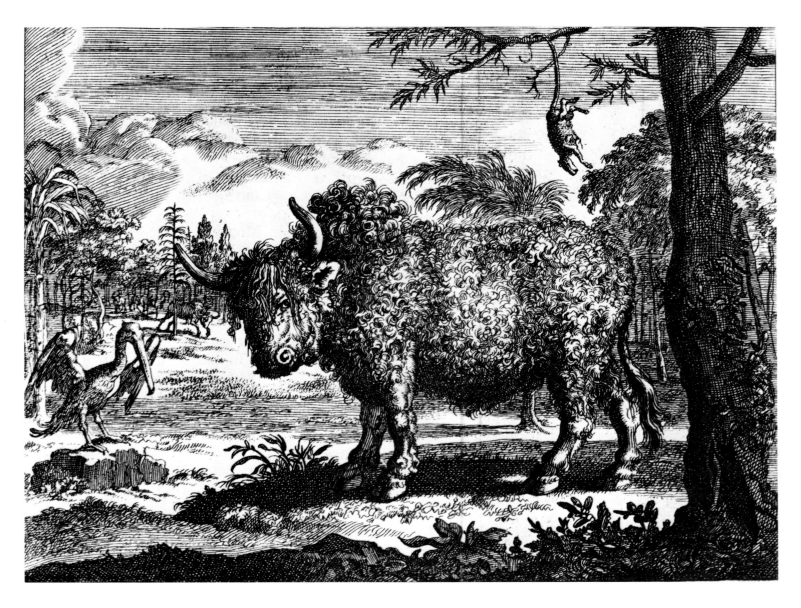

Artist unknown. The Buffalo. 1698. Engraving. From A New Discovery of a Vast Country in America *by Louis Hennepin. Prints and Photographs Division, Library of Congress, Washington, D.C.*

European illustrators struggled bravely with the depiction of the American bison as described by startled visitors to the New World. This artist had a little more success than most with the bison, but his ecology was purely speculative, combining the opossum of the woodlands, the bison of the prairies, and the pelican of the tropics.

The Eastern box turtle, as the artist noted, was one that "the Sauages esteeme aboue all other Torts." Besides being prized as gourmet fare, the box turtle, because of its equable temperament and low center of gravity, was believed capable of holding the earth upon its handsome back.

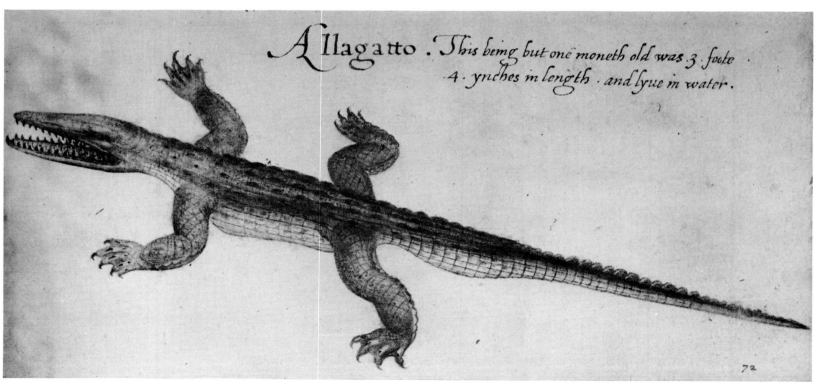

Allagatto. This being but one moneth old was 3 foote 4 ynches in length. and lyue in water.

John White. Swallowtail Butterfly. *1585–86. Watercolor, 5¾ × 7¾". Reproduced by courtesy of the trustees of the British Museum, London*

This beautiful creature begins its life as a singularly revolting-looking caterpillar, but develops into America's largest and most splendid butterfly, the tiger swallowtail. John White painted this striking watercolor in Virginia.

Catesby. From the large region then known as the Carolinas, Catesby sent back numerous specimens of birds, oven-dried and stuffed with tobacco dust, as well as snakes and smaller creatures bottled in rum. It is not surprising that after the long journey across the Atlantic many of the bottles, boxes, and jars arrived in England without their preservatives.

A sort of transatlantic Johnny Appleseed, Catesby provided his sponsors with gardens full of New World plants. But his most lasting contribution was the set of plates that he prepared at his own expense on his return to England and published in installments (1731–43) under the exhaustive title *The Natural History of Carolina, Florida, and the Bahama Islands: Containing the Figures of Birds, Beasts, Fishes, Serpents, Insects, and Plants: Particularly the Forest-Trees, Shrubs, and other Plants, not hitherto described, or very incorrectly figured by Authors. Together with their Descriptions in English and French. To which, are added Observations on the Air, Soil, and Waters: With Remarks upon Agriculture, Grain, Pulse, Roots, &c. To the Whole, Is Prefixed a new and correct map of the Countries Treated of.* For the first time there was a serious attempt at identifying and classifying the flora and fauna of North America. Catesby etched the figures himself from his own paintings, and the first tinted copies were executed under his supervision. That the hand-colored etchings were handsome as well as accurate representations made a strong impression on the first generation of American artist-naturalists, who came to look upon Catesby's *Natural History* as a Bible.

Until the great generation of the Audubons and their peers, however, birds and beasts were almost completely ignored by native American artists. The art of America's first century and a half was instead an art of historical painting and portraiture. It is true that pets (birds, cats, dogs, squirrels, monkeys, peacocks, and deer) were worked into some of the early portraits, especially those of children, and the hounds and horses of a well-conducted hunt were considered suitable adjuncts for landscape. Historical painters made generous use of cavalry horses as stage props to elevate the important characters above the heads of common foot soldiers.

Most native beasts, nevertheless, were virtually excluded from the decor of colonial houses. Since this was a time when the country was literally a wilderness, it seems strange to find in painting only house pets and generals' steeds and an occasional hunting scene. Because art was largely an upper-class matter, most first-generation American artists turned for guidance to Europe, particularly to England, which was not a wilderness by any stretch of the imagination. Only when America became broadly middle class did the nondomesticated animal make a significant appearance.

John White. Allagatto. *1585–86. Watercolor, 4½ × 9⅛". Reproduced by courtesy of the trustees of the British Museum, London*

Early visitors to the New World had great difficulty with the alligator (or allagatto in an early variant spelling). Apparently it was a creature almost impossible to describe with any hope of being taken seriously. John White decided on understatement as the wisest course, choosing a docile specimen barely out of the egg.

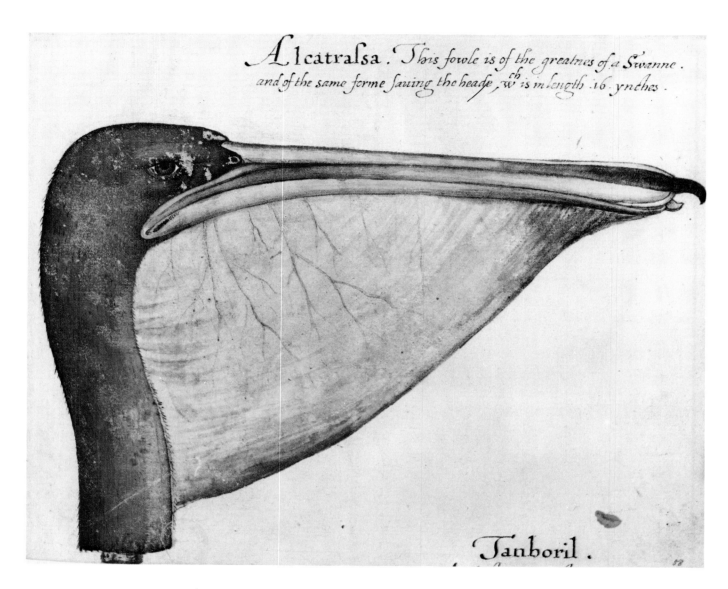

Alcatralsa. This fowle is of the greatnes of a Swanne. and of the same forme sauing the heade, wch is in length .16. ynches.

Tanboril.

John White. Alcatrassa. 1585–86. Watercolor, $7\frac{1}{4} \times 8\frac{3}{4}''$. Reproduced by courtesy of the trustees of the British Museum, London

The pelican, dating back to the Pleistocene epoch, roams great distances each day to fill its bill with fish for the family dinner. This strange creature survives today largely because it received federal protection in time to prevent a plume-hungry hat industry from plucking the last of its members. In fact, it has gradually increased its range in recent years.

Mark Catesby. The Flamingo. c. 1727–31. Hand-colored etching. From The Natural History of Carolina, Florida, and the Bahama Islands *by Mark Catesby. Prints and Photographs Division, Library of Congress, Washington, D.C.*

The American flamingo breeds chiefly in the Bahamas, but occasionally, like human vacationers, it visits Florida. Its bill is ingeniously designed so that the lower half acts as an upper one when its head is bent down; thus the bird can eat without lifting its head. The flamingo's existence is now more assured since its plumage has fortunately passed out of women's fashions.

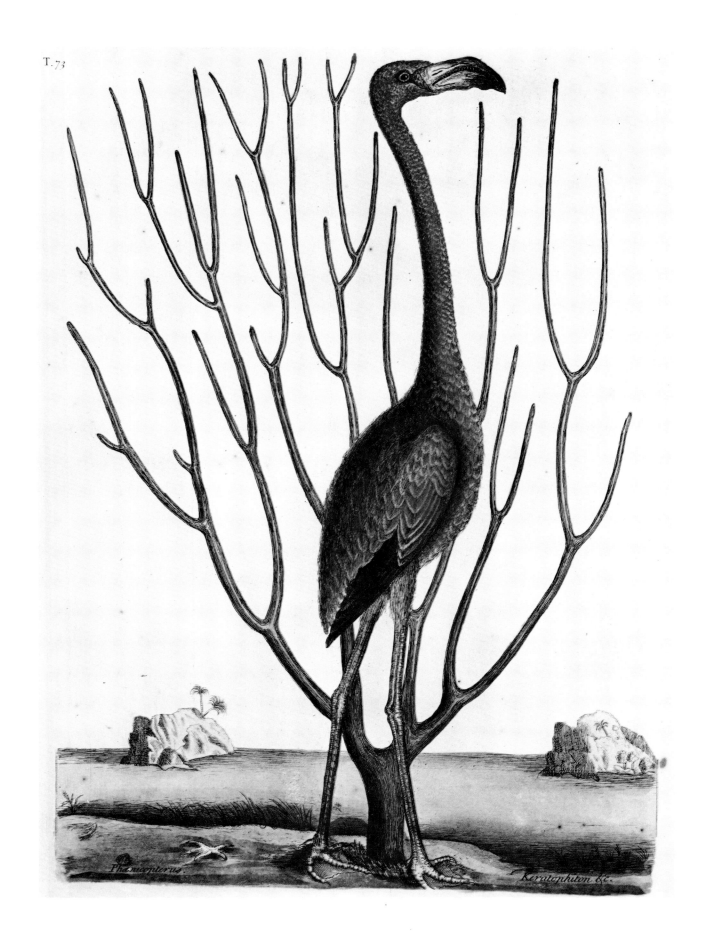

Phœnicopterus.

Keratophiton &c.

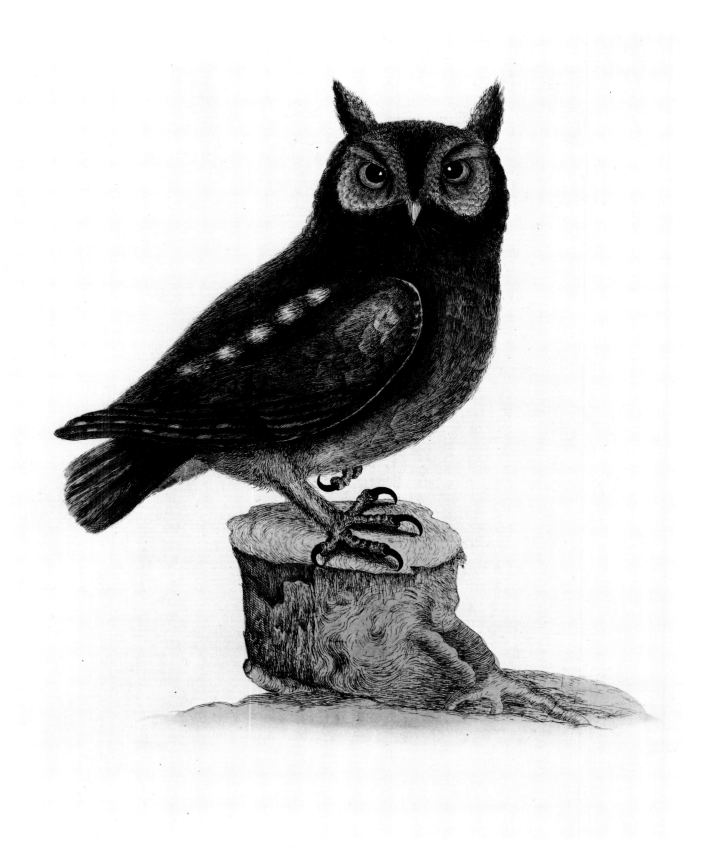

Mark Catesby. The Little Owl. *c. 1727–31. Hand-colored etching. From* The Natural History of Carolina, Florida, and the Bahama Islands *by Mark Catesby. Prints and Photographs Division, Library of Congress, Washington, D.C.*

During the eighteenth century the quest for an appropriate patriotic imagery gave prominence to two resident American creatures—albeit ones straight out of the howling wilderness. The whole explanation of why, and by what formal means, the emerging Republic chose the rattlesnake for a flag and the bald eagle as an emblem is still not entirely clear; yet certain details are particularly fascinating. One, of course, is the apparent perversity of the two choices: these two creatures could hardly have been selected for their inspiring or appealing qualities. Another interesting point is the extent to which Benjamin Franklin was involved in both decisions—even though in one of these his opinion did not prevail.

Since 1717 Britain had been transporting convicted criminals to the colonies, which created enormous difficulties for local authorities. Writing in the *Pennsylvania Gazette* (May 9, 1751), Franklin offered a reciprocal arrangement: "In some of the uninhabited Parts of these Provinces, there are Numbers of these venomous Reptiles we call RATTLE-SNAKES. . . . However mischievous those Creatures are with us, they may possibly change their Natures, if they were to change the Climate. . . . In the Spring of the Year, when they first creep out of their Holes, they are feeble, heavy, slow, and easily taken. . . . Some Thousands might be collected annually, and *transported* to Britain. There I would propose to have them carefully distributed in St. James's Park, in the Spring-Gardens and other Places of Pleasure about London; in the Gardens of all the Nobility and Gentry throughout the Nation; but particularly in the Gardens of the *Prime Ministers*, the *Lords of Trade* and *Members of Parliament*; for to them we are *most particularly* obliged."

Evidently the notion pleased Franklin because he reiterated it often. He again made use of the rattlesnake in the *Gazette* exactly three years later; in this issue the woodcut *Join, or Die* was a vivid appeal for colonial unity against the French and Indians. In 1775 the rattlesnake flag was hoisted up the mast of John Paul Jones's ship *Alfred*, and thereafter, through the Revolution, it stood for the determined impudence of the Yankee spirit: "Don't Tread on Me."

On the question of elevating the bald eagle to official status by putting it on the Great Seal of the United States, Franklin, who had devoted considerable thought to American symbolism and imagery,

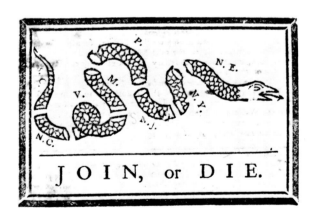

Benjamin Franklin (attr.). Join, or Die. *1754. Woodcut. From* Pennsylvania Gazette *(May 9, 1754). Rare Book Division, New York Public Library. Astor, Lenox and Tilden Foundations*

The glass snake, a limbless lizard also known as the joint snake, may have been the inspiration for this early American political cartoon. The tail of this lizard is extremely brittle and breaks easily from its body when struck, but it eventually regenerates. Rural people still hold to the belief that the glass snake, if cut into pieces, will reassemble itself before sundown.

The screech owl is rigidly monogamous; yet of all birds it is perhaps the most slovenly housekeeper. Its call is not so much a screech but a plaintive protest or mournful descending cry. Catesby prepared most of the hand-colored etchings himself for the Natural History, *published in installments between 1731 and 1743.*

John Singleton Copley. Study for "The Siege of Gibraltar." *c. 1786. Pencil and chalk,*
$12\frac{1}{4} \times 13\frac{1}{2}''$. *Hilson Gallery, Deerfield Academy, Deerfield, Mass. Charles P. Russell*
Collection

American artists of the eighteenth century had little interest in painting animals
except when necessary in the telling of a story. John Singleton Copley, known
for meticulous attention to detail in his elaborate historical paintings, needed
a horse for his enormous canvas The Siege of Gibraltar *because the hero of*
the battle had to be raised above the common rabble of soldiers.

John Singleton Copley. Study for "The Siege of Gibraltar." *c. 1786. Crayon and chalk,*
13 × 10''. Addison Gallery of American Art, Phillips Academy, Andover, Mass.

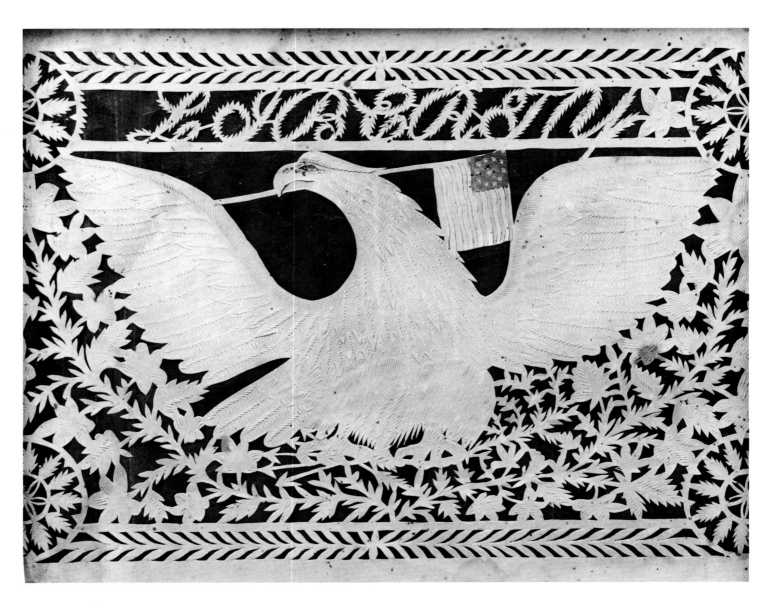

Artist unknown. Spread Eagle. *c. 1780–1800. Paper cutwork, 8 × 10". Henry Francis du Pont Winterthur Museum, Winterthur, Del.*

A craze for intricate paper cutwork swept America in the late eighteenth century. The bald eagle, representing power, grandeur, and authority, became a popular subject for this art of scissors and pins.

Artist unknown. Eagle and Rattlesnake. *c. 1780–1800. Paper cutwork, 7 × 12". Henry Francis du Pont Winterthur Museum, Winterthur, Del.*

In what was undoubtedly an exultant political commentary, a skillful artist deftly cut a scrap of paper into an emblem for the postrevolutionary age: the American eagle clutching the loathesome enemy in its vicelike talons. The roiling serpent, tyrant on its own terrain, cannot withstand the indomitable spirit of the new nation.

46

was less enthusiastic. "I wish," wrote Franklin to his daughter Sarah Bache on January 26, 1784, "the bald eagle had not been chosen as the representative of our country; he is a bird of bad moral character; he does not get his living honestly; you may have seen him perched on some dead tree, where, too lazy to fish for himself, he watches the labor of the fishing-hawk; and, when that diligent bird has at length taken a fish, and is bearing it to his nest for the support of his mate and young ones, the bald eagle pursues him, and takes it from him. With all this injustice he is never in good case; but, like those among men who live by sharping and robbing, he is generally poor, and often very lousy. Besides, he is a rank coward; the little *kingbird*, not bigger than a sparrow, attacks him boldly and drives him out of the district. . . . In truth, the turkey is in comparison a much more respectable bird, and withal a true original native of America. Eagles have been found in all countries, but the turkey was peculiar to ours; the first of the species seen in Europe, being brought to France by the Jesuits from Canada, and served up at the wedding table of Charles the Ninth. He is, besides, (though a little vain and silly, it is true, but not the worse emblem for that,) a bird of courage, and would not hesitate to attack a grenadier of the British guards, who should presume to invade his farmyard with a *red* coat on."

There were similar objections in other quarters but no sooner had Congress made the eagle the official emblem of the new Republic in 1782 than it began to appear everywhere. Virtually every surface that could be decorated bore an eagle. Eagles were soon minted on coins, and through a thriving East-West trade the coins found their way to the Orient; almost by return shipment arrived barrels of export china adorned with the American eagle. The ingenious quilt makers of the 1790s were inspired by the ubiquitous presence of the eagle in design, as were the women who practiced the intricate art of paper cutwork. In their hands the spread-winged eagle became a design motif of extraordinary decorative vitality.

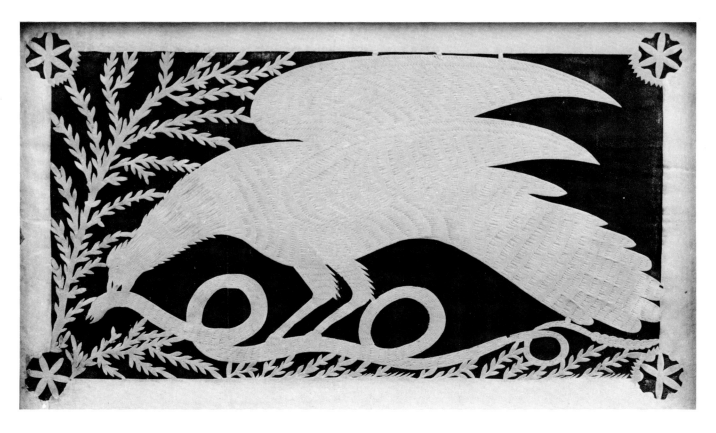

The Hooded Serpent.

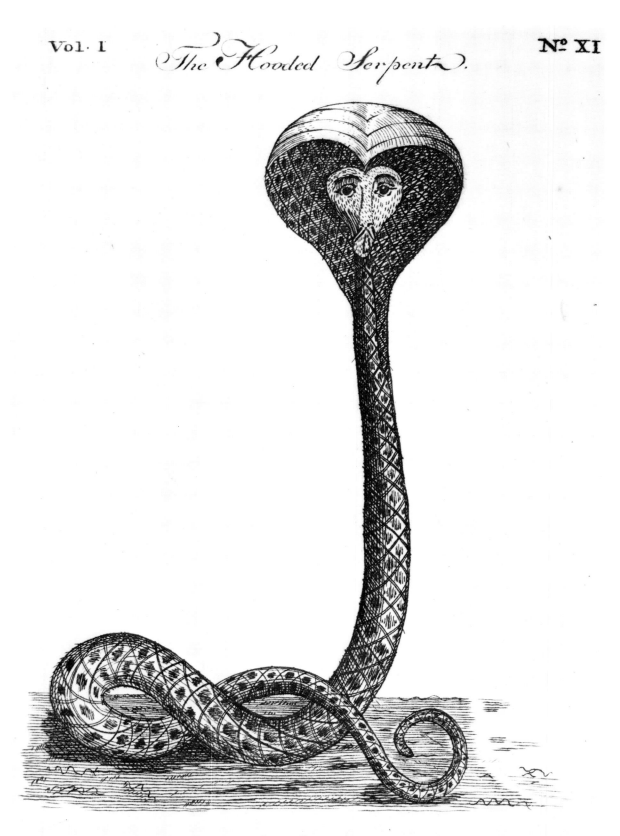

Engraved for Royl American Magazine.

William Bartram. Great Yellow Bream. *1774. Watercolor, 9¼ × 10½″. British Museum (Natural History), London*

"This is a very bold and ravenous fish," wrote Bartram in 1791, "like the leopard himself in some hole or dark retreat & rushes out on a sudden snaping up the smaller fish passing by."

Paul Revere. The Hooded Serpent. *1774. Engraving. From* The Royal American Magazine *(Vol. I, No. XI). American Antiquarian Society, Worcester, Mass.*

It has been said that Paul Revere, as he is known today, was the invention of Henry Wadsworth Longfellow. For a revolutionary activist, Revere seems somewhat unrevolutionary as an artist in copying engravings from English magazines such as this cobra after an English print dated 1771. The cobra, rather fancifully attired in tattersall, looks harmless enough, but this dreaded snake of Asia has signaled by its expanded hood that it will soon strike.

While the Revolutionary War preoccupied the rest of the country, William Bartram—the shy son of John Bartram, America's first resident botanist—slogged through the fever-infested waterways of the Deep South, collecting notes and specimens for Sir John Fothergill, prominent London physician and Quaker philanthropist. William Bartram belonged to the eighteenth century both by chronology and by conditioning, yet he was to become the spiritual father of the generation of the Audubons, Alexander Wilson, and the Peales. He journeyed through the Carolinas, Georgia, Florida, and the Indian country to the west, territory traveled by Mark Catesby on a similar mission. Bartram's 1791 account of his journey was the first real preview of the nineteenth-century census of American wildlife, a project that ultimately engaged many artists and naturalists and that would not be completed for a hundred years.

Bartram's *Travels Through North and South Carolina, Georgia, East and West Florida* (Philadelphia, 1791) was to have a palpable effect on the works of some of his contemporaries in Europe, especially on exponents of romanticism such as William Wordsworth, Samuel Taylor Coleridge, and François René, vicomte de Chateaubriand, who discovered in Bartram's vivid descriptions of the American wilderness confirmation of their own somewhat intellectual ideas about returning to nature.

Like the later accounts by the Audubons and Catlin, Bartram's *Travels* was a wide-ranging commentary on plant and animal life and Indian lore, punctuated by wild accounts of the artist's own escapades. Bartram's sketch *The Alegator of Saint Johns* was the result of a particularly hair-raising episode. "How shall I express myself so as to convey an adequate idea of it to the reader, and at the same time avoid raising suspicions of my veracity?" Bartram asked himself. "The horrid noise of their closing jaws, their plunging amidst the broken banks of fish, and rising with their prey some feet upright above the water, the floods of water and blood running out of their mouths, and the clouds of vapour issuing from their wide nostrils, were truly frightful."

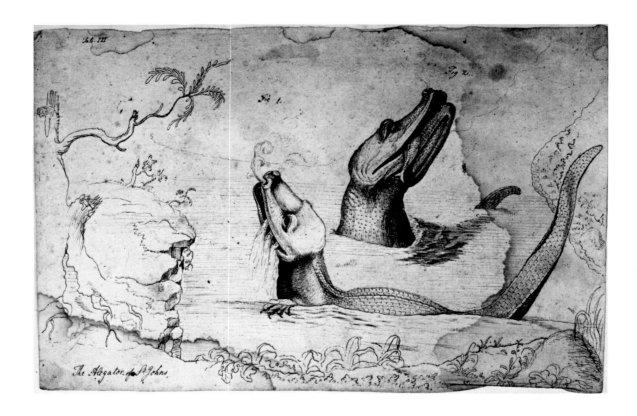

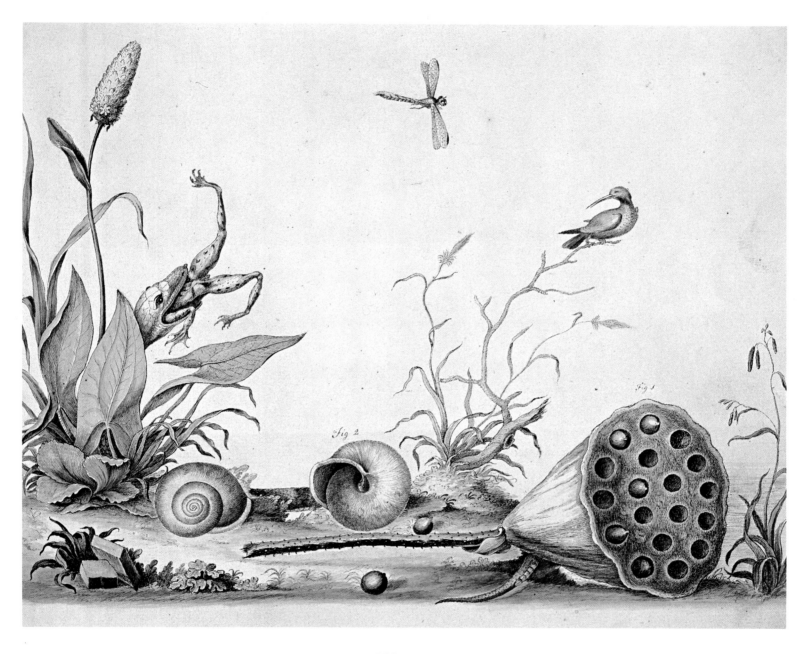

William Bartram. Snails. *c. 1774. Watercolor, 9 × 10½″. British Museum (Natural History), London*

The reptilian creature, which is gingerly swallowing a frog, appears to be a hognose snake, or puff adder, a comic creature that commonly startles its enemies by hissing and puffing ferociously.

William Bartram. The Alegator of Saint Johns. *c. 1774. Watercolor, 9 × 14″. British Museum (Natural History), London*

William Bartram's exploration of the Saint Johns River in eastern Florida brought him face to face with a group of irritable alligators. Terrified, the artist maneuvered his skiff to safety, but, as his sketch reveals, he equated the beasts with smoke-breathing dragons.

THE
ELEPHANT,

ACCORDING to the account of the celebrated BUFFON, is the moft refpectable Animal in the world. In fize he furpaffes all other terreftrial creatures; and by his intelligence, makes as near an approach to man, as matter can approach fpirit. A fufficient proof that there is not too much faid of the knowledge of this animal is, that the Proprietor having been abfent for ten weeks, the moment he arrived at the door of his apartment, and fpoke to the keeper, the animal's knowledge was beyond any doubt confirmed by the cries he uttered forth, till his Friend came within reach of his trunk, with which he careffed him, to the aftonifhment of all thofe who faw him. This moft curious and furprifing animal is juft arrived in this town, from Philadelphia, where he will ftay but a few days.———He is only four years old, and weighs about 3000 weight, but will not have come to his full growth till he fhall be between 30 and 40 years old. He meafures from the end of his trunk to the tip of his tail 15 feet 8 inches, round the body 10 feet 6 inches, round his head 7 feet 2 inches, round his leg above the knee 3 feet 3 inches, round his ankle 2 feet 2 inches. He eats 130 weight a day, and drinks all kinds of fpirituous liquors; fome days he has drank 30 bottles of porter, drawing the corks with his trunk. He is fo tame that he travels loofe, and has never attempted to hurt any one. He appeared on the ftage, at the New Theatre in Philadelphia, to the great fatisfaction of a refpectable audience.

A refpectable and convenient place is fitted up adjoining the Store of Mr. Bartlet, Market-Street, for the reception of thofe ladies and gentlemen who may be pleafed to view the greateft natural curiofity ever prefented to the curious, which is to be feen from funrife till fundown, every day in the week.

☞ The Elephant having deftroyed many papers of confequence, it is recommended to vifitors not to come near him with fuch papers.

Admittance *ONE QUARTER OF A DOLLAR*——Children *ONE EIGHTH OF A DOL-LAR.*

Newburyport, Sept. 19, 1797.

Oct 23/05

52

"Drawn from Nature"

For a time the issue of peaceable kingdom versus howling wilderness lay dormant. This was during the age of John James Audubon, George Catlin, Alexander Wilson, and the Peale family, all men of a scientific turn of mind who attempted to make some kind of rational order out of the American scene —not to deny nature's mysteries nor to brood over them but to describe and catalog them one by one. These men readily accepted the challenge of the American wilderness and, despite the appalling conditions of backwoods travel, recorded accurately and with painstaking attention to detail the characteristics of hundreds of creatures never before seen—let alone painted—by the white man.

Despite the many rare and attractive beasts that wandered the North American continent in the early decades of the Republic, the average American displayed a strong predilection for animals behind bars. The beer-drinking beast in the 1797 *Elephant* broadside is a perfect illustration of the common attitude toward wildlife that prevailed in the generation before Audubon. This creature, exhibited to a raucous and enthusiastic public, was a native of the howling wilderness of Africa, and, significantly, it was heavily guarded and kept in a constant state of affable torpor. Here, surely, was man's dominion over beast at its most extreme.

At the beginning of the nineteenth century quite another sort of elephant came to light, marking the beginning of a scientifically minded century. By 1801 natural science had advanced in the United States to such a degree that when the prehistoric bones of what was first known only as "the great American *incognitum*" were exhumed in Ulster County, New York, there was enough taxonomic knowledge in Philadelphia to put the bones back together correctly and easily. Charles Willson Peale and his son Rembrandt thereupon assembled a mastodon exhibit, which outdrew all of the traveling menageries both at home and in England.

In Philadelphia, the Peales' hometown, the newly independent nation began to take stock of itself. Even while legislators toiled in Independence Hall, there was already emerging a young intellectual oligarchy whose avocations in the fields of astronomy, geology, taxonomy, seismology, electricity, magnetism, botany, zoology, and paleontology—to name only a few of their concerns—

Artist unknown. The Elephant. 1797. Woodcut, 9½ × 7¾" (overall). New-York Historical Society

This eighteenth-century broadside, printed in Newburyport, Massachusetts, for the exhibition of a prodigiously talented elephant, would have precipitated vehement protests had the temperance movements or the ASPCA been in existence in 1797. History does not record what became of the elephant, but surely its life was a merry, if not a long one.

brought them together under the composite discipline of "philosophy." Since the political exigencies of the nation were no longer the most pressing order of business in Philadelphia, Charles Willson Peale's large and talented family and their friend William Bartram could direct their energies toward leading the scientific community into a new age. William Bartram's *Travels* had gone into many editions, but no one knew better than Bartram, who was now in his sixties, how much more remained to be done. He suspected that countless birds and other animals had yet to be sought out, named, and drawn from nature. At Bartram's urging, a young schoolteacher named Alexander Wilson set off to the hinterlands for the purpose of taking an extensive census of America's bird population.

Wilson was an ornithologist's ornithologist. His achievements were prodigious, and the tragedy of his career was that just as he reached his prime he fell under the shadow of John James Audubon, whose own publications attracted much more attention and acclaim. Wilson's *American Ornithology* barely scratched the surface, covering only a fraction of the hundreds of birds in North America, but his conscientious attempt cannot by any standards be judged a failure. Wilson had keen powers of observation, and his birds showed a vivacity and liveliness that not even Audubon could match. Later ornithologists emphatically asserted that Wilson never made a mistake.

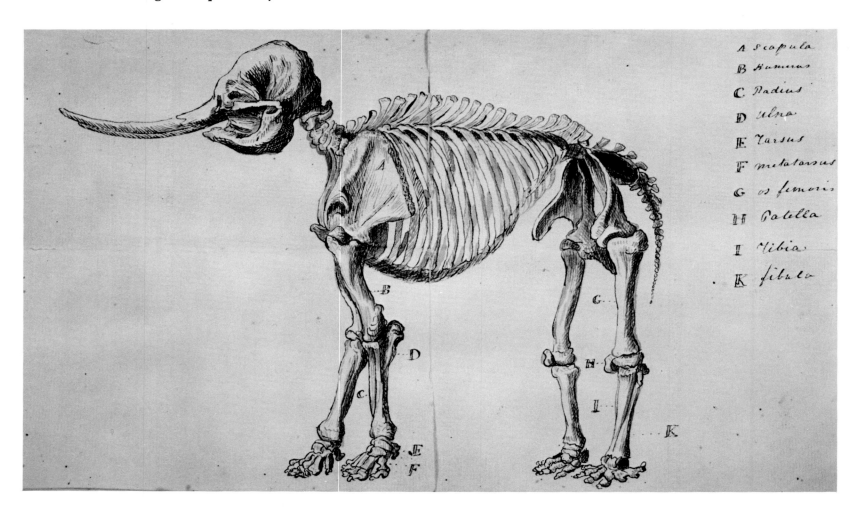

Rembrandt Peale. Mastodon Skeleton *(detail).* 1801. Ink, 15¼ × 12¾" *(overall).*
American Philosophical Society Library, Philadelphia

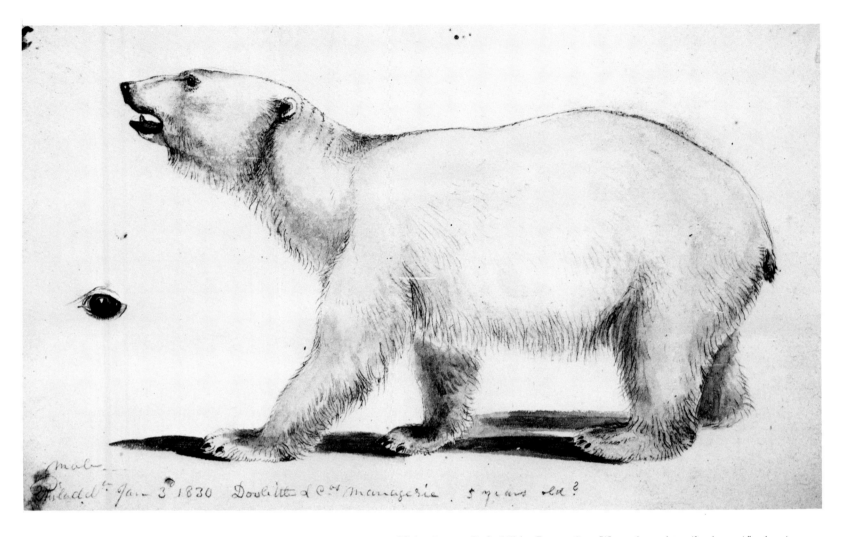

Titian Ramsay Peale. White Bear. 1830. Watercolor and pencil, 5½ × 9¼". American Philosophical Society Library, Philadelphia

The polar bear has a fine Roman nose and a proud bearing. Menagerie specimens like this one were captured at considerable risk by arctic whalers, but they were enthusiastically appreciated by the American public as the menageries made the rounds of fairgrounds and public parks in the period before zoological gardens were established.

Quite as extraordinary as the discovery of mastodon remains in Ulster County, New York, was the incredibly slow migration of generations of mastodons from the valley of the Nile across Asia to the North American continent, which thousands of years ago joined Asia at the Bering Strait. That journey—ending with the discovery of its bones in 1801—took over thirty-six million years.

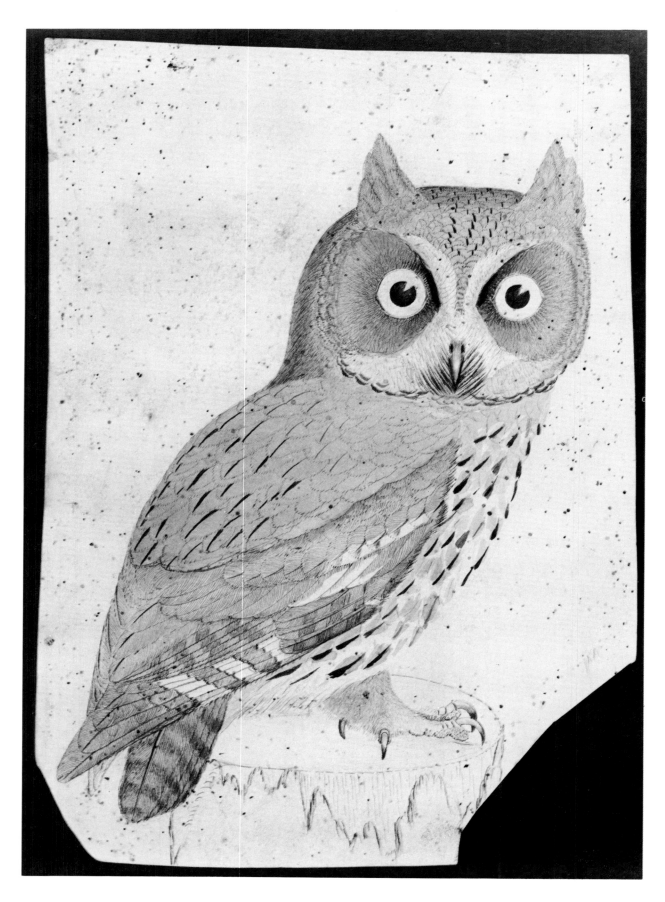

Alexander Wilson. Owl. 1804. Ink and watercolor, 10½ × 7⅝". Houghton Library,
Harvard University, Cambridge, Mass.

Rubens Peale. Two Ruffed Grouse in Underbrush. *1864. Oil, 19¼ × 27¼″. Detroit Institute of Arts. Gift of Dexter M. Ferry, Jr.*

The ruffed grouse, the state bird of Pennsylvania, is a friendly creature as well as a delicious one—a fatal combination of traits indeed. It is one of the most popular game birds in America, so popular that it is the sportsmen themselves who have done most to protect it from extinction. Rubens Peale, Titian's younger brother, painted this pair when he was only seventeen.

Alexander Wilson began his ornithological career tentatively, sketching from both collected specimens and the books in the library of William Bartram, who was his neighbor and mentor. Wilson made this drawing from the stuffed owl that stood in his schoolroom, but he evidently also used Mark Catesby's engraving The Little Owl *(shown on page 42) as a guide, for the two are quite similar in pose and perch.*

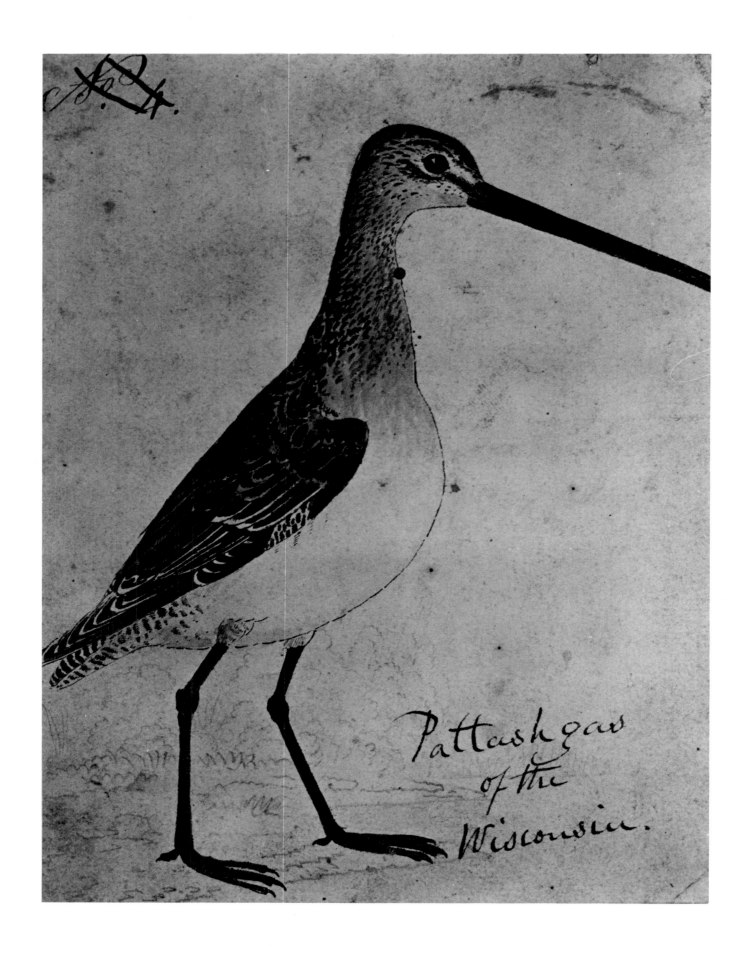

Peter Rindisbacher. Pattashgas of the Wisconsin. *c. 1826–29. Watercolor, 6½ × 5".*
State Historical Society of Wisconsin, Madison. Iconographic Collection

Peter Rindisbacher gained considerable fame as a painter of Indian life.
Occasionally he would make sketches of wildlife, such as the long-billed
dowitcher of the arctic and subarctic region. Ornithologically the drawing is
somewhat out of proportion; nevertheless the bird's mildly bashful glance is
true to nature. Pattashgas is an American Indian name for this bird.

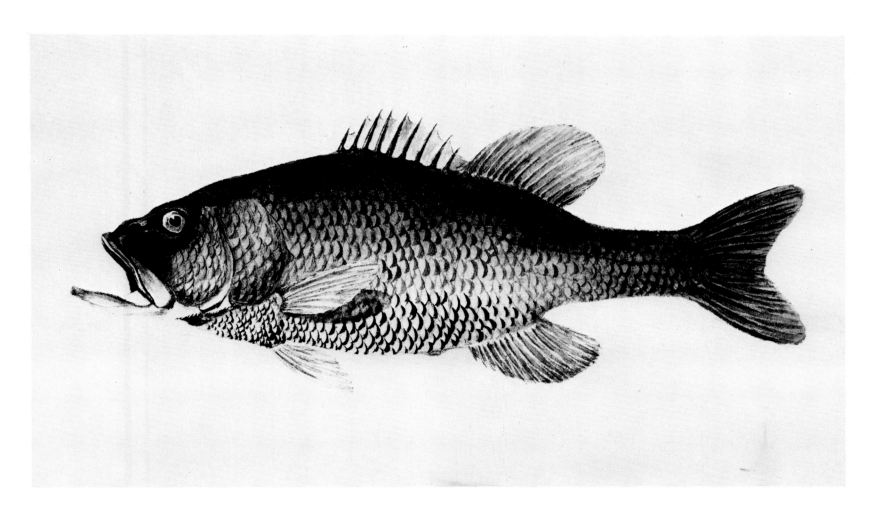

Titian Ramsay Peale. Fish. *1820. Watercolor and pencil, 5½ × 8½". American*
Philosophical Society Library, Philadelphia

Pound for pound, the bass family provides the American angler with more
exciting sport than any other freshwater fish. These scaly creatures are
adaptable to a variety of conditions, but being hauled out of the water is not
one of them. Titian Peale, fourth of Charles Willson Peale's nine artistic
children, landed this specimen in New Orleans.

The incomparable John James Audubon has come in for a critical reevaluation in recent years. He possessed both luck and skill, but it seems certain now that he occasionally accepted credit where none was due, letting people believe he was the Lost Dauphin and borrowing ideas from others, which apparently he did on more than one occasion from Alexander Wilson. Despite his private weaknesses, however, Audubon did much to extend the popular knowledge of American beasts, and his ingenuity of technique (a combination of pencil, pastel, and watercolor) was equaled only by his invention of a way to wire up dead specimens in poses more dramatic and lifelike than possible before.

Between the publication of Audubon's two great contributions to the study of American fauna, *The Birds of America* (1827–38) and *The Viviparous Quadrupeds* (1842–45), other artist-naturalists made their appearance, and by the end of the 1830s a certain pattern could already be observed in the personal (if not the scientific) lives of that great generation. Typically the artist-naturalist had roots in the Philadelphia region; he came from a family devoted equally to the pursuits of art and science; he possessed a character obsessive enough to make the miseries of wilderness travel worthwhile; and he had the misfortune of being a sadly inefficient businessman.

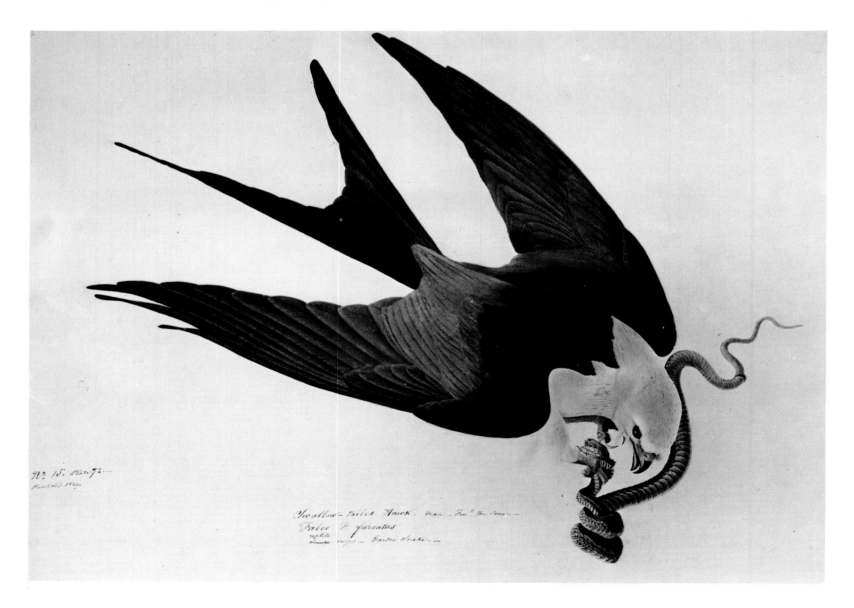

John James Audubon. Swallow-tailed Hawk. *1821. Watercolor, 20¾ × 29". New-York Historical Society*

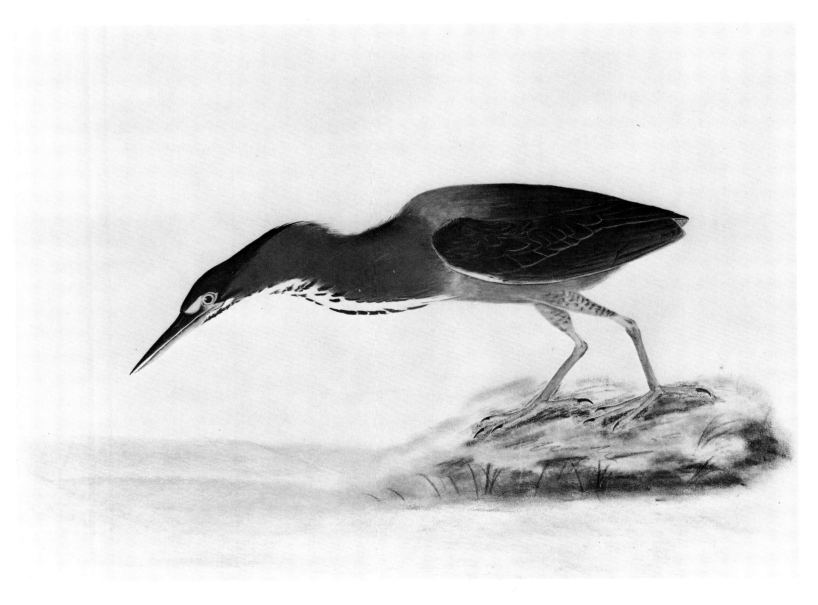

John James Audubon. Green Heron. 1810. Watercolor, 15 × 23". Houghton Library, Harvard University, Cambridge, Mass.

The green heron, known also as shitepoke or fly-up-the-creek, is a solitary bird. Compared to larger, more elegant-looking herons, the little green heron appears somewhat clumsily designed, but its consummate skill as a fisherman more than compensates for its awkward appearance.

The swallow-tailed kite, or swallow-tailed hawk, is a dramatic-looking flesh eater with an impressive diet—snakes, lizards, frogs, even young alligators —which it can consume in the midst of flight. The swallow-tailed kite is becoming increasingly rare because of man's obsession with shotguns, poison baits, and insecticides. It is now on the list of endangered species, surviving only in a few southern swamps where man is loath to venture.

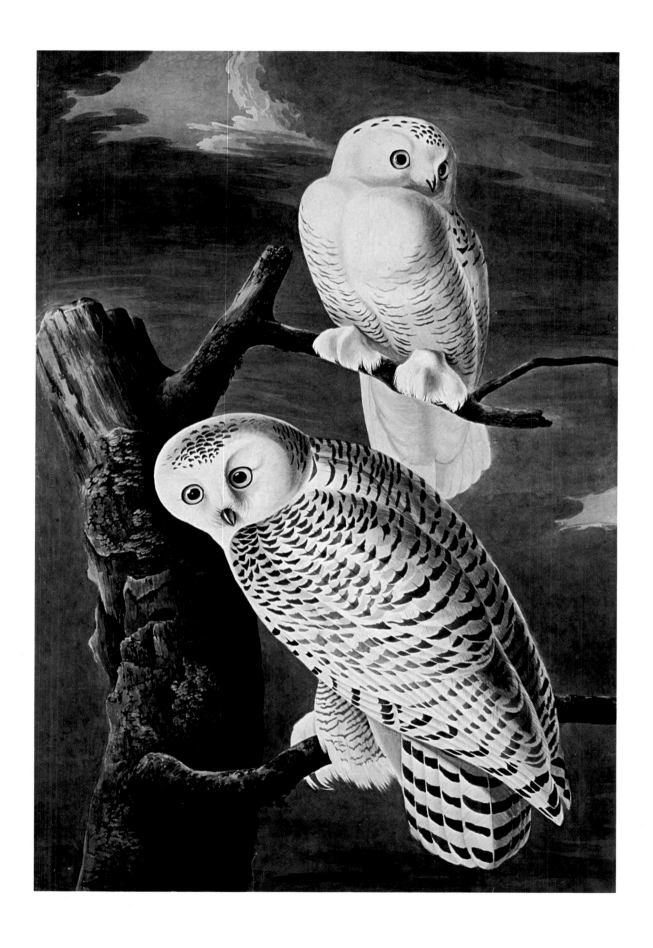

Except for the fact that he did not come from a family of scientific amateurs, George Catlin had these qualities. Like Charles Willson Peale, Catlin was a museum proprietor. Like Audubon, he was an encyclopedist. Like Bartram, he was a vivid prose writer. Like John White, he was a competent self-trained painter. Like all of his kind, he suffered frequent and disturbing shifts of fortune and was constantly having to drop his work to fend off bill collectors.

Men such as William Bartram and John White pictured and described Indians as well as wildlife, and no doubt they, like Jean-Jacques Rousseau, thought of the Noble Savage as part of the native fauna. But only Catlin was really ahead of his time in his sensitivity to the balance of nature and the place of the Indian: he knew that even in the early nineteenth century, animal and Indian alike were rapidly disappearing. His life's work was to make people conscious of the continent's natural splendor —both human and animal—before it vanished entirely.

The buffalo hunt of the Indians was a theme that fascinated Catlin. Enthusiastically describing the hunt in his *Letters and Notes,* he wrote: "The mode in which these Indians kill this noble animal is spirited and thrilling in the extreme. . . . I have almost daily accompanied parties of Indians to see the fun, and have often shared in it myself; but much oftener ran my horse by their sides, to see how the thing was done—to study the modes and expressions of these splendid scenes, which I am industriously putting upon the canvass." But his enthusiasm waned when he witnessed a tribe of Indians wantonly slaughtering bison by the hundreds not for meat but only for their hides. He decided on the spot to launch a campaign against the senseless ravaging of nature by the American fur trade.

In the 1840s, on his return from the West, Catlin embarked on a titanic struggle to place his pictures before the public, something that was not a problem for Audubon, who was well established by this time. Audubon's *Quadrupeds* came off the presses without calamity. His sons were old enough to assume some of the burdensome work of painting background scenery and of keeping the accounts. Audubon's *Quadrupeds* was a collaborative effort: it involved a number of friends and acquaintances as well as his sons Victor Gifford Audubon and John Woodhouse Audubon. As was also true of the earlier *Birds*, the plates for *Quadrupeds* were immediately denounced as shocking by a part of the non-scientific public; they were even considered immoral. Yet from Audubon's point of view, if, like his *Swallow-tailed Hawk*, some creatures were more predatory by nature or less fastidious than we might like, then so be it—he would not bowdlerize.

John James Audubon. Snowy Owl. 1829. Watercolor and pencil, 38¼ × 25½". New-York Historical Society. Purchased from Mrs. John J. Audubon, 1863

The huge snowy owl's range is centered in the arctic region. It is seldom observed much south of the Canadian border unless driven by extreme hunger or cold. Although this owl is diurnal, Audubon chose it for the subject of a night scene.

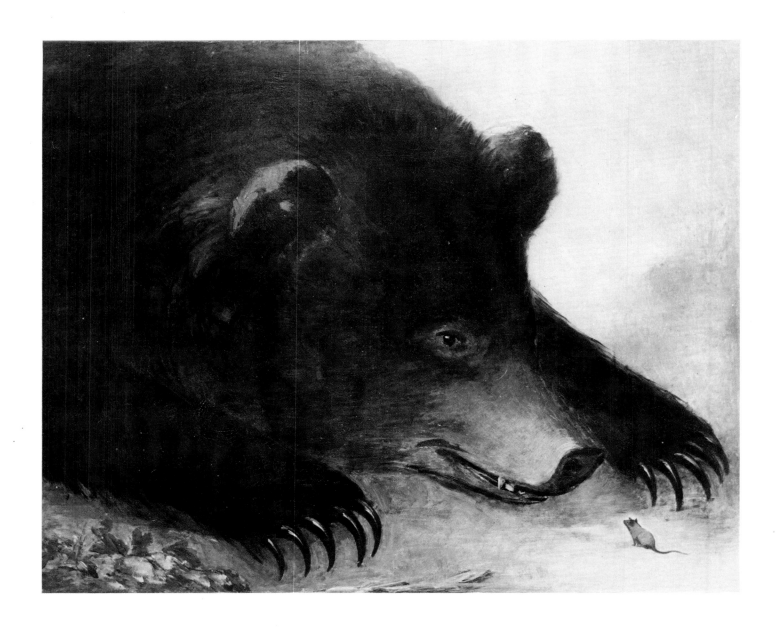

George Catlin. Portraits of Grizzly Bear and Mouse, from Life. *1832. Oil, 26½ × 32½". National Collection of Fine Arts, Smithsonian Institution, Washington, D.C.*

The grizzly bear's grisly reputation rests, to a large degree, on the fact that it is extremely nearsighted and frequently attacks any moving object. Catlin's mouse stands a good chance of survival, however, because the bear must clearly see that no danger is imminent.

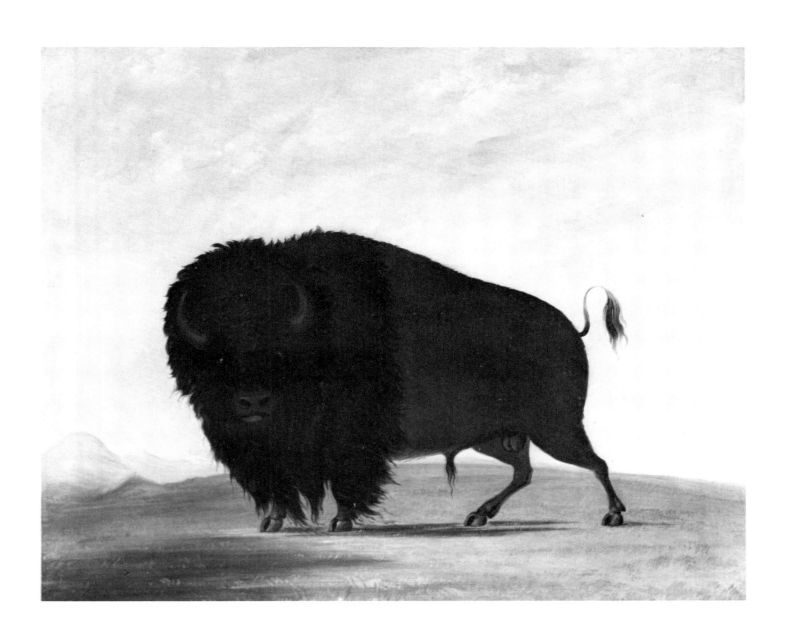

George Catlin. Buffalo Bull Grazing on the Prairie in His Native State. *1832. Oil, 24 × 29". National Collection of Fine Arts, Smithsonian Institution, Washington, D.C.*

George Catlin, the unrivaled chronicler of Indian life on the western plains, made the preliminary sketches for many of his paintings while on horseback. The sketch for this powerful painting was done at full gallop through a stampeding herd near Fort Union at the mouth of the Yellowstone River. His Indian companions, who were laying in a supply of meat for the coming winter, were delighted by the sight of Catlin on horseback recording the chase in his sketchbook and teased him unmercifully.

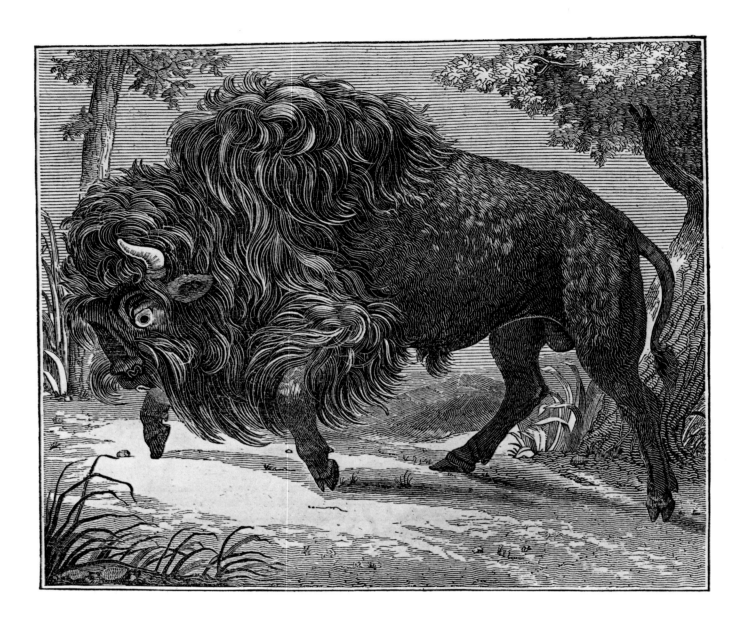

Artist unknown. The Bison, or Wild Ox of America. *1834. Woodcut. From* The
American Magazine of Useful and Entertaining Knowledge *(December 1834).*
Prints and Photographs Division, Library of Congress, Washington, D.C.

*To judge from the preponderance of buffalo in American painting and
illustration, the nation was totally enthralled with this creature during much of
the nineteenth century. Yet it is interesting to note that depictions of the buffalo
usually fit into only two categories: gory chase scenes in which the buffalo
takes on the role of a bleeding toro; and handsome, somewhat abstract
illustrations such as this one in* The American Magazine of Useful and
Entertaining Knowledge.

John James Audubon. American Black Rat. *1842. Watercolor, 21¾ × 27½". American Museum of Natural History, New York*

On the morning of September 2, 1842, undoubtedly the Audubon household had something other than eggs for breakfast; the artist had caught marauders at work in his henhouse the night before.

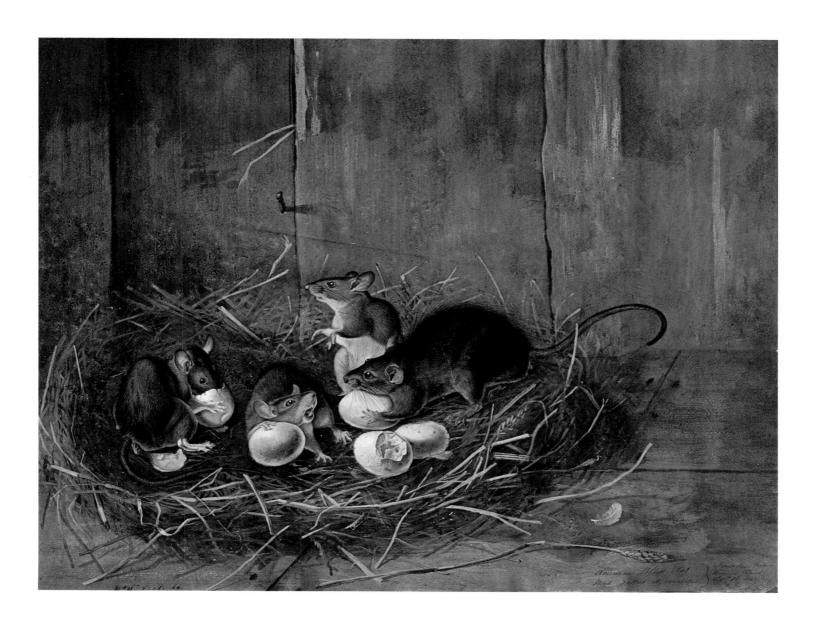

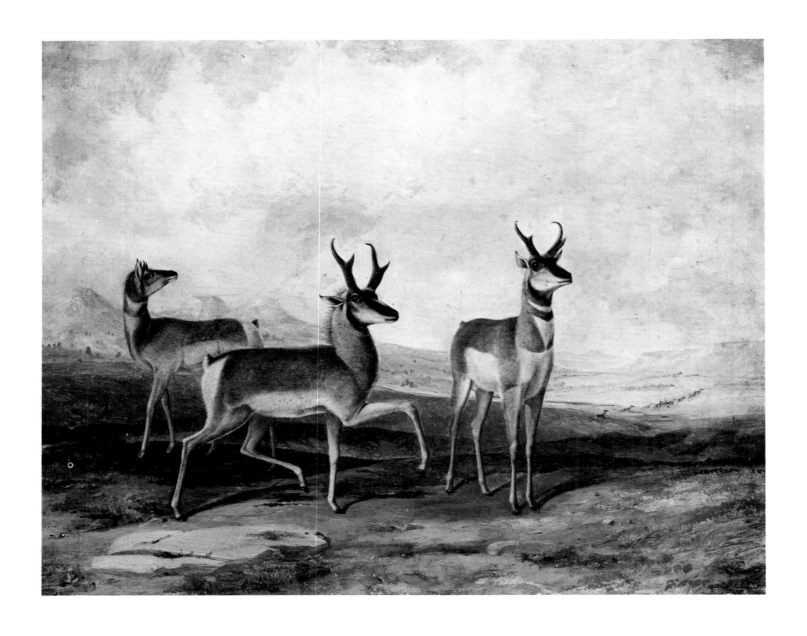

John Woodhouse Audubon. Prong-horned Antelope. *1844. Oil, 20⅞ × 26½″. American Museum of Natural History, New York*

The pronghorn is one of America's most splendid native animals. It is capable of remarkable feats: it can run up to fifty miles an hour and can leap as high as twenty feet. Like the bison, this graceful, sharp-sighted creature was nearly decimated in the nineteenth century but now has some federal and state protection.

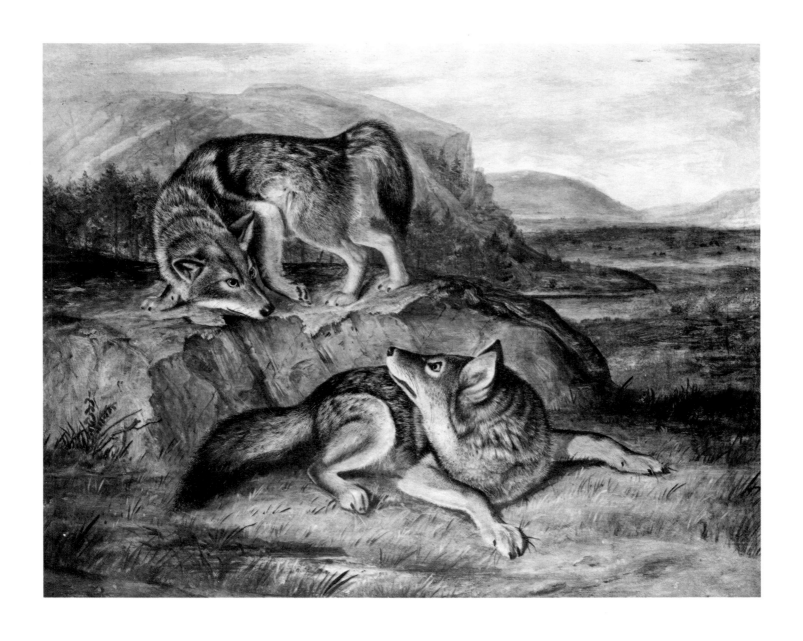

John Woodhouse Audubon. Gray Wolf (White American Wolf). *1843. Oil, 22 ×
26⅝". American Museum of Natural History, New York*

*The wolf, one of the most misunderstood animals in America, was depicted by
the son of John James Audubon in what many people still believe is the wolf's
typical attitude—snarling with fangs bared and back arched. This menacing
stance, however, does not signify raw aggression but a determination to defend
itself, its family, its food, or its territory.*

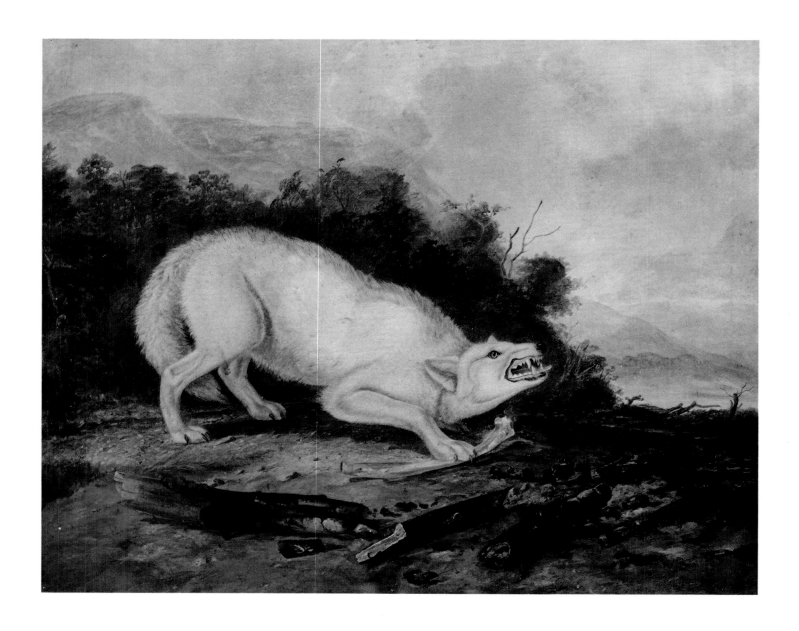

John Woodhouse Audubon. Coyote or Prairie Wolf. *c. 1843. Oil, 22 × 25⅜″. American
Museum of Natural History, New York*

The coyote has managed to extend its range since Audubon's Quadrupeds,
*despite ranchers' attempts to exterminate it. Smaller and less rapacious than
the wolf, the coyote, too, is incompatible with man's economic interests, yet its
ingenuity at eluding harassed stockmen has earned it their grudging respect.*

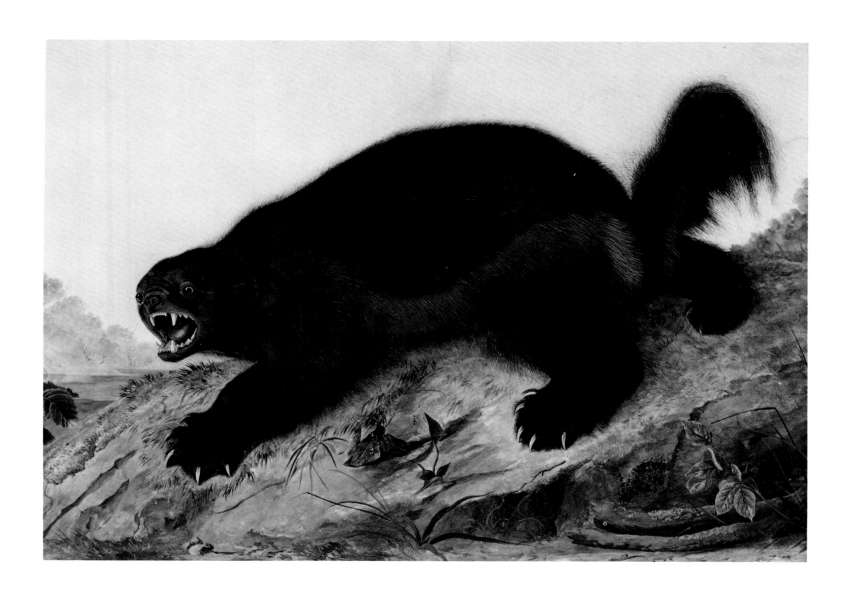

John James Audubon. Wolverine. *1841. Watercolor, 25⅛ × 36″ . American Museum of Natural History, New York*

The wolverine, largest member of the weasel family, possesses the most fearsome qualities of bear, wildcat, and wolf in addition to an uncanny ability to hit and run without leaving a trace.

John James Audubon. Soft-haired Squirrel. *c. 1845. Watercolor, 11¼ × 16". Wadsworth Atheneum, Hartford, Conn. Gift of Henry Schnakenberg*

Part clown, part pest, the squirrel is an animal familiar even to city dwellers. Squirrels seem always to be foraging about for something to eat, which is understandable since they must maintain a pulse of around 300 and a comfortable body temperature at 102 degrees.

John James Audubon. Bridled Weasel. *1845. Lithograph, 15¾ × 25". Smithsonian Institution, Washington, D.C. Harry T. Peters "America on Stone" Lithography Collection*

The weasel's reputation has suffered unjustly over the years for its alleged damage to Farmer Brown's chickens. Actually the weasel is nature's mousetrap, roving scores of acres each night eliminating innumerable small destructive rodents.

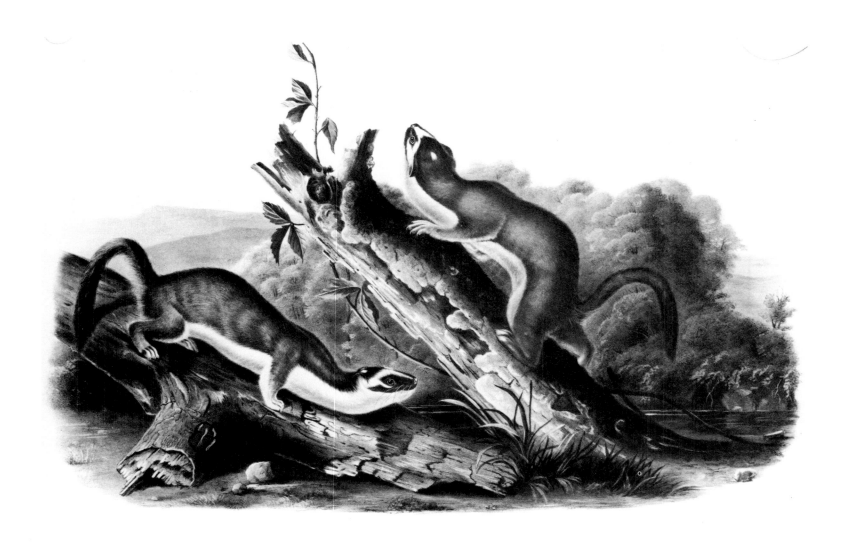

John James Audubon died in 1851, his work complete. George Catlin continued to travel throughout the Western Hemisphere until the end of the 1860s, writing, painting, and running on the tail of his enthusiasms. The Peales still made an animal painting now and then.

In 1863 yet another Pennsylvanian, Martin Johnson Heade, set out in pursuit of *his* obsession—the elusive, evanescent hummingbird. His paintings of hummingbirds—those both north and south of the Caribbean (and sometimes combined in the same painting)—had an extraordinary, jewellike quality. He posed the birds in a kind of pulsing, humid tropical still life quite different from anything attempted by more literal-minded artists. Yet his artistic ties with the mainstream of American landscape art made Heade one of the few painters who were able to gain both the privilege of exhibiting in the National Academy of Design and the patronage of knowledgeable, well-to-do nature lovers. An inveterate traveler, Heade roamed the tropics for several decades as mystic adventurer and proselytizer for his beloved hummingbirds.

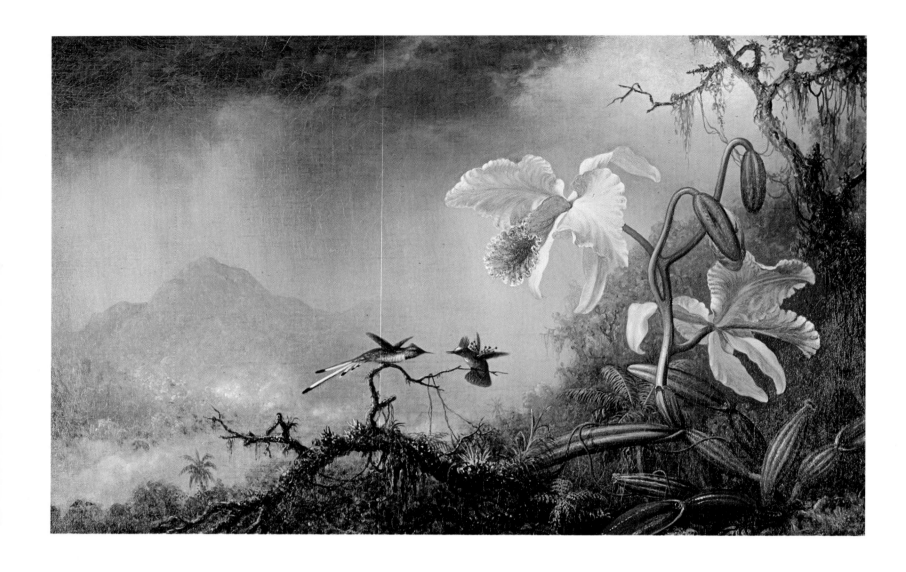

Martin Johnson Heade. Two Fighting Hummingbirds with Two Orchids. *1875.*
Oil, 17½ × 27¾″. Whitney Museum of American Art, New York. Gift of Henry
Schnakenberg in memory of Juliana Force

Virtually everything commonly thought about hummingbirds is illusion: their
daintiness (they eat fifty or sixty meals a day), their fragility (they fly from
continent to continent), and their brilliance (which results from refraction of
light, not pigments). Appropriately they have been given names far fancier
than the common wren or woodpecker. Here a Cora's sheartail fights with a
tufted coquette.

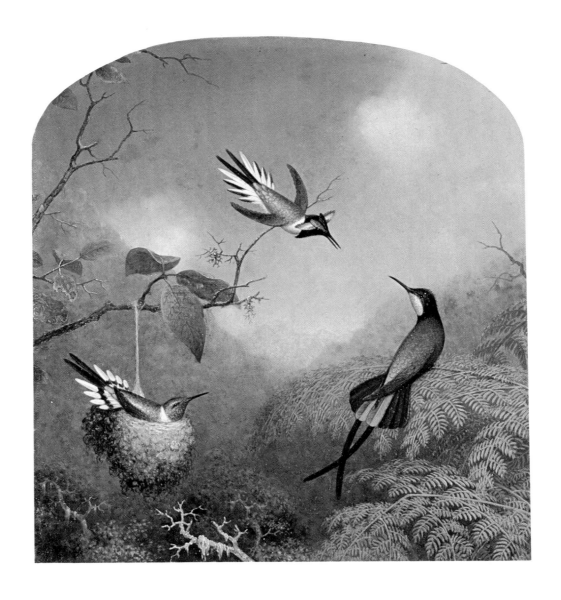

Martin Johnson Heade. Brazilian Hummingbirds. *1866. Oil, 14 × 13″. Webb Gallery of American Art, Shelburne Museum, Shelburne, Vt.*

A pair of sun gems pose with a crimson topaz. Eastern North America has but one native species of hummingbird, the rubythroat. To see dazzlers like these one must go, as Heade did several times, to the tropical rain forests of Central and South America.

During the last decades of the nineteenth century the work of identifying and classifying native American fauna gradually took a prosaic turn. Indigenous species that had eluded Audubon and his brethren were being captured, named, and painted by museum curators and artists in the employ of the U.S. government as American bureaucracy took upon itself the financing and publication of numerous volumes reporting on railroad surveys, coastal mapping expeditions, and paramilitary forays into the Far West. Zoological illustrations for these, though voluminous and immensely competent, were as matter-of-fact as befits a government commission.

By 1900 the animal census of America was nearly complete. At that time Abbott Handerson Thayer, a highly regarded turn-of-the-century portraitist, came up with the revolutionary proposition that all previous artistic work in the field of natural history was, in one important respect, completely erroneous. Although Audubon and his contemporaries had made an admirable attempt to show birds and animals in their accustomed surroundings, Thayer insisted that this was not enough. He felt that in the interests of artistic and scientific clarity, they had wrongly stressed the contrast between bird and branch, between subject and background.

Thayer was noted as a portrayer of muscular madonnas in a sweet Bostonian style, but he was also a keen naturalist and enthusiastic sportsman. In his frequent visits to the wilderness with his son Gerald it became obvious to Thayer that from an animal's point of view it would be advantageous to remain as inconspicuous as possible. Handsome as a specimen might look when drawn against an attractive naturalistic backdrop, the rules of nature seemed to dictate that the best place for an animal to avoid its enemies would be deep in the concealment of the underbrush.

The Thayers and their friends attempted to prove their hypothesis by preparing a series of paintings and photographs that were the exact opposites of the work previously executed by the painters of nature. Deliberately, as in Gerald Thayer's *Male Ruffed Grouse in the Forest*, their animals were made to disappear into their surroundings as if by magic. The animals lost nothing in scientific accuracy and gained instead a startlingly realistic new dimension.

The Thayers' researches led to the development of military camouflage in World War I, but Abbott Thayer's obsession with the concept of concealing coloration led him into endless arguments. He insisted that the British should consult him about the painting of battleships, and he squabbled

about the universality of his discoveries with anyone who would listen, including his fellow sportsman Theodore Roosevelt. Nevertheless, Thayer's influence was salutary; here was another example of the artist, rather than the scientist, who discovered an important principle in nature.

When the American Museum of Natural History was opened in New York, zoological exhibitions were spartan. A description of the new museum in *The Century Magazine* (August 1882) indicates how the ideas and originality of someone like Thayer would have been valuable: "The specimens, being of the best that can be obtained, the more satisfactorily stand the test behind the flood of light admitted through the great plate-glass doors. The old method of native bough and moss accessories is abandoned: its too naturalistic litter proves a nuisance in a well-ordered museum. According to the present method the objects are regarded as so many works of art."

One of Abbott Thayer's protégés was Louis Agassiz Fuertes, who became the most sought-after illustrator of bird books in the early twentieth century. Fuertes had much to do with putting some "naturalistic litter" back into the exhibits of the American Museum of Natural History. As an illustrator, he had to endure the barbarities of primitive color reproduction, but his birds had a strong sense of personality and a painterly quality not found in later illustrated bird books. After Fuertes's accidental death in 1927, the painting of wildlife took a decidedly prosaic turn.

Since the middle of the 1930s field guides and animal encyclopedias have dispensed with artistic individualism in favor of highly photographic illustrations that ruthlessly eliminate such distractions as atmosphere and natural habitat. There remains the question for many critics: Is the achievement of perfect scientific detachment compatible with art?

The great artist-naturalists of the nineteenth century did not worry much about the moral implications of nature's mysteries. It is apparent that they did not regard nature as a dichotomy between howling wilderness and peaceable kingdom. Instead they accepted the idea that nature, especially in the wild, could be both at the same time, and they got on with the necessary work of examining and delineating everything they saw, genus by genus and species by species. Though they exchanged correspondence with scientific giants like the Swedish botanist and taxonomist Carolus Linnaeus and the German naturalist Alexander von Humboldt, they thought of themselves simply as practical and useful men—the census takers in a new land.

Abbott H. Thayer and Rockwell Kent, with Gerald H. Thayer and Emma B. Thayer.
Copperhead Snake on Dead Leaves. *1909. Lithograph. From* Concealing-Coloration
in the Animal Kingdom *by Gerald H. Thayer. Library of Congress, Washington, D.C.*

*Gerald Thayer, in his treatise on concealing coloration, noted that the most
successful animal camouflage was "not an exact reproduction of the actual
background pattern, but a picture of that pattern as it looks when more or less
altered and refined by distance." This treacherous reptile has disappeared so
completely into its environment that a stencil overlay (bottom) had to be
provided as an aid for undiscerning viewers.*

78

Gerald H. Thayer. Male Ruffed Grouse in the Forest. *c. 1905. Watercolor on cardboard, 20¼ × 26¼". Metropolitan Museum of Art, New York. Rogers Fund*

This watercolor was one of the most successful of Gerald Thayer's essays in animal camouflage. In characteristically densely detailed prose the artist wrote in his book on concealing coloration: "This picture was painted from woodland photographs, etc., and from a stuffed grouse in a house-lighting artificially arranged to suit the bird's counter-shading. . . . The bird is in plain sight, but invisible—such is the wonderful power of full obliterative coloration. Nature has, as it were, used the bird's visually unsubstantialized body as a canvas on which to paint a forest vista . . . which causes its form to pass for an empty space."

Louis Agassiz Fuertes. Road Runner. *c. 1900. Watercolor and pencil, 8½ × 11".*
American Museum of Natural History, New York

The roadrunner, tail-up in courtship attitude, is a member of the cuckoo family.
Mainly a terrestrial bird, the roadrunner commutes speedily along the endless
straight highways of the American Southwest (it can travel over ground at up
to fifteen miles an hour), pausing occasionally to dine upon such delicacies
as lizards, scorpions, tarantulas, and small snakes.

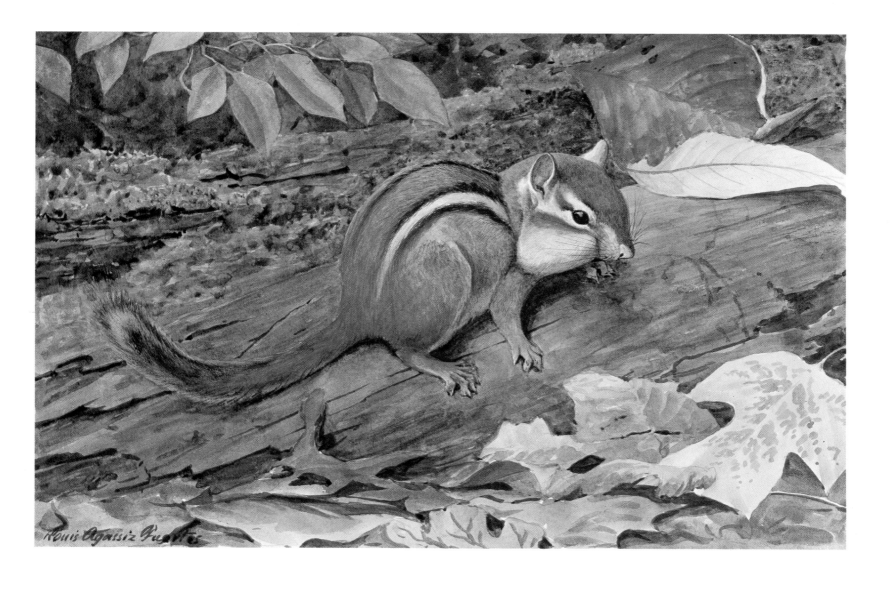

Louis Agassiz Fuertes. Eastern Chipmunk. *1918. Watercolor on illustration board,* $8\frac{1}{4} \times 13\frac{3}{8}''$. © *1918 by The National Geographic Society, Washington, D.C.*

Fuertes, named for the great Harvard naturalist, Louis Agassiz, was commissioned by the National Geographic *to illustrate a special 1918 issue on small American mammals. Fuertes wisely chose to set this scene in autumn, when the chipmunk is busiest and most in evidence. On his death in 1927* Science *magazine noted that the "word went about that birds had souls and that Fuertes could see and transcribe them." The same could be said of his quadrupeds, which are luminous with intelligence.*

Asher B. Durand. The Old Oak Tree. *1844. Oil, 36 × 48″. New-York Historical Society*

A cow lying in a pasture tends to add a deep sense of peace to any landscape. If the docile and disinterested-looking animals were not present, this painting would have appeared somewhat foreboding, with its sweeping branches ominously dominating a lowering sky.

Animals in the Academy

While the artist-naturalists were in the wilds taking their arduous census of American animal life, the literati in Boston and the landscape painters in New York were formulating what would remain the prevailing American taste in landscape for generations. Ralph Waldo Emerson and Henry David Thoreau believed that their loftiest thoughts came to them when they were alone with nature. Their concept of nature included quiet ponds, deserted beaches, leaf-strewn mountain paths, babbling streams, and—above all—virgin forests. It was an antimaterialist, even anticivilization view, which ascribed a sort of sanctity to the natural world—a view not very different from the wilderness concepts nurtured by the Audubon Society and the Sierra Club today. For the nineteenth-century landscape painter the motif of solitude and communion with nature allowed, even required, the use of animals to evoke the various moods and emotions nature was expected to impart.

Like the artist-naturalists, the landscape painters were motivated by the forces of European romanticism. But while the former based their life-styles, consciously or unconsciously, upon the romantic passion for cosmic experience, the academic artists were influenced more by the stylistic aspects of the movement. These were the men who by midcentury were swarming through Europe on the grand tour, meditating upon ruins, admiring the art of the masters, and, not incidentally, developing and refining their technique. With such credentials they could be reasonably sure of admittance into the National Academy.

Today the term "academic" is in great disfavor, evoking as it does the image of a cut-and-dried, rule-ridden arbitrary art establishment. In mid-nineteenth-century America, however, the National Academy was a vigorous and much-needed institution, exhibiting the work of non-European artists for the first time. The artist-naturalists reached a sizable audience through their published works. The academists, on the other hand, were not so interested in the dissemination of knowledge as Audubon and Catlin, and thought of themselves as easel painters, dealing in still life, portraiture, or landscape. Their main problem was to get their work before the public, and the National Academy of Design filled that need by bringing artists together with buyers on a scale previously unknown. For a time at least it was the unrivaled place of exhibition for American painting, and animals were welcome. Far from the perilous wilderness of Audubon and Wilson, a decidedly different menagerie was moving into the Academy's Venetian palazzo on Twenty-third Street.

The academic artist's place of business was the studio rather than the forest, and his residence was more likely to be New York than Philadelphia. He frequently possessed a much keener business sense than his naturalist contemporaries, who were forever crusading and begging for patronage. Field expeditions for most of the artist-naturalists were hazardous, lonely journeys; academic painters, when they did venture west of the Hudson Valley, often were able to carry out their explorations with the protection and patronage of the federal government. All in all the academists tended to lead a more leisurely and gentlemanly existence.

Alfred Jacob Miller. Rocky Mountain Sheep on Scott's Bluff. *1837. Pen and pencil,*
5¾ × 7⅞". Courtesy Kennedy Galleries, Inc., New York

For the pioneers following the Oregon Trail westward, Scott's Bluff provided
the first relief from the monotony of weeks of flat horizon. Many artists made
sketches of its strangely shaped silhouette, but few, besides Alfred Jacob
Miller, had the opportunity of capturing the wary bighorn.

The painters who became associated with the National Academy absorbed as much as they
could of Europe's present and past preoccupations, but they did not swallow European romanticism
whole—at least not at first, as a glance at their animal paintings makes clear. The great French ani-
mal painters and sculptors, such as Eugène Delacroix, Théodore Géricault, and Antoine-Louis Barye,
had frequented Paris's Jardin des Plantes, where they gained their extensive knowledge of animal
forms and studied with admiration what they considered the innate primitivism and passionate bes-
tiality of the animal kingdom. Oddly the Europeans, who had to settle for zoological gardens for
their firsthand knowledge of wild animals, were fascinated by the theme of animals in combat, ful-
filling the ageless law of the jungle.

Albert Bierstadt. Valley of the Yosemite. *1864. Oil on prepared millboard, $11\frac{3}{4} \times 19\frac{1}{4}''$. Museum of Fine Arts, Boston. M. and M. Karolik Collection*

Albert Bierstadt placed the elk in his landscape for much the same reason the previous generation of studio artists had utilized the cow: to evoke an aura of timelessness and serenity. The American elk—more authentically known as wapiti, from the Indian name for this creature—is actually a deer, similar to the European red deer but larger.

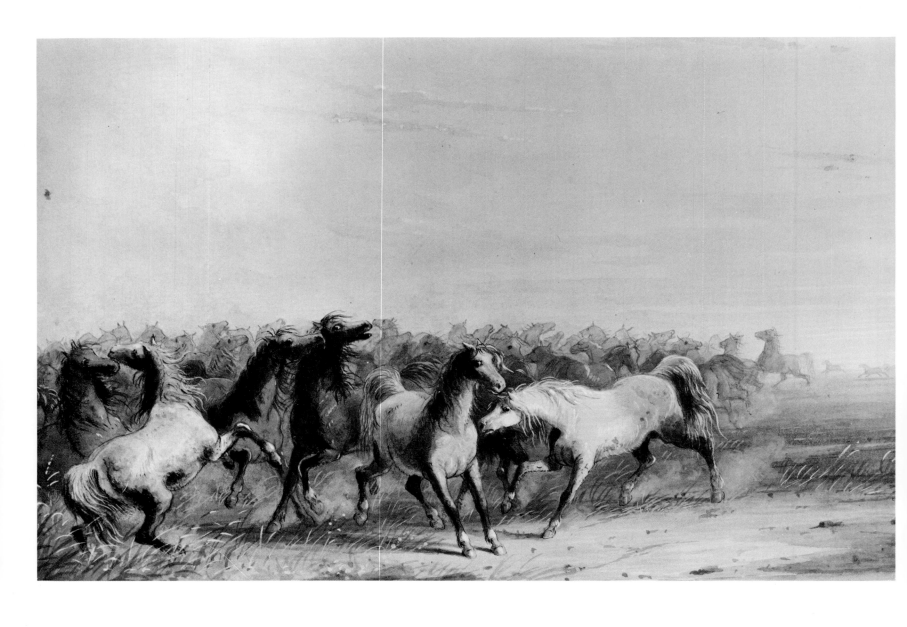

Alfred Jacob Miller. Wild Horses. *1837. Watercolor, $9\frac{1}{2} \times 14\frac{5}{8}''$. Walters Art Gallery, Baltimore*

Early visitors to the western plains were awed by herds of mustangs, hardy wild descendants of horses brought across the Atlantic by Spanish conquistadores three centuries before Miller painted this characteristically energetic watercolor.

In America primal contests could readily be observed in the wild, but the academic artists tended rather perversely to concentrate on the more static animal characteristics: majesty, dignity, and serenity. The artists returned from Europe with a new realization that wild beasts were not inappropriate as the subject of fine art—in a way these beasts even became fashionable. Yet in their animal paintings violence was implied as a threat at most or simply hinted at—it was not a present reality. Not that the animals in American art lacked passion; Frederic Remington and some of the "cowboy artists" would finally express in American terms the spirit of Barye and Delacroix, but this was not until much later—at the end of the century. The nineteenth-century American animal painter was not an *animalier* in the European sense; he was simply a landscape painter, and in this period the animals exhibited in the National Academy were generalizations, placed on the canvas as accessories to the scenery.

Certain animals, both domesticated and wild, were particularly popular in the nineteenth century. Cows resting in a field promoted a sense of tranquillity; a lone stag on a promontory conveyed solitude; a herd of bison became synonymous with power and majesty; wild horses symbolized consummate freedom; seals on a rock in the ocean evoked the sublime continuity of nature.

As subject matter the very names of many animals summoned romantic connotations of the wilderness: wolf, lynx, bear, cougar, and mustang. The opportunity to observe these exotic beasts in the wild attracted wealthy Europeans to the United States who, in turn, encouraged American artists to paint these animals. One of the first painters so commissioned by a European visitor was Alfred Jacob Miller.

Miller was neither an academician nor a professional naturalist, but an obscure young Baltimore portrait painter. In the 1830s Miller became painter in residence for an expedition to a fur traders' rendezvous on the remote upper course of the Missouri River. Miller's patron, Captain William Drummond Stewart, wanted to fill his Scottish castle with authentic specimens and memorabilia from the New World. To augment the stuffed heads and the antlers that he anticipated acquiring, Stewart also wanted oil paintings as souvenirs of his American adventure.

On this short expedition Miller produced one of the finest sets of detailed on-the-spot sketches of American frontier life and wildlife before the time of Frederic Remington. Miller's animals, like his Indians and his landscapes, had an unstudied elegance that was uncommon in American art; yet beneath his graceful calligraphy there is so much respect for detail that one needs a magnifying glass to appreciate it.

Bierstadt accompanied General F. W. Lander's surveying expedition to the Oregon Territory in 1858. It was a long, arduous trip, but one that was extremely productive for the U.S. Geological Survey and the artist alike. The oil sketches Bierstadt made on the journey show that his interests were by no means confined to the spectacles of landscape and atmosphere for which he became famous.

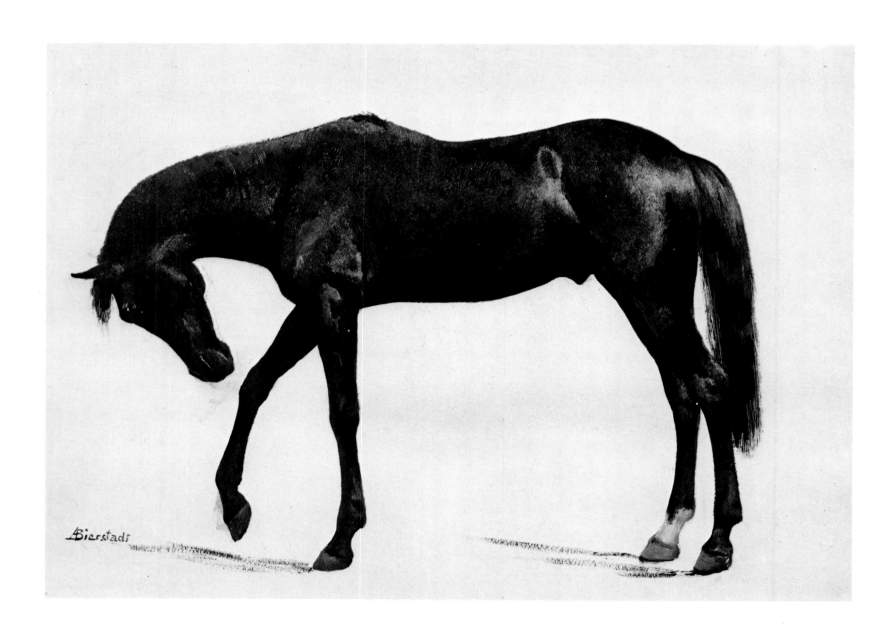

Albert Bierstadt. The Black Horse. c. 1858. Oil on paper, 13½ × 19¼". Museum of Fine Arts, Boston. M. and M. Karolik Collection

Throughout his career Bierstadt turned again and again to animals. He was a great collector of taxidermy specimens and even contemplated at one time compiling an encyclopedic work like John James Audubon's Quadrupeds.

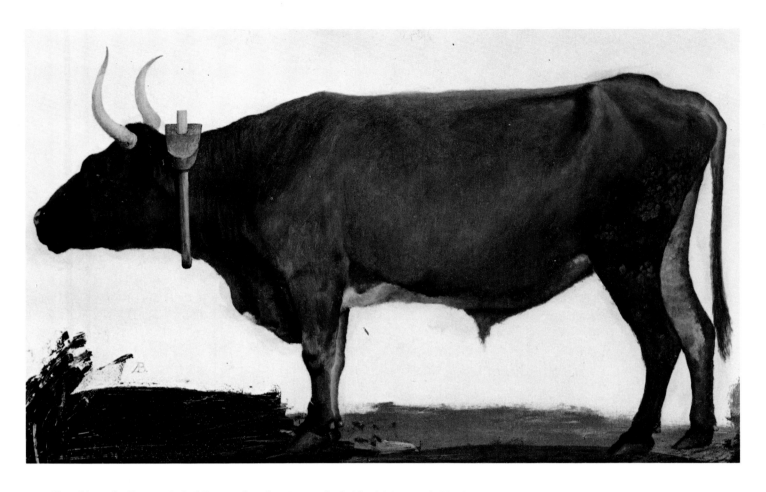

Albert Bierstadt. Ox. c. 1858. Oil on cardboard, 12¼ × 19". Oakland Museum, Oakland, Calif. Gift of the Kahn Foundation

Throughout the nineteenth century the romantic taste for wild animals in American painting wore a slightly virtuous air. Asher B. Durand, a prominent figure in the Hudson River School and one of the founders of the National Academy of Design, declared in a letter to *The Crayon* (January 31, 1855) that a "landscape will be great in proportion as it declares the glory of God, be a representation of his works, and not of the works of man." Durand had great influence on his colleagues, and if they had followed this mid-nineteenth-century dictum to the letter, animals should have leapt to the foreground in the painting of nature. But progress beyond the pedestrian cow-strewn pasture scene required a certain daring that Durand himself did not possess.

A painter who understood the possibilities of the unpeopled landscape was Albert Bierstadt. Perhaps it was a combination of factors that raised Bierstadt to the summits of commercial and critical success: his boldness, his showmanship, his stylish Düsseldorf training, and his good fortune in having a European patron. While traveling in the Rocky Mountains, he made an important discovery. Until this time, Americans had been uncomfortably sensitive about their lack of any real history; they looked with longing toward the European heritage of ruined castles and ancient glory. In the Rockies, however, Bierstadt recognized a natural antiquity among American geological ruins. So much the better, in the light of Durand's pronouncement, that the country's monuments were God's works, not man's. A vista like the *Valley of the Yosemite* revealed God's acropolis, not created for the glory of man but as the operatic setting for a family of wapiti.

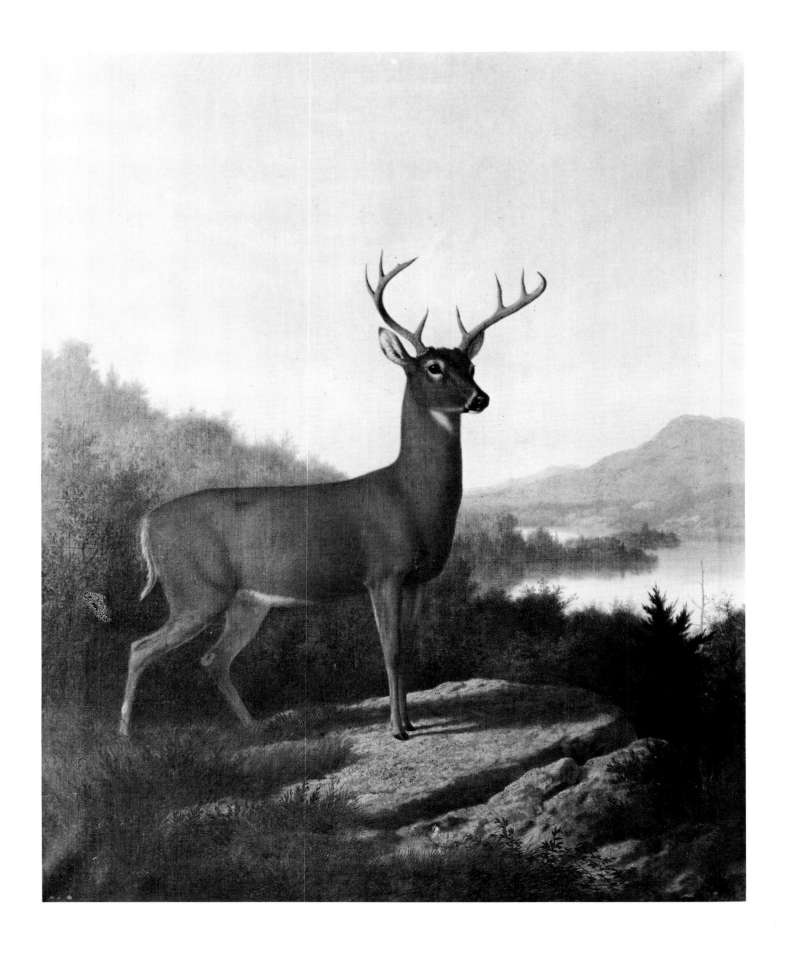

Thomas Hewes Hinckley. Stag in the Adirondacks. *1866. Oil, 36 × 29". Corcoran Gallery of Art, Washington, D.C. Gift of Captain Robert M. Hinckley*

T. H. Hinckley, one of the most popular nineteenth-century painters of animals, never sold this particular work. He may have been especially fond of it—or his clients, many of whom were experienced hunters, may have been disappointed with the stag's proportions.

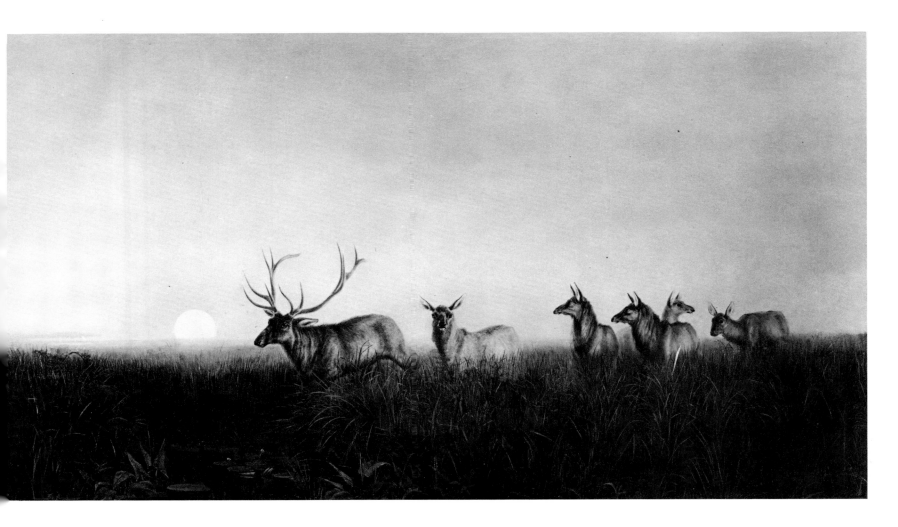

William Jacob Hays. Herd of Elk at Sunrise. *1862. Oil, 25½ × 47½". Collection Lindley and Charles Eberstadt, New York*

The fetish of carrying elk's teeth as good luck charms was eventually unlucky for this animal. Although it once inhabited a range even larger than that of the bison, it is seldom seen today on the western plains of the United States.

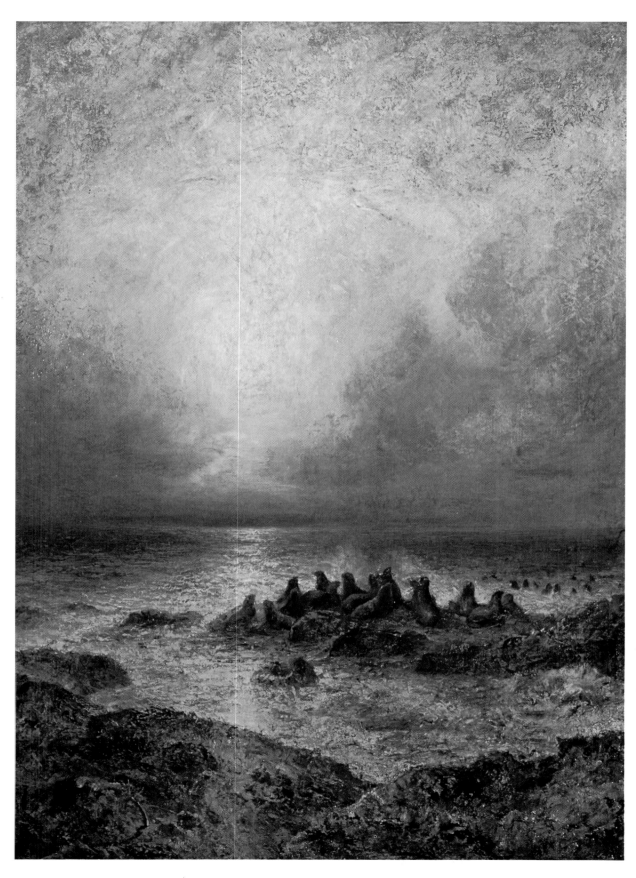

Ralph Albert Blakelock. Seal Rocks. *c. 1890. Oil, 42 × 31". Paine Art Center and Arboretum, Oshkosh, Wis.*

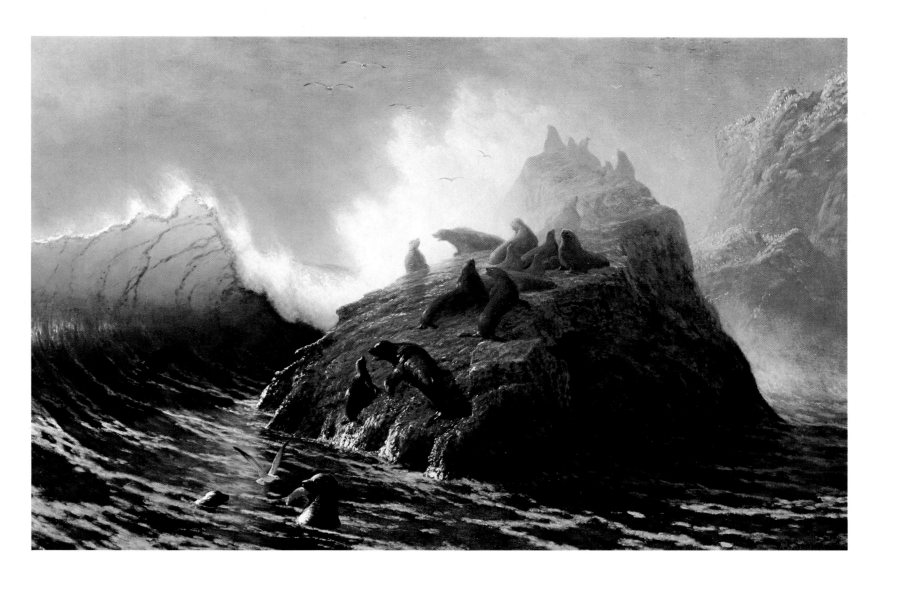

Blakelock shared with Albert Bierstadt and Martin J. Heade a compulsion
to follow the westward movement all the way to the Pacific coast. Each of
these artists discovered not an end there but a beginning, for just beyond the
edge of the continent they encountered the fresh mystery of the ocean, symbol-
ized by the free-spirited California sea lion.

In the same New York studio building where Bierstadt composed his vast panoramas labored a lesser-known master of the landscape-with-animals school, William Jacob Hays. Unlike Bierstadt, Hays seems to have made only one extended trip to the West, but he may have felt that further travel was unnecessary because, among other things, he was an expert taxidermist. His studio was filled with the requisite raw materials for his art. "Large pictures of buffaloes, deer and other wild animals of the prairies and forests, are always striking features of Mr. Hays' studio," runs a contemporary account in *Frank Leslie's Illustrated Weekly* (January 23, 1869). "It also possesses, to some extent, the characteristics of a museum, being garnished with numerous trophies of the chase, such as moose heads, horns of the wapiti and caribou, and many specimens of birds and quadrupeds, prepared by the artist himself." It seems likely, owing to the artful concealment of their legs, that Hays's elk in *Herd of Elk at Sunrise* were drawn in New York from his collection of stuffed heads.

Thomas Hewes Hinckley made a specialty of wild game and cattle portraits. Although he catered chiefly to sportsmen and newly landed gentry, he was capable of works of much broader appeal. His *Stag in the Adirondacks*, executed after a trip abroad during which he came under the influence of European animal painters, had much of the polish, if not the consummate skill, of the European masters of the genre.

Along with the prospering American economy there developed a greater preoccupation with the art of interior decoration and with it a sharply increased demand for all sorts of animal paintings. A shrewd analysis of the middle-class art market was sufficient to bring fame and fortune to many mediocre animal painters. For the adornment of the drawing rooms of the newly rich, paintings were selected primarily for size and for subject matter. An unsigned satirical piece in *Harper's New Monthly Magazine* (June 1867) purports to convey some advice to painters from a seasoned auctioneer: "One cow looking over another cow's back is very well liked. It is a mistake to paint much of a landscape in cattle-pieces; the cattle always seem to be the owners of the whole domain. Horses' heads are heavy to handle . . . dogs are more liked. . . . In the hope that [artists] may turn to dogs, I state that the prices are always fifty per cent higher for them than for pitchers or flower-pots."

It was inevitable that the more volatile aspects of late romanticism would have a deleterious effect, and some serious artists fell victim to its more morbid aspects. A few of America's most promising painters, both in and out of the National Academy, were overwhelmed by symptoms of withdrawal from life. Ralph Albert Blakelock's fate was overshadowed by brooding and hardship; he

couldn't support his family of ten and starved his way into madness. Not until it was too late did the Academy honor him with membership. As a younger man, Blakelock had undertaken a lengthy trip in order to sketch the West Coast. For the rest of his productive life he assembled landscape compositions of great depth out of his sketches and memories from a happier time.

Another sad figure was William Morris Hunt. There was an air of regret—almost of failure—about Hunt, which was quite at odds with the external facts of his life. Beloved pupil of François

Ralph Albert Blakelock. Two Deer Lying Down. *c. 1870. Ink, 2¾ × 5″ (sight). Addison Gallery of American Art, Phillips Academy, Andover, Mass.*

Even at rest, these two fawns have their ears cocked for any hint of danger. Blakelock, temperamentally attuned to the deer's instinctive nervousness, was somehow able to get close enough to make a quick, tiny sketch.

Millet, teacher of John La Farge, apostle and exemplar to his countrymen of everything French—Hunt, nevertheless, was not content to be simply an influence. He was quoted in *Harper's* (July 1880) as saying bitterly, "If I had lived abroad, I might have been a painter." In the literary-minded New England of Hunt's day it was not necessary to *paint* a whale: the mere suggestion of its presence in the vicinity was subject enough for his *Spouting Whale*. "It is the impression of the thing you want," Hunt declared in a studio lecture, published in *Talks on Art* (Boston, 1877). It very likely was on an overcast day such as that depicted in *Spouting Whale* that Hunt mysteriously drowned in a tide pool on the Isle of Shoals off the coast of New Hampshire.

The fact that Albert Pinkham Ryder often chose subject matter obscure to his contemporaries—as well as to the viewer today—has encouraged a romantic mystique to surround his name. Through a haze Ryder has come to represent the epitome of the American romantic: a hermit by preference and otherworldly in his commercial transactions, he was misunderstood in his own time, misled, misinterpreted, even mistreated, and simultaneously compelled to pursue his own unattainable self-prophecies. It is interesting to note that in his animal paintings Ryder could be surprisingly earthy. Enigmatic as the bulk of his work may have been, his animals, particularly his horses, were based not on imagination but on observation of the real world.

While the conflicting passions of late romanticism took their toll on the hypersensitive, Thomas Eakins, Philadelphia's superlative painter, photographer, sculptor, and teacher, kept his footing on firmer ground. For Eakins inspiration was not to be invoked by toying dangerously with the inner soul but by painstakingly examining and getting to know his subjects as thoroughly as he could. This thoroughness, tempered with insight, is apparent in his portraits and no less so in his paintings of horses. Besides being an enthusiastic horseman, Eakins also dissected the carcasses of horses to study the intricacies of their musculature. When his friend Fairman Rogers bought one of Philadelphia's first four-in-hand coaches, Eakins was the natural choice to paint the handsome coach, the four bay horses, and the Rogers family enjoying a drive in Fairmount Park. In his thorough, analytical way, Eakins prefaced the undertaking with numerous wax models and sketches of each horse.

Late romanticism did little to assuage the sense of alienation felt by many artists in America, and many of them exiled themselves abroad. William Harnett and Herman Hartwich resided in Munich for a time, and Charles Caryl Coleman took a villa at Capri. But by far the most famous—and colorful—expatriate of the time was James Abbott McNeill Whistler.

William Morris Hunt. Spouting Whale. *c. 1875. Oil, 19½ × 16⅛". National Collection of Fine Arts, Smithsonian Institution, Washington, D.C. Gift of William T. Evans*

William Morris Hunt was a fast man with the brush, but the whale all but eluded him. As Herman Melville wrote of the whale in Moby Dick, *"His is an unwritten life." For the most part it has also remained an unpainted one.*

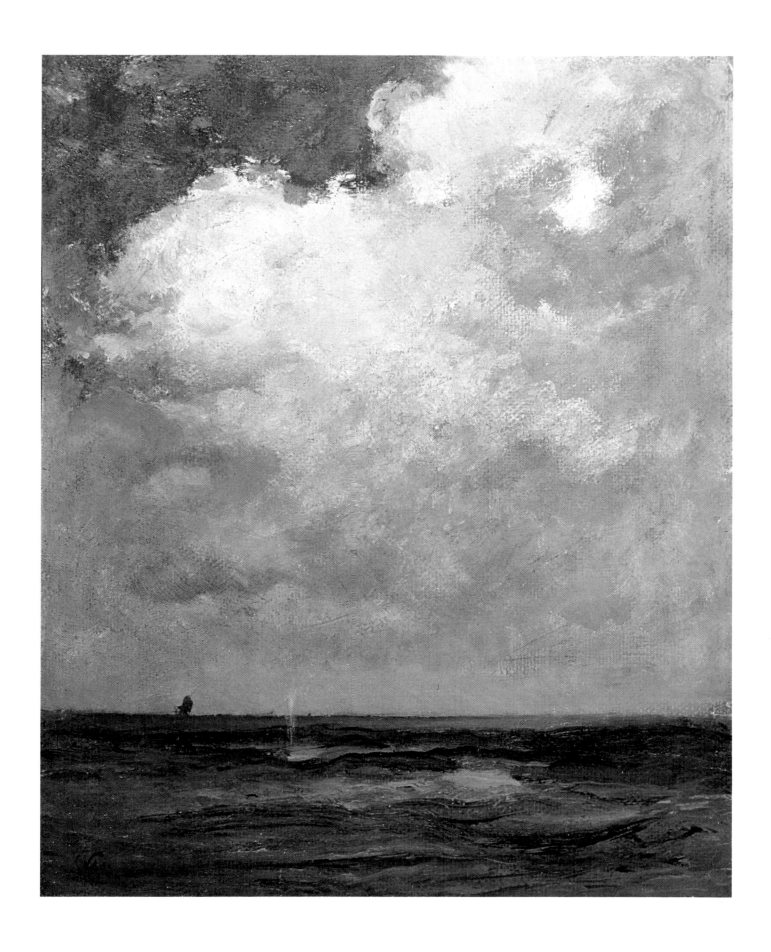

Albert Pinkham Ryder. The Grazing Horse. c. 1875–80. Oil, $10\frac{1}{4} \times 14\frac{1}{4}''$. Brooklyn Museum. Graham School of Design Fund

Early in his career before he withdrew into his lonely imagination, Ryder painted this quiet pastoral scene, pervaded with a tranquillity not found in the tormented work of his later years.

Albert Pinkham Ryder. The Stable. c. 1875–80. Oil, 8 × 10″. Corcoran Gallery of Art, Washington, D.C. Gift of Mrs. Francis S. Smithers

Ryder worked and reworked his paintings, loading his canvases so heavily with paint that many of them became honeycombed with hairline cracks. Often the effect is like looking through a clouded window at a half-recalled memory.

Thomas Eakins. The Fairman Rogers Four-in-hand. *1879. Oil, 24 × 36".*
Philadelphia Museum of Art. Gift of William Alexander Dick

Much care was given to the selection and training of the horses for the four-in-hand carriage; they had to have an even disposition and be well disciplined and responsive. Just as important, they had to be as handsome and as elegant as the vehicles themselves. Fairman Rogers, an eminent Philadelphia engineer and intimate friend of Eakins, commissioned Eakins to paint his splendid four-in-hand coach and team on an outing in Fairmount Park.

In his investigations of the anatomy of the horse Eakins made sketches of skeletal and muscular structure from his own dissections. For the painting The Fairman Rogers Four-in-hand, *Eakins, in his thorough way, painted several sketches of each horse and even modeled wax figures of them. From all these studies he arrived at the quintessential horse.*

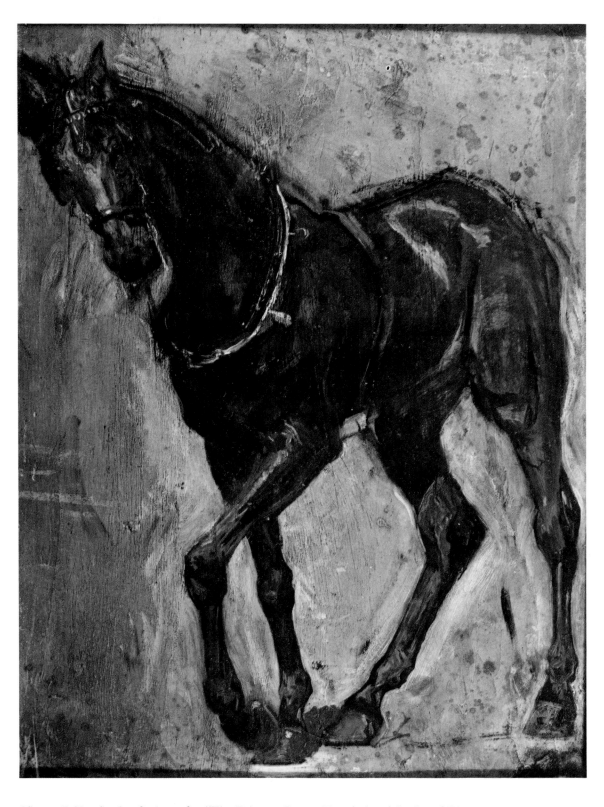

Thomas Eakins. Study of a horse for "The Fairman Rogers Four-in-hand." *1879. Oil on wood, mounted on fiberboard 14⅝ × 10⅜", mounted on masonite 16⅛ × 12". Hirshhorn Museum and Sculpture Garden, Washington, D.C.*

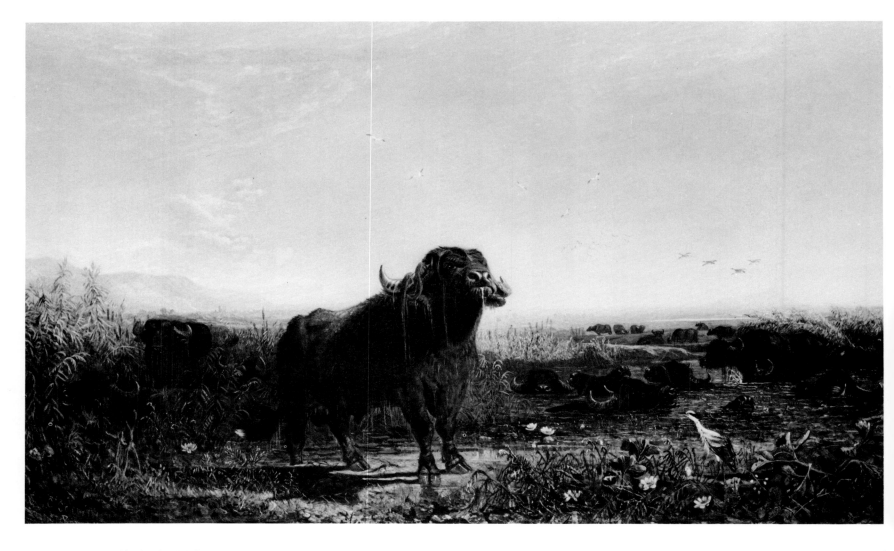

Charles Caryl Coleman. Herd of Water Buffalo in a Natural Setting. *1879. Oil, 22 ×
35″. Courtesy Richard Green Gallery, London*

*The mighty cape buffalo inhabits the lower two-thirds of Africa, where it
congregates by the hundreds—grazing by night and trampling the marshes by
day. Coleman was primarily a painter of landscapes and portraits, but because
of his early training under William Holbrook Beard, he maintained an
interest in animals and their behavior.*

Herman Hartwich. Meditation. *1885. Oil, 11¼ × 8¾″. National Collection of Fine Arts,
Smithsonian Institution, Washington, D.C. Gift of Mrs. Emily Dorothy Ammann*

*The rhesus monkey was a popular house pet in Europe, and it was the organ
grinder's steadfast companion. Except as a subject for expatriate painters like
Hartwich, there was little interest or economic importance attached to the
rhesus monkey in the United States until recently, when it became valued as
a laboratory animal and pioneer to outer space.*

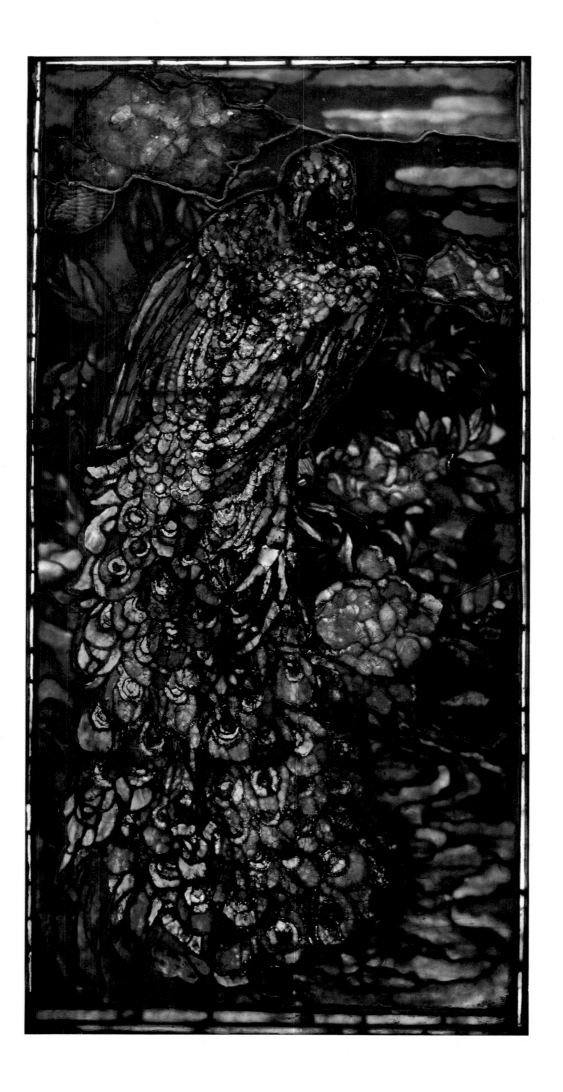

James Abbett McNeill Whistler. The Peacock Room: The Rich Peacock and the Poor Peacock. *1876–77. Oil and gold leaf on leather, 71 × 186″. Freer Gallery of Art, Smithsonian Institution, Washington, D.C.*

Since the days of Solomon and even earlier, man has held the peacock in high esteem. Its extraordinary beauty and the considerable economic importance of its feathers have helped place this bird among the aristocrats in the hierarchy of the avian kingdom.

John La Farge. The Peacock Window. *c. 1890. Stained glass, 44½ × 24¾″ (with frame). Worcester Art Museum, Worcester, Mass.*

During the late nineteenth century the peacock became an important icon in the imagery of the arbiters of aesthetics. For them the peacock embodied the anti-functionalist thesis of art for art's sake.

Whistler's father had been the architect of some of New England's finest bridges, and Whistler himself had been enrolled at West Point, but defying his practical Yankee background, Whistler left America in 1855 and devoted himself to a career built on extraordinarily sensitive painting and on equally insensitive manners. Like everything he undertook, Whistler's celebrated London adventure in interior decoration, the so-called Peacock Room, was attended by controversy. The Peacock Room, now in the Freer Gallery in Washington, D.C., still evokes the elemental spirit of Whistler: gloriously intemperate and exquisitely skillful.

A typical Whistler imbroglio surrounded the creation of his graceful golden peacocks. A prosperous London shipping magnate desired a fitting background for his collection of blue-and-white porcelain and hired a professional decorator to do the job. Whistler convinced the client that the decorator's scheme not only would *not* enhance the blue-and-white but would actually compete with it. One way or another—there are various versions to the story—Whistler gained access to the room and in a frenzy of blue paint and a blizzard of gilt transformed the walls of the whole room, which were covered in expensive antique Spanish leather, into a forest of peacocks. His restrained title for the outcome was *Harmony in Blue and Gold*. The doors were opened to the press and predictably the uproar was considerable. The decorator went mad, and the flabbergasted owner, possessed of a more stable temperament and a keen business sense, refused to pay Whistler a fee he thought exorbitant. In revenge Whistler availed himself of the owner's next absence to add an allegorical pair of peacocks called *The Rich Peacock and the Poor Peacock*. The rich peacock, of course, represented the hapless patron and the other, clearly enjoying the last laugh, stood for Whistler himself.

All American painters of animals were not eccentrics or uncertified madmen. Frederic Edwin Church, for example, was eminently practical; his purview was the spectacular, sublime, transcendental scenery he saw in his long travels, from Labrador to Colombia—a scenery he rendered expertly on enormous canvases. Long after his traveling was ended by arthritis, he took a board no larger than a sheet of letter paper and with crippled hands painted his first kitten by lamplight. "My dear Mr. Johnson," he wrote in a note carefully preserved by the proud recipient. "Will you please accept the accompanying imperfect sketch of the lovely Persian kitten you so kindly presented to me. . . . I must apologize for not sending it sooner—I delayed in order to make a copy for my little girl. . . . I never painted a cat before so I make no apologies." Church seldom apologized for his painting nor, indeed, did he need to.

Fastidious, aloof, and a bit precious, John La Farge was not one to suffer fools, and the public, eager to keep up with his esoteric activities, was always a step behind—but La Farge, pupil of William Morris Hunt and privileged habitué of society's innermost circles, would only quicken his pace. "There is nothing the public detests more than a change in the manner of doing anything," he complained in 1906 in a letter to his biographer, Royal Cortissoz. "We associate the man with his work to such an extent as to forget that, like everyone else, he may follow some path to suit himself." The small watercolor *Uncanny Badger* is the kind of thing La Farge did to suit himself.

Frederic Edwin Church. Persian Kitten. *1883. Oil on board, $11\frac{1}{2} \times 9\frac{3}{4}''$. Courtesy Kennedy Galleries, Inc., New York*

The eyes of all cats dilate and appear mysterious in dim light, but only the Persian has round pupils. Thus, of all varieties of cats this one has the most penetrating gaze, as noted by Church in a rare departure from his usual large panoramic landscape.

A more public statement was La Farge's once-famous *Peacock Window*. After looking at the delicate and refined adornment of French churches, La Farge may have felt that putting his art on public view was not necessarily casting pearls before swine. Besides teaching himself the rudiments of stained glass, he achieved refinements of the medium previously undreamed of. The *Peacock Window* was not a window at all, but a freestanding piece. It was not an attempt to carry over the language of easel painting into the medium of glass; in La Farge's hands stained glass was brilliantly expressive on its own terms. It created a sensation among connoisseurs on both sides of the Atlantic.

La Farge and Whistler, for all their efforts to disassociate themselves from the masses, inevitably became idols for a great many people who were completely unknown to them but who followed the painters' activities in the press. But probably no nineteenth-century American artist did less to discourage an adoring public than John Singer Sargent. Sargent allowed his audience to perceive him as the dashing portrayer of "beautiful people" of the time rather than as a fallible human being. How elegant and how easy his life, both artistic and social, must have seemed to his faithful audience!

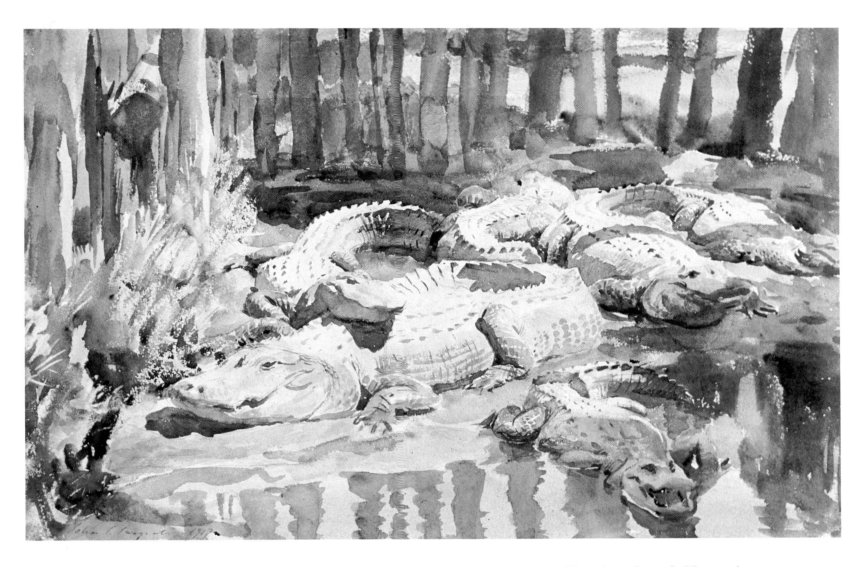

John Singer Sergent. Muddy Alligators. *1917. Watercolor, 13⅝ × 21″. Worcester Art Museum, Worcester, Mass.*

Sargent's alligators, painted on a vacation in Florida, were a far cry from the frothing dragons William Bartram thought he saw nearly a century and a half earlier (see The Alegator of Saint Johns *on page 50). Sargent's creatures are definitely realistic—big, broad-faced, seemingly lethargic but cunningly alert.*

Winslow Homer. Dog on a Log. *1889. Watercolor, 13¾ × 19¾″. Addison Gallery of American Art, Phillips Academy, Andover, Mass.*

Winslow Homer sketched this hound, or one like it, several times during the long periods he spent in the north woods. It is the kind of dog that hunters and woodsmen often rate as equal to, or better than, a human being—more faithful, more reliable, and very often more courageous.

John La Farge. The Uncanny Badger. *1872. Watercolor, 8 × 8″. Courtesy Kennedy Galleries, Inc., New York*

The American badger, like the skunk, belongs to the nocturnal family of weasels. Indians thought of it as good medicine, but the Japanese, for whom La Farge felt a special affinity, considered it a sorcerer and often depicted it like a leper, carrying a warning bell.

Yet he moved among social cannibals both at home and abroad all of his adult life. There were times when he was able to slip away from his adoring public, and on a Florida vacation he produced in *Muddy Alligators* such a pungent essay on reptile society that one wonders whether it might not have been intentionally executed as a satire, for his own enjoyment, of the complacent crowd he tolerated during the social season.

Winslow Homer lived an ascetic life, but in a way he, too, inhabited two worlds. One he portrayed in his monumental oils, where the forces of nature—whether on sea or on land—told of the dramatic struggle between life and death. But a gentler side surfaced in his watercolors, of which *Mink Pond* is a superb example. In this medium he could speak simply of the quiet, peaceable, and private world of animals from something very close to the animals' point of view. In these watercolors, where a frog is the ruler of the lily pad, man would be singularly out of place. In Homer's silent streams and pools the trout swims peacefully and soundlessly in the shadows, unmolested by human presence. It is as if a fundamental transformation occurred when the artist turned his attention from salt water to fresh. Few American artists had Homer's profound understanding of the implications of the howling wilderness, and even fewer respected, as he did in his watercolors, the privacy of nature's most peaceful moments.

In the closing years of the nineteenth century those charter members of the National Academy who were still vigorous continued to travel. The older men had to be content with their sketchbooks for inspiration. As the century leaned toward its final years, landscape artists cast about futilely for new vistas that would elicit the kind of public wonder and astonishment that had brought them fame long ago. Bierstadt had painted the seal rocks off the California coast while the memory was still fresh. But Blakelock's version of the seal rocks, painted in the lavish colors of the fin de siècle, was done at the time of his first nervous breakdown twenty years after he had first made the sketches. Martin Johnson Heade also took up the same subject in the 1870s, as did other artists in a vain search for new frontiers. It is understandable that these artists should have been moved by this particular scene. Even visitors today find themselves gripped by a romantic spell in the presence of the restless herds of sea lions. "The din of the rookeries," writes the naturalist Peter Matthiessen in *Wildlife in America* (1959), "is muffled in the ocean wash, and the random bark which rises above the groaning of the herd is whirled away quickly on the sea wind, but facing seaward with one's back to civilization, one senses the wild quality of a scene many thousands of years old."

Until the late 1880s the National Academy had continued to be the acknowledged arbiter of artistic taste in America. It had vigorously championed the cause of native American artists when there was no other place for them to turn, and in so doing it gave the stamp of approval to animals as a legitimate subject for serious painting. But already the art scene had begun to change. The animal,

like any other subject matter that called too much attention to itself, fell upon increasingly hard times. There was perhaps a premonition of this in William Morris Hunt's treatment of his subject in *Spouting Whale*, painted around 1875. The message from France was beginning to be taken seriously: style rather than subject matter would become the emphasis in fine art, and some American critics were becoming impatient with the current naturalistic style and were comparing it unfavorably with the wonderful new illusions being achieved by Jean-Baptiste Camille Corot and his circle through brushwork alone. *How* one painted rather than *what* one painted became increasingly important to both the artists and the new generation of critics, who kept a close eye on the European scene. The public, on the other hand, fell farther and farther to the rear of the avant-garde. Apparently what the public wanted was education, enlightenment, and uplift, and so for a variety of reasons it indulged in a brief but intense pursuit of allegory and myth.

Owing to America's dogged rejection of graven images and all things pagan, gods and goddesses and mythological beasts did not make their presence known in American art until late in the nineteenth century. There was, however, the brief sound of horses' wings flapping in 1893 as the country went mad over mural painting during the World's Columbian Exposition in Chicago. Pegasus painted on plaster seemed at that time capable of carrying American high-mindedness to new and loftier realms, but the paint quickly faded, and the horseless carriage soon brought America back to earth.

Sensing the factionalism among the artists at home, collectors and patrons, as well as gentry with large houses to decorate and plenty of money to spend, went browsing in Europe. The bearded gentlemen of the National Academy, vigorous to the last, refused to retire (all that hiking and camping had endowed them with what seemed to younger artists an inappropriate tendency to reign forever). With Winslow Homer at the helm the watercolorists were forming a new society, and a society for painters influenced by the Barbizon School—French artists who broke with classical tradition and sought inspiration directly from nature—also came into being. The National Academy of Design, once the champion of the new native art, had become the last bastion of conservatism. Artists with something fresh to say had to look elsewhere for exhibition space.

The artistic turmoil at the end of the nineteenth century profoundly affected the painting of animals. By this time animals had become commercialized: they sold so well as meat for sentimental potboilers that most sophisticated painters shunned them altogether. The grand days of the velvet-hung potted-palmed vernissage were coming to an end. If one were capable of looking at it

Winslow Homer. Fish and Butterflies. *1900. Watercolor and pencil, 14½ × 20¾″. Sterling and Francine Clark Art Institute, Williamstown, Mass.*

The yellow perch and the tiger swallowtail have similar markings (dark stripes against yellow). Homer, in his distinctive poetic manner, seems to be allowing each creature to sample the other's habitat as well as coloration.

Winslow Homer. The Mink Pond. *1891. Watercolor, 14 × 21″. Fogg Art Museum, Harvard University, Cambridge, Mass. Grenville L. Winthrop Bequest*

In Winslow Homer's time every young American boy was intimately familiar with the sunfish and the bullfrog. The sunfish (familiarly known as punkin seed or stump knocker) made good quarry for stick-and-string fishermen, and the bullfrog often went to school in a pants pocket. But none of these minor threats intrudes upon the deep tranquillity of Homer's pond.

from the animals' point of view, perhaps the most disturbing change of all at the turn of the century could be seen in the life-style of the younger artists. They became increasingly indoor men. They lived a Bohemian existence in Paris and New York, or they presided at salons or spent long hours penning letters to past patrons and granting interviews to biographers and critics. Although they continued to move about the American countryside bag, baggage, and retinue—which was the current fashion—and although they might see half a dozen wild animals on an afternoon's outing, the outdoor scene "drawn from nature" had all but vanished. Animals were out, as were the Catskills and the Adirondacks. It was the beginning of a period when anything at all American-looking would no longer be in vogue.

By the eve of World War I animals were so scarce on the art scene that the huge 1913 Armory Show in New York contained in its American section only one or two cows, one pig, a Pegasus and some horses by Ryder, three swans, and a scattering of hunting dogs among the paintings. It was a poor showing indeed compared with some of the major exhibitions at the National Academy in the nineteenth century when the animal kingdom was always present in full force.

The presence or absence of animals could scarcely have mattered to the curious multitudes who came to the Sixty-ninth Regiment Armory to view the new art from Europe. The general public as well as the critics were outraged by the radical innovations of the French moderns—the plethora of satirical cartoons and reviews criticizing and mocking the works reveals how profound a shock it was. But for artists and critics alike the message was clear: it was time for America to shed its artistic complacency.

By 1913 the conventional approaches to art were already being challenged by an upstart generation of artists derisively referred to as the Ash Can School, a band of determined rebels who took to the streets and tenements in search of the real and the relevant. The Armory Show merely confirmed their belief that radically new ways of seeing and of communicating were long overdue.

The American public was ill prepared for an outright artistic revolution—particularly one imported from abroad by agitators outside the art establishment. Nevertheless, the simplification into elemental forms, the unfettered rhythms, the expressive distortions, and unmuddied colors of the French moderns appealed strongly to the restless younger American artists. After the Armistice they took off for Paris in unprecedented numbers, many of them never to return.

William Harnett. Lobster and "Le Figaro." *1882. Oil, $11\frac{1}{2} \times 9\frac{1}{4}$". Courtesy Kennedy Galleries, Inc., New York*

Even while traveling in Europe, William Harnett found the makings for his characteristic still life: something to eat, something to drink, and something to read. The lobster that was enjoyed in Munich in the nineteenth century was undoubtedly one of the large European crayfish.

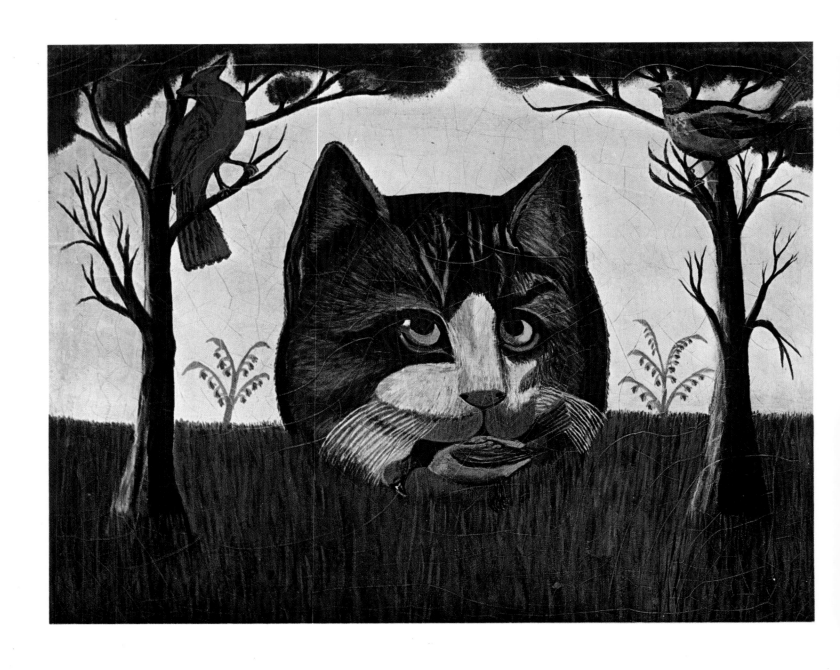

Artist unknown. The Cat. *c. 1840. Oil, 16 × 20″. Collection Edgar William and Bernice Chrysler Garbisch, New York and Cambridge, Md.*

As early as 1818 local legislation in Massachusetts forbade the destruction of some songbirds, and by 1864 eleven states had similar laws. Nevertheless, the average house cat often lived outside the law and still does.

Primitives Revisited

In the early decades of the twentieth century animals faced stiff competition from newer, more strident artistic concerns at home and abroad. American art was in turmoil as it sought a new identity for the modern age, and in the minds of many painters and critics the past had come to be the chief obstacle in the path of progress. Yet, while artists struggled to free themselves from the hidebound traditions of an earlier, more complacent era, the past itself unexpectedly began to yield its own version of modern art, an art overflowing with spontaneity, rhythm, individuality, and color.

After many decades of ignominious exile in the attics, barns, and cellars of innumerable ordinary American households, American folk art received a resounding welcome from critics whose eyes trained by exposure to Paul Gauguin, Georges Braque, and Pablo Picasso found it as daring as anything in France. The rediscovery caused a small sensation in the art world. Even the most dedicated modernists hailed it as a major event. City folks bought station wagons and flocked to the country in search of old weather vanes, figureheads, quilts, decoys, cigar store Indians, stenciled furniture, country crockery, samplers, and hooked rugs. Most of all, they searched for paintings executed with that distinctive unabashed sincerity which is the hallmark of the unsophisticated artist everywhere, especially in rural nineteenth-century America.

The rediscovery of nonacademic American art revived the flagging spirits of a public just recently resigned to accepting Paris's superiority in all things. The rediscovery established that a bold, experimental, abstract, innovative form of expression had existed all along in this country, waiting only for appreciation and modern reevaluation. But it also brought a number of vexing problems.

The most troublesome question was that of nomenclature, a question debated by critics even today. Many terms were proposed, such as folk, amateur, nonacademic, primitive, vernacular, and naive. None of these terms was really satisfactory, and the lack of agreement among art historians and collectors was particularly frustrating to the critics of the 1920s, who were accustomed to discussing the multifarious twentieth-century European artistic movements in catchy, convenient terms, frequently coined by the artists themselves. They were now dealing with works created by ordinary citizens who generally did not think of themselves as artists at all and who seldom bothered even to sign their work. If anyone had interviewed them, they would doubtless have agreed with the philosophy of Grandma Moses, quoted in *Life* (September 19, 1960): "Paintin's not important. The important thing is keepin' busy. If you know somethin' well, you can always paint it . . . [but] people would be better off buyin' chickens."

As more native folk art was uncovered, each find created new problems for aficionados: not only was there indecision regarding nomenclature, there were also perplexities of chronology and attribution. Many of the works obviously came from the nineteenth century—but beyond that the dating of folk art was conjectural at best. Lacking concrete information, many collectors settled instinctively

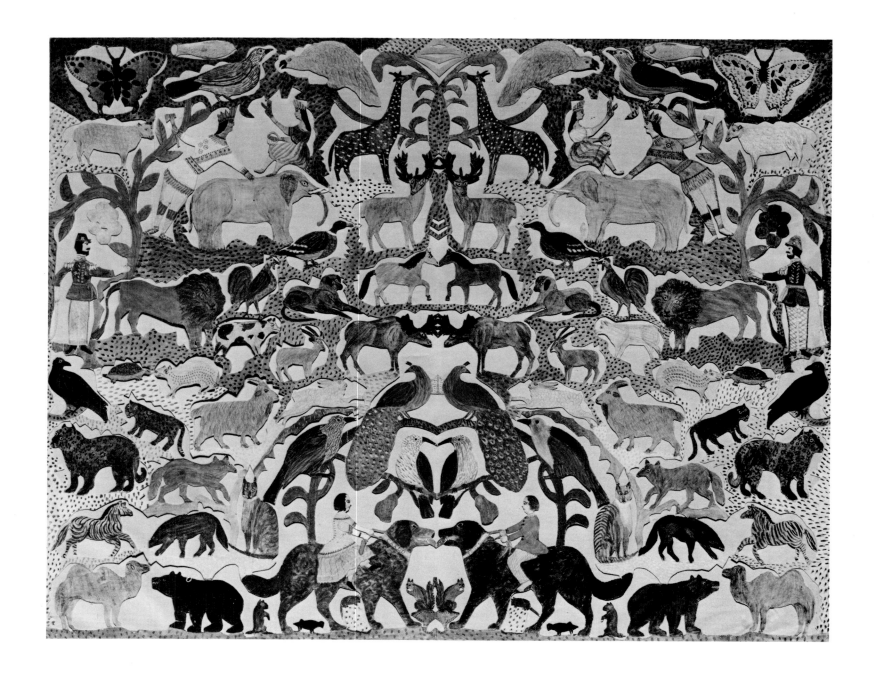

Artist unknown. Cutout of Animals. c. 1840. Watercolor on cut paper, 18⅞ × 23¾".
National Gallery of Art, Washington, D.C. Gift of Edgar William and Bernice Chrysler
Garbisch

With a blithe disregard for scale but with a keen respect for nature's multi-
plicity, this anonymous artist (perhaps a child) assembled two of practically
every kind of beast in a large paper cutout, wasting no space and sparing no
detail.

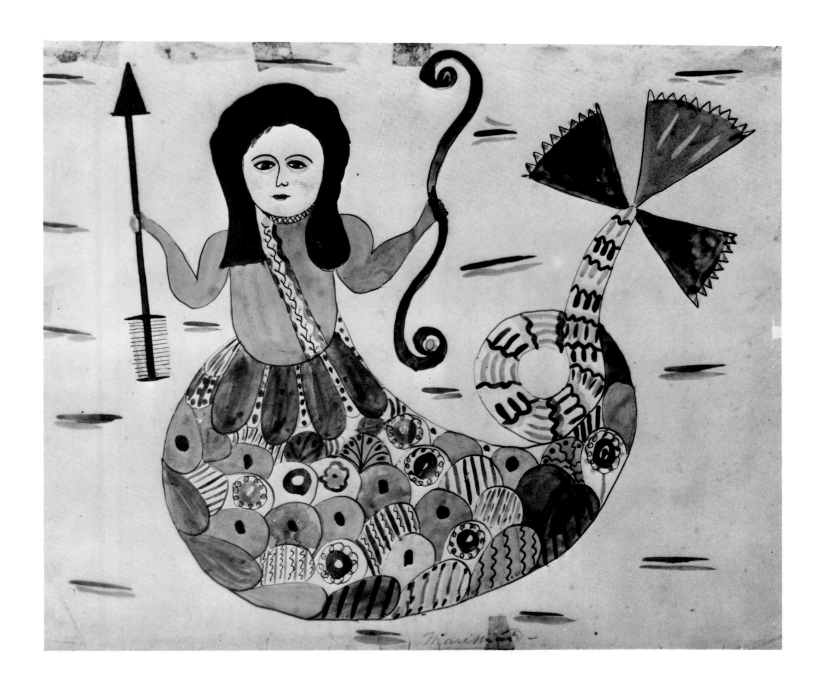

Mary Ann Willson. Marimaid. c. 1820. Watercolor, 13 × 15½". New York State Historical Association, Cooperstown

Mermaids were tempting creatures for American folk artists, just as they were for homesick and lonely sailors on the high seas. This mermaid was constructed in a rather unseaworthy manner, but perhaps—as Jean Lipman suggested in "Mermaids in Folk Art" (Antiques, March 1948)—she could work the tail like a propeller.

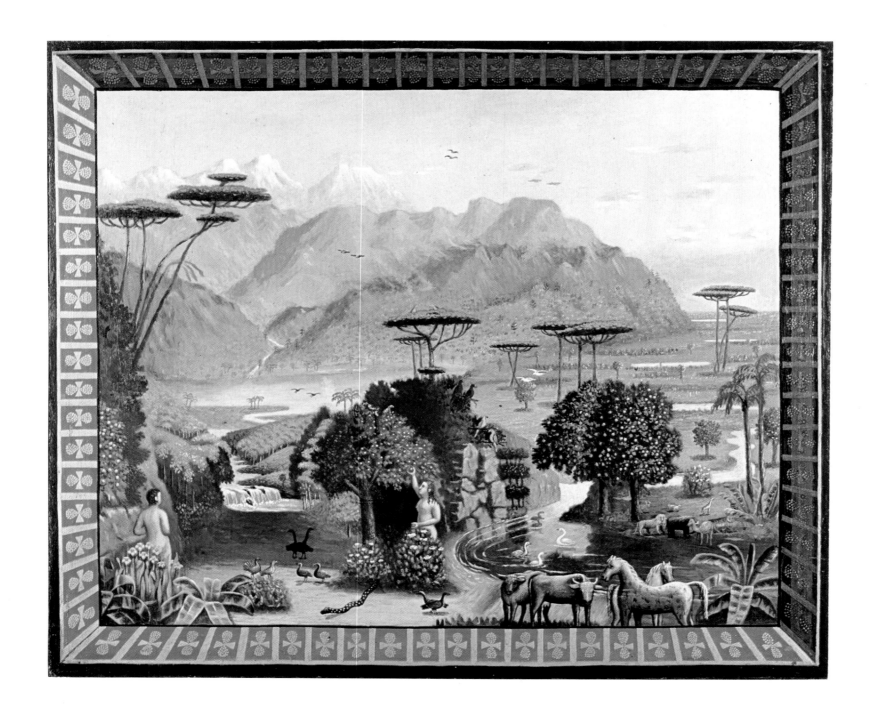

Erastus Salisbury Field. The Garden of Eden. *c. 1860. Oil, 35 × 41½″. Webb Gallery of American Art, Shelburne Museum, Shelburne, Vt.*

Erastus Salisbury Field had one of the most active imaginations of his artistic generation. His Eden, roughly coinciding with Darwin's Origin of Species, was almost Tibetan in its isolation from the mill towns of Field's native Massachusetts. The beasts in the painting were of course prescribed by the Bible, but nobody would call this serpent "subtil."

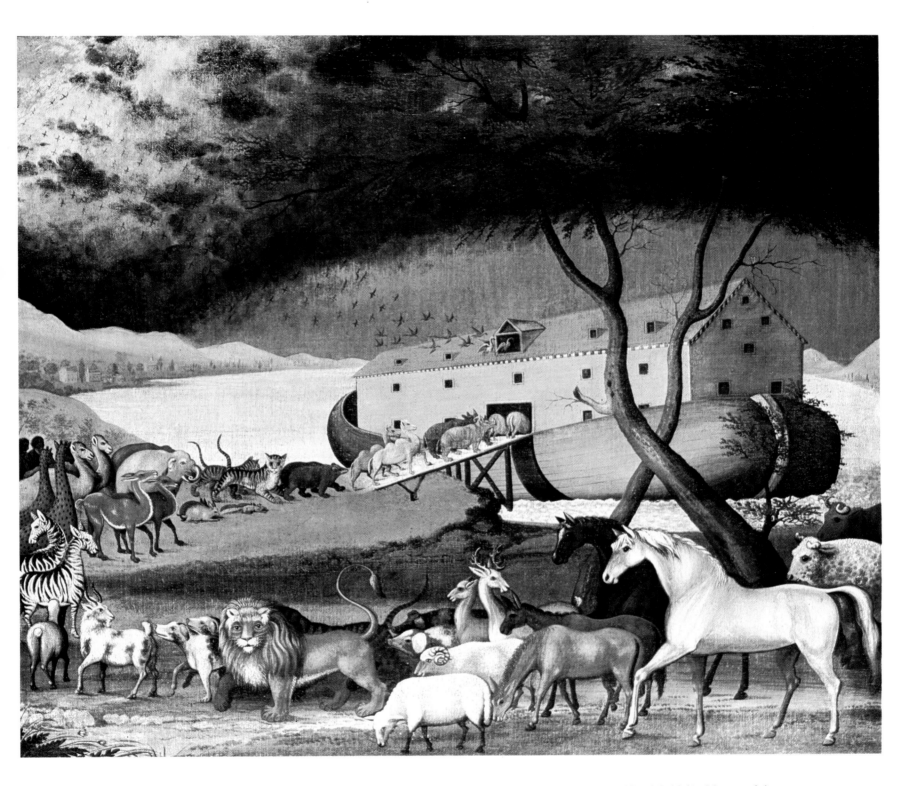

Edward Hicks. Noah's Ark. c. 1848. Oil, 26½ × 30½". Philadelphia Museum of Art. Bequest of Lisa Norris Elkins

Inspired by Nathaniel Currier's immensely successful lithographs of Noah's menagerie entering the ark, Hicks improved upon the original by adding trees and ominous storm clouds. The whole array of the animal kingdom is assembled at once for the voyage to new beginnings far from the corruption of man.

upon an all-purpose date, "circa 1840," a date that symbolically summed up a climate rather than a moment in time. The coming of age of America, the golden period of preindustrial individualism, and the fruition of Jacksonian democracy engendered a new self-confidence in the country. It still seems appropriate that catalog and caption copywriters used this attribution, for although much of American folk art was eventually dated with scholarly authority, the tradition of naive art in general belongs in spirit to the 1840s.

Today it is possible to ascertain the date of a work of art more scientifically; the same is true of authorship. Over the years bits and pieces of the lives of the artists have come to light, making the term "anonymous" less and less applicable. In fact, to a greater extent than was realized at first, the creators of these humble masterpieces proved to be not only amateurs and homebodies but also men and women whose livelihood depended on their art. Even those who led the most itinerant and rootless lives have been identified at least tentatively. Diligent and painstaking searches through courthouse ledgers, church records, and journals have yielded a great deal of information that the artists and their clients, with charming but inconvenient modesty, deemed unworthy of note.

As a group these self-taught artists were a heterogeneous lot, and generalizations are risky if not impossible. Mary Ann Willson, who apparently was something of a character even for the individualistic age she lived in, once boasted that her watercolors were sold in every corner of the land; in actuality she lived by farming and could afford only the paints and inks she was able to concoct herself from nuts, barks, and berries. Yet her unique visions of both the natural and the supernatural worlds did not suffer from a limited palette or an impoverished imagination. Whatever she may have lacked in temporal wealth and fame was more than offset by her wit and artistic courage.

Erastus Salisbury Field, whose art *was* widely known and respected, represents another extreme: Field, who studied briefly with Samuel F. B. Morse, knew enough about academic art to view his own artistic life with dissatisfaction. His career as a portrait painter all but finished by the daguerreotype mania that swept the nation in the middle of the nineteenth century, he spent his remaining years dreaming of grand monuments to the Republic which could never be built and of the innocent time when Adam and Eve held dominion over the animal kingdom.

Edward Hicks also had moments of despair, when he saw himself as "nothing but a poor old worthless insignificant painter." His love of painting conflicted sharply with his Quaker principles, which held the visual arts to be unnecessary and, therefore, to be despised.

Heinrich Otto, one of the best of the Pennsylvania German artisans, mixed Old World creatures with those of the New World in his heraldic designs. The pair of lions rampant are reminiscent of the armorial bearings of European tradition; on the other hand, the Carolina parakeet, the only parrot of temperate North America, was populous in Otto's time in Pennsylvania's orchards and cornfields—so much so that despite its beauty farmers completely wiped it out by the early twentieth century.

Not all of America's citizen-artists were burdened by introspection or idiosyncracy—the majority could afford neither the time nor the energy. Many religious communities, like the Shakers, Moravians, Rappists, Mennonites, Readers, Dunkers, Schwenkfelders, Anabaptists, and Jansonites, though artistically prolific, required of their members long hours of heavy toil in the fields. And the large number of free-lance folk artists who were house painters by profession, or carriage painters or sign painters, could indulge their fancy for picture painting only when the day's labor was over. They had no opportunity to study the paintings of the masters, except those reproduced by woodcut or engraving in the popular press. Until the last quarter of the nineteenth century, art schools and museums were a rarity, and thus virtually every rural artist, isolated from the mainstream traditions, had to start at the beginning, meeting each artistic problem with a solution of his or her own invention. As a result, folk art lacks the continuity that characterizes fine art, in which each generation builds on the achievements of the past.

It was this perennial newness of nonacademic American art, its apparent independence from stultifying conventions, that was responsible for its enthusiastic reception within the urban centers of the 1920s and 1930s—a period when trained artists were consciously attempting to unlearn most of what they had been taught in the art schools. Nevertheless, recent evidence implies that the untutored artist, far from satisfied with his lack of artistic discipline, hungered constantly for the technical skills denied him by place and circumstance. The artistic innocence that modernists found refreshing was simply cause for embarrassment and consternation to artists struggling to achieve

Heinrich Otto. Ornamental Drawing. c. 1790. Watercolor, 9 × 13½". Henry Ford Museum and Greenfield Village, Dearborn, Mich.

123

realism. The tradition of fine art was actually well known to many of them. They referred to it as the "New-York fashion," and they strove, with varying success, to master its secrets.

The rural academies and seminaries of the nineteenth century made a conscientious effort to introduce their pupils to some of the fashionable artistic niceties of the city, and although they often resorted to dictatorial methods, the underpaid instructors in these institutions of middle-class enlightenment exerted a notable influence on the history of native amateur art.

A. Tapy. The Neigh of an Iron Horse. *1859. Oil, 14⅛ × 18⅛″. Collection Edgar William and Bernice Chrysler Garbisch, New York and Cambridge, Md.*

Bedlam broke loose on the plains when the steam locomotive made its appearance, belching smoke, roaring, and scattering animals from the right-of-way. The wild horse had long enjoyed a free run of the prairies, but as Tapy's dramatic painting testifies, by the middle of the nineteenth century the three-century reign of the mustang was coming to an end.

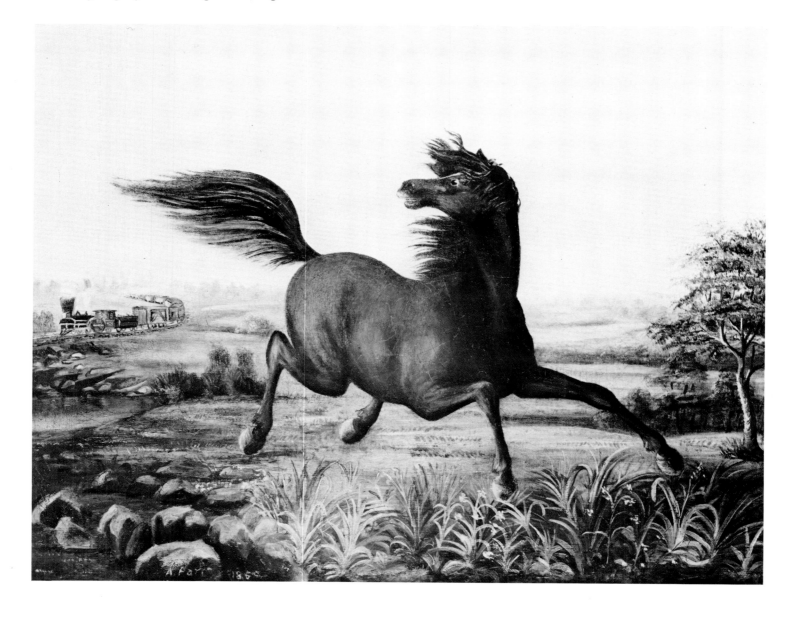

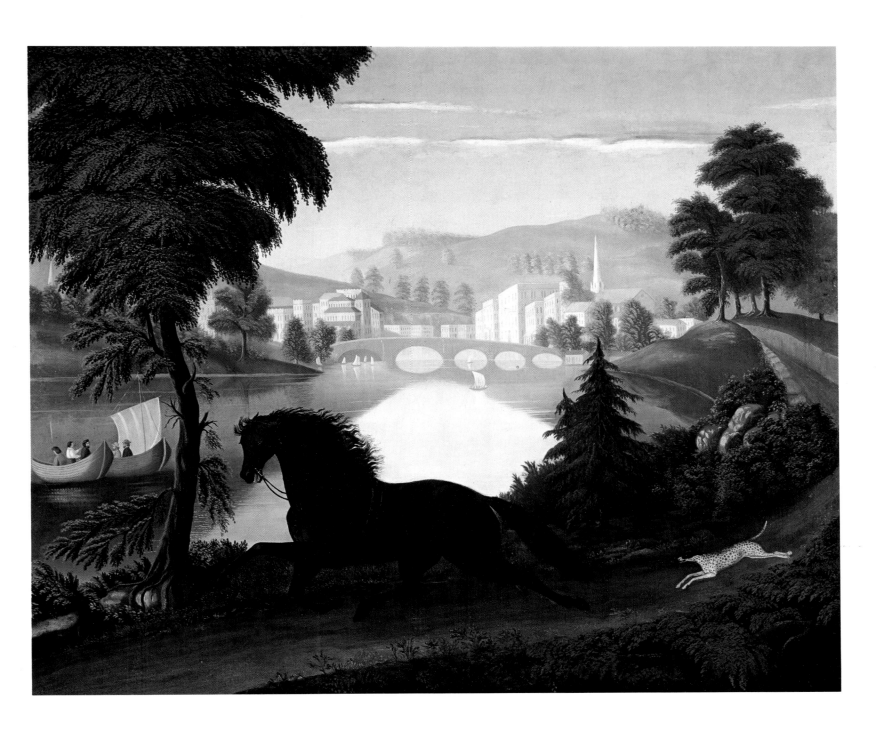

Artist unknown. The Runaway Horse. *c. 1850. Oil, 31¼ × 38½". Collection Mrs. L. F. McCollum, Houston*

This runaway horse, like many animals in American art, is a free spirit, galloping out of the mysterious past, crossing our field of vision briefly, and disappearing into a world of its own again. There are several tantalizing mysteries to ponder. Is the dalmatian chasing the horse or joining a dash for freedom? Is the scene New England or some tranquil Italian landscape? And can they shift for themselves beyond that idyllic village?

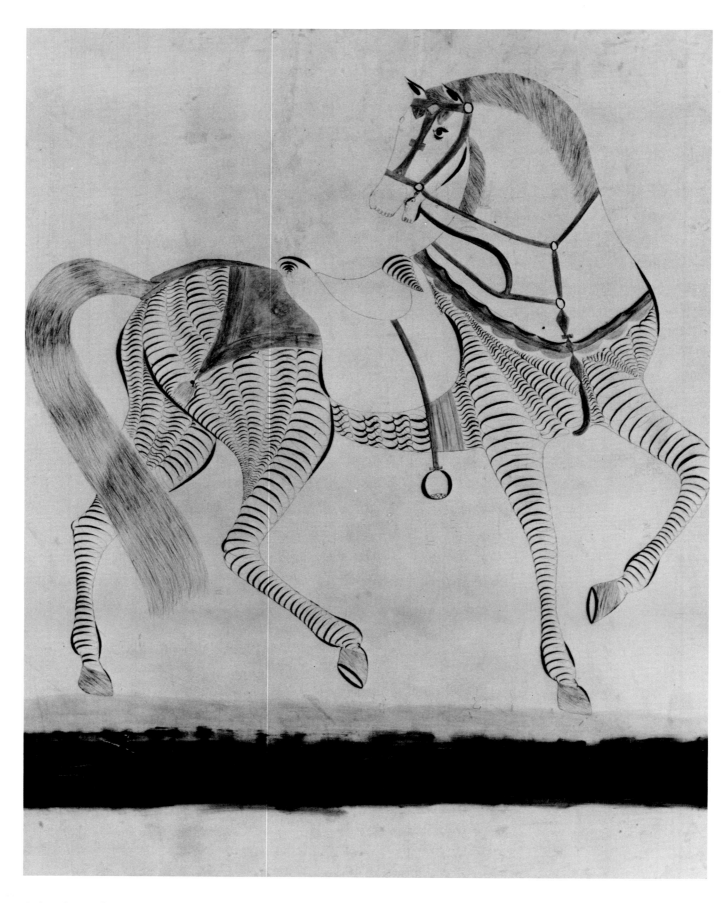

Artist unknown. Caparisoned Horse. *c. 1850. Ink and watercolor, 23 × 17½″. Abby Aldrich Rockefeller Folk Art Center, Williamsburg, Va.*

Calligraphic drawing, for instance, was a regular part of the curricula of boys schools. Platt Roger Spencer, who devised the impressive script prevalent throughout the second half of the nineteenth century, insisted on repeated drill for learning letter forms; once the students mastered the alphabet perfectly, they were encouraged to use their practiced steel pens on much more entertaining projects, like eagles and lions and prancing horses.

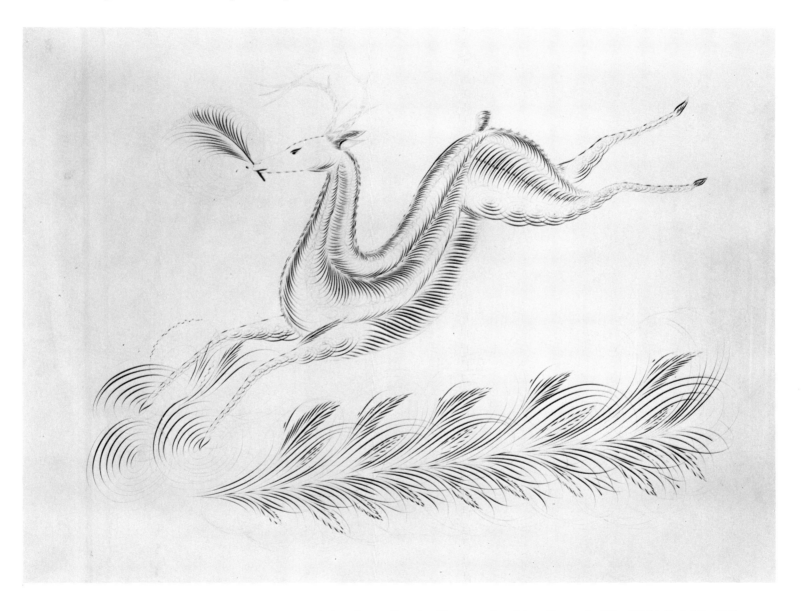

Artist unknown. Leaping Deer. *c. 1850. Ink, 21⅞ × 29″. Abby Aldrich Rockefeller Folk Art Center, Williamsburg, Va.*

The by-product of Platt Roger Spencer's rigorous handwriting courses, calligraphic art, was a sweet reward indeed for the diligent student permitted to graduate from scratching out rows and rows of O's and A's to the becurlicued realm of pictures.

The nineteenth-century schoolchild who spent years learning how to handle a steel pen for writing was also acquiring a technique unknown to today's ballpoint generation: the airy, elegant art of penmanship drawing.

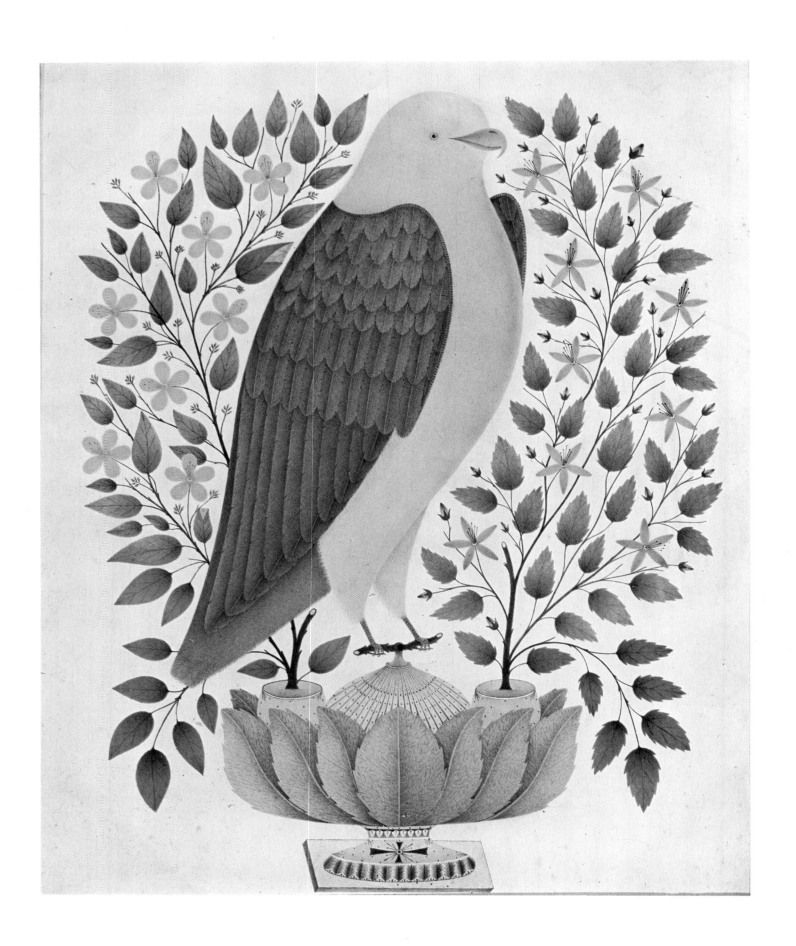

For young ladies in the seminaries there was the art known as Chinese, or theorem, painting: stencils, cut painstakingly from oiled paper, could be combined in an infinite number of ways to produce a finished picture, or theorem. The stencils were provided by the instructor, and the student used them to paint on paper, silk, or velvet. Despite its built-in limitations, this technique could be utilized by a talented pupil with remarkably lively results. Although the mainstay of the theorem painter was the high-waisted fruit bowl overflowing with flowers and delicacies, there were other subjects—including exotic fauna, especially birds—that were also highly favored by the young ladies.

Animal imagery in folk art was not confined to the humble materials of watercolor and ink. Many beguiling creatures were painted in the more expensive and technically demanding medium of oil. But it was not easy for the rural artist to acquire training in the arcane skills of grinding the necessary pigments, distilling the solvents, boiling the malodorous oil, and storing the resulting, sometimes volatile, concoctions, not to mention mixing the colors and applying them to canvas in a workmanlike manner. European tours or leisurely sessions with the masters were out of the question. Novices could, however, follow the relatively uncomplicated recipes used by coach and sign painters, and in fact many masterpieces of folk art were made with ordinary house paint.

Whatever the medium, animals are legion in folk art. There are lions more ferocious than in any jungle. Heavy black bears sway in the branches of fragile pear trees. Squirrels make themselves at home in velvet-hung parlors. Gazelles and horses leap and frolic about with a freedom that defies the force of gravity. Birds and beasts two by two fearlessly climb the ramps of innumerable unseaworthy-looking Noah's Arks. The art of the Pennsylvania Germans abounds in parrots, unicorns, and fallow deer, creatures of the medieval imagination from whence they sprang. Stiff, tentative portraits by itinerant Yankee limners were immeasurably enlivened by the frequent inclusion of animals. And the family cat, as pampered in the nineteenth century as it is today, played a stellar role in the iconography of American folk art. For that matter, so did the family cow.

Artist unknown. Stylized Bird. c. 1840. Watercolor and stencil, 17⅛ × 14⅜". Metropolitan Museum of Art, New York. Gift of Edgar William and Bernice Chrysler Garbisch

Amid sprays of exquisitely rendered foliage a resplendent bird—perhaps an eagle—shows off its perfectly groomed wing feathers. With the aid of stencils the unidentified artist achieved a masterpiece of theorem painting.

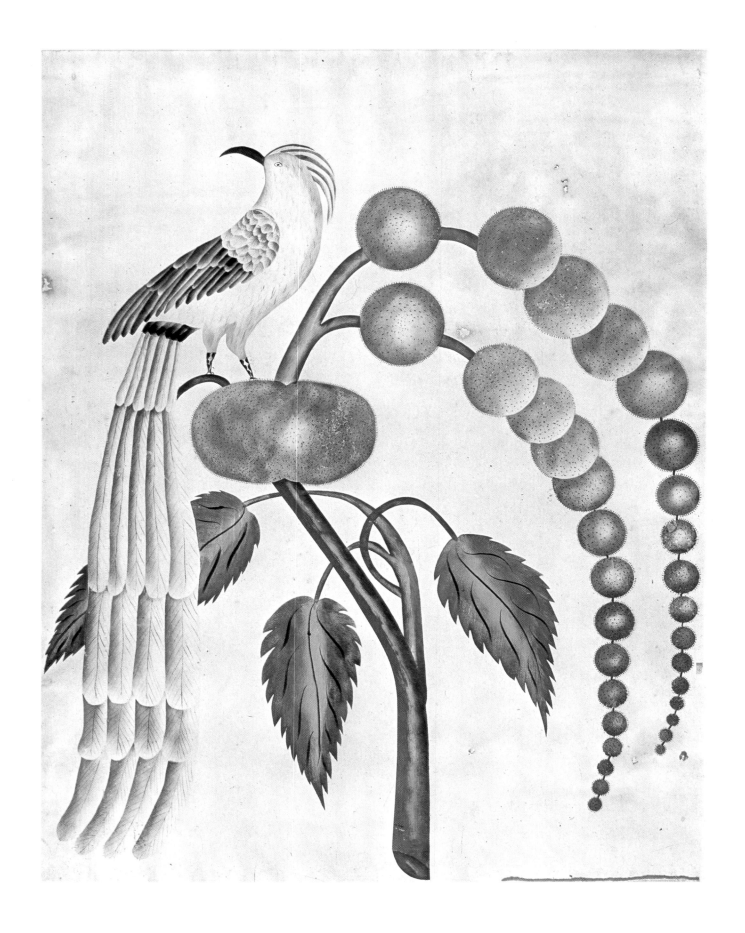

Artist unknown. Tropical Bird and Fruit. *c. 1830. Watercolor and stencil, 24½ × 18¾".*
New York State Historical Association, Cooperstown

A flamboyant bird from some imagined South Seas paradise seems to stand for
the unexpressed yearnings of early nineteenth century America. The simple
stenciled elements have been boldly arranged into a composition of considerable
rhythm and grace.

Artist unknown. Bear in a Tree. *c. 1850. Watercolor and stencil, 8⅜ × 14½". National*
Gallery of Art, Washington, D.C. Gift of Edgar William and Bernice Chrysler Garbisch

Like many American primitive animals, these frisky stenciled beasts were
thoroughly European in habitat: the fallow deer and the European bear and
wildcat. Working from memory or from book illustrations, the artist, with
little regard for the laws of gravity, arranged them all in a forest of sponged
and stenciled trees.

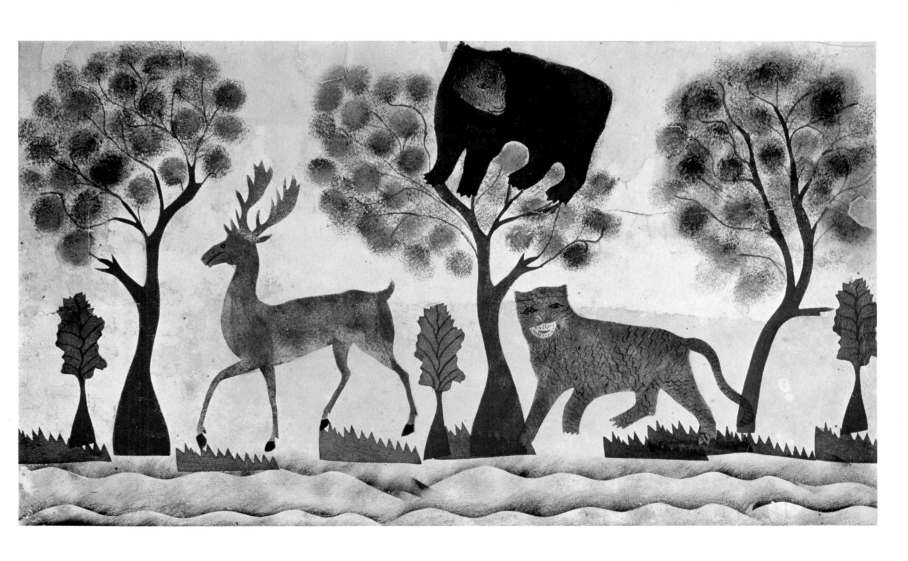

Artist unknown. Peacockish Pheasant. *c. 1810. Watercolor, $8\frac{1}{4} \times 6\frac{1}{4}''$. Henry Francis du Pont Winterthur Museum, Winterthur, Del.*

The pheasant, a native of China, was not imported to America until years after this watercolor was executed. The inspiration therefore must have been an oriental import—perhaps a piece of decorated china—copied freely by a fine Pennsylvania German hand.

Artist unknown. Lion in a Wood. *c. 1840. Fireboard. Oil on wood, $33 \times 46''$. Private collection, Brookline, Mass.*

This impressive beast once guarded the chimney of the Dresser Tavern in Charlton, Massachusetts. With such a ferocious lion protecting the hearth the innkeeper and his guests must have felt quite secure late at night against unwelcome prowlers as well as wintry drafts.

Artist unknown. Tinkle, a Cat. *1883. Oil, 23¾ × 18″. Webb Gallery of American Art, Shelburne Museum, Shelburne, Vt.*

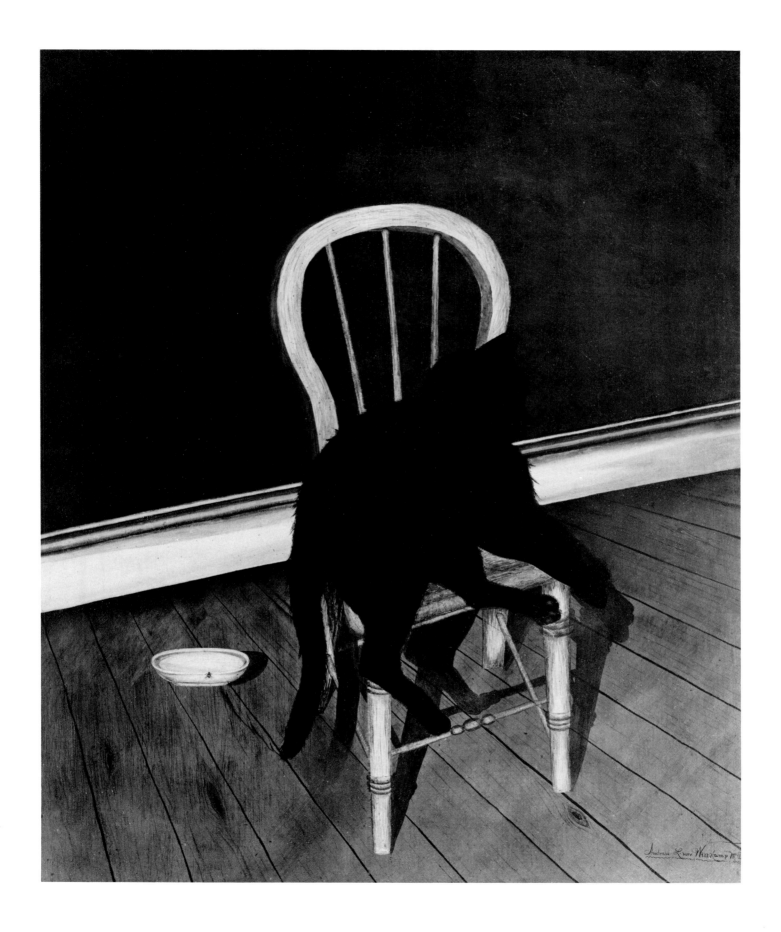

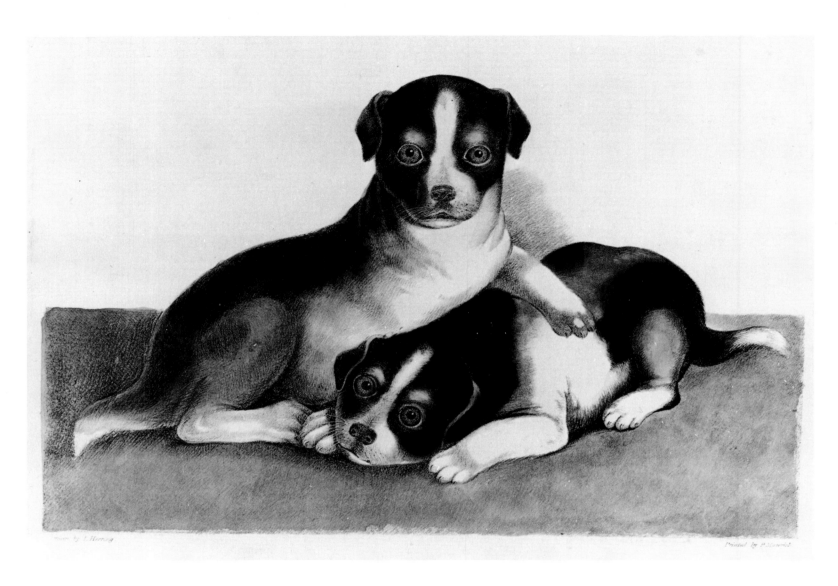

I. Herring. Untitled. c. 1830. Lithograph, 10 × 15". Smithsonian Institution, Washington, D.C. Harry T. Peters "America on Stone" Lithography Collection

Folk artists, as well as professionals, enjoyed extensive borrowing privileges in the nineteenth century (copyright laws were not really effective until the 1870s). One popular favorite was a pair of pointer puppies, which was lithographed by several busy printing firms and also found its way into hooked rugs, watercolors; and even portraiture.

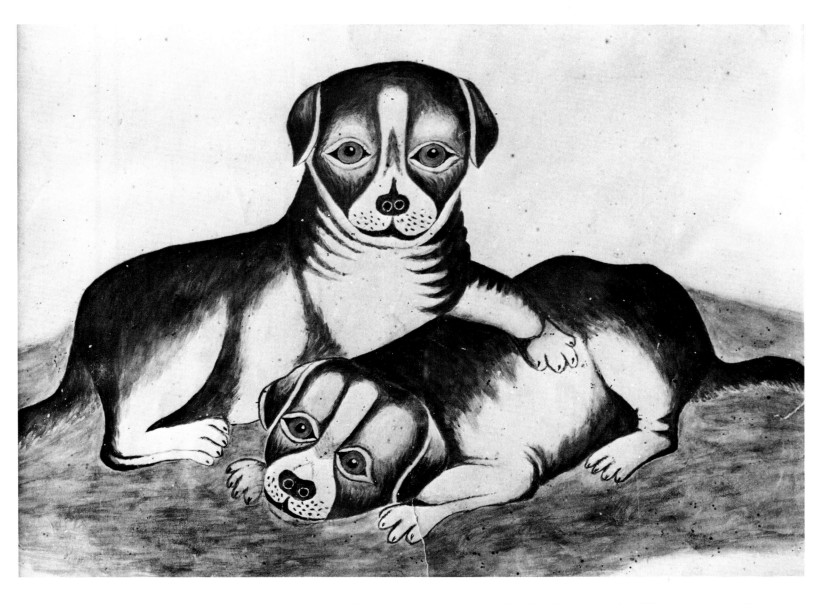

Artist unknown. Two Brown and White Puppies. *c. 1850. Watercolor, 12 × 15½".*
Colby College Art Museum, Waterford, Maine. American Heritage Collection

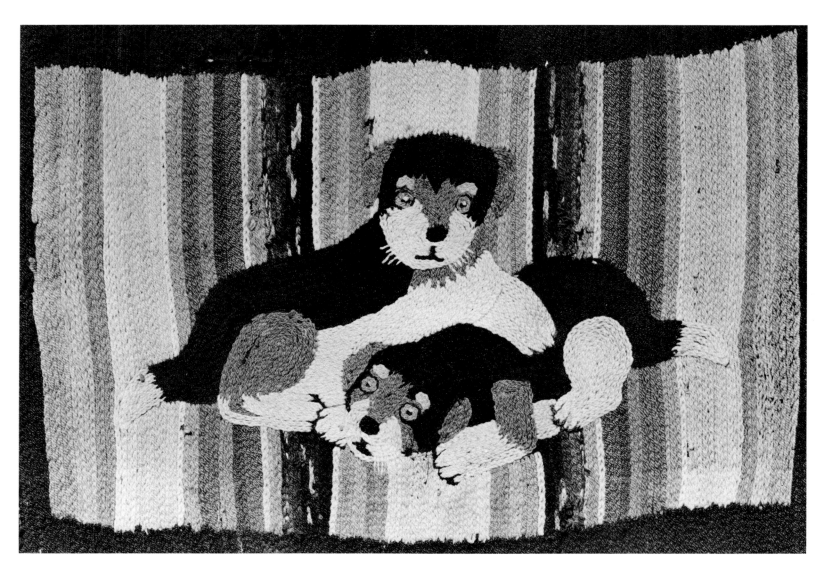

Zeruah Caswell. Wool Carpet *(detail). 1832–35. Wool on wool. Metropolitan Museum of Art, New York. Gift of Katherine Keyes*

Noah North (attr.). Boy Holding Dog. *c. 1835. Oil, 15½ × 12″. Abby Aldrich Rockefeller Folk Art Center, Williamsburg, Va.*

Lifted from Herring's untitled lithograph (or from some earlier printed or painted source), the wide-eyed puppy makes its appearance again, in the arms of a handsome child. The portrait is attributed to Noah North, an artist who worked in Kentucky, Ohio, and New York during the 1830s.

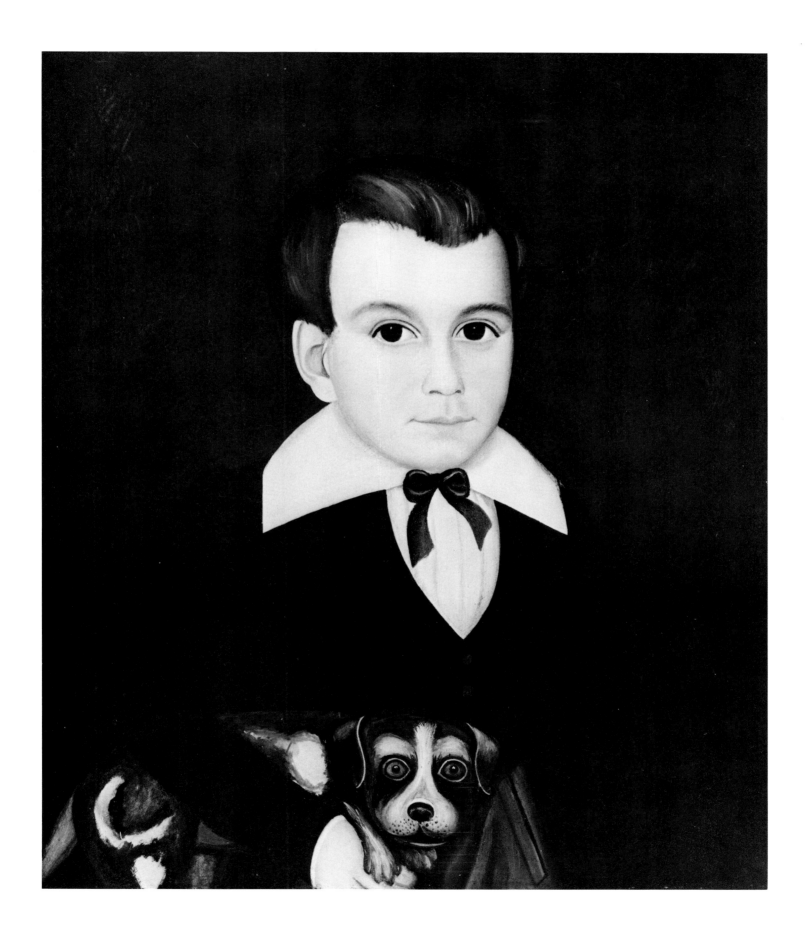

The tradition of folk art continues even today, but, except for the lone eccentric working in utter isolation the life of the American folk artist has been radically altered since the era of rediscovery. The critics and collectors of the twenties, thirties, and forties, exhilarated by the excitement of the hunt, combed the country in search of living primitive artists and they found many: John Kane, toiling in a cold-water Pittsburgh tenement; Grandma Moses perched high on a hill in upstate New York; Joseph Pickett, living as a boat builder in Bucks County, Pennsylvania; old Morris Hirshfield, the retired Manhattan garment manufacturer. Cameramen arrived, contracts were drawn up, checks were written—some of them quite substantial. Inevitably twentieth-century folk art became chic.

Modern primitives became part of the art establishment. In 1939 the Museum of Modern Art moved uptown in New York, celebrating its tenth anniversary in new streamlined headquarters on West Fifty-third Street. In the inaugural exhibition, "Art in Our Time," alongside the works of Renoir, Gauguin, Cézanne, Seurat, Van Gogh, and Picasso were displayed twenty-three works of American folk art. Dorothy C. Miller, writing in the exhibition catalog, paid official homage at last to the "clear childlike vision and straightforward technique qualities" of the art of the common man.

Morris Hirshfield. Tiger. 1940. Oil, 28 × 39⅞". Museum of Modern Art, New York. Abby Aldrich Rockefeller Fund

Morris Hirshfield's tiger burns as bright as any dreamed of by William Blake. Tigers usually prefer dense jungle cover, but this one, with understandable pride (and the help of the artist), has emerged into the open for all to see his finely tailored stripes.

[?] *Freeman. Peter Volo. c. 1914. Watercolor, 12⅛ × 18″. New York State Historical Association, Cooperstown*

The primitive style of the self-taught painter continued even after the flourishing period of folk art in the nineteenth century all but came to an end. This twentieth-century artist's attention to architectural detail suggests that he may have been employed in one of the building trades; he apparently was not an expert on horses. Nevertheless, he was not afraid of attempting on paper the impression of all-out headlong speed.

Morris Hirshfield. Nude on a Sofa with Three Pussies. *1941. Oil, 26 × 34″. Courtesy James Maroney, Inc., New York*

The love of pattern, the giddy use of aerial perspective, and the lack of reverence for conventional subject matter, all characteristics of nineteenth-century folk art, were kept alive in the work of twentieth-century individualists like Morris Hirshfield, who, like many modern primitives, took up painting late in life.

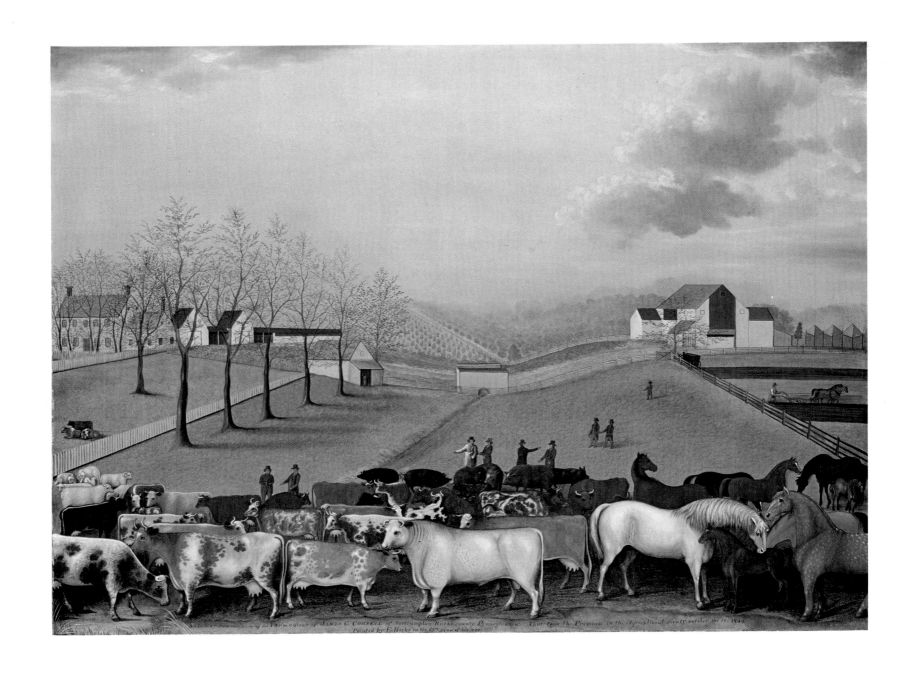

Edward Hicks. The Cornell Farm. *1848. Oil, 36¾ × 49″. National Gallery of Art, Washington, D.C. Gift of Edgar William and Bernice Chrysler Garbisch*

Livestock raising in America was in its infancy when Edward Hicks painted this renowned nineteenth-century farm. The more enlightened husbandmen of the time were beginning to experiment with imported breeds, and James Cornell's herd included at least four: Guernsey, Ayrshire, Holstein, and Angus. Cornell's horses were sturdy farm horses, not the elegant trotters popular a few years later.

The Cow in the Parlor, the Tabloid Tiger, the Talking Rabbit,
and the Matinee Mouse

Some of the most interesting and often captivating animals in American art staked out as early as the eighteenth century a realm of their own—far from the wilderness or the National Academy but conveniently close to the nation's burgeoning centers of commerce. For a century and a half these creatures have patrolled the fringes of art history, mingling at times with more aristocratic animals but generally keeping their distance. A few of them have become so firmly entrenched in the nation's subconscious that they deserve to be chronicled.

By the middle of the nineteenth century a number of separate and distinct animal specialties had already established a foothold in American art. Among the first of these to gain widespread popularity was the animal portrait, which provided a steady income for many artists and contributed considerably to the richness and variety of Victorian interior decoration. The animal portrait was not unlike its human counterpart, in which fine silks and satins, imported laces, and aristocratic paraphernalia left no doubt about the substance, character, and fortitude of the sitter. Animal portraits also stressed gentility and good breeding—not with elegant accessories attesting to financial achievement but by the gleaming coats, deep chests, and fine configurations of the animals themselves.

The custom of immortalizing livestock on canvas originated in England, but in the United States it took on a characteristic earthiness of its own. Following the English tradition the animal was usually painted broadside in order to show off its best anatomical points. Often the proud owner or trainer was invited to pose with his stock, and due attention was paid to the animal's lineage, progeny, and prize winnings.

The artists who executed these barnyard portraits obviously led itinerant lives. Many artists were capable of painting actual barns as well as pictures of them, and even if they restricted their work to portraiture, they were on the road much of the time traveling from farm to farm. After the Civil War, country fairs grew to a considerable size, and the job of the livestock portraitist became easier. Brimming with pride and prize money, most stockmen could be persuaded to have a painting made to commemorate the big day. All it took, as an enterprising artist like Newbold H. Trotter quickly learned, was being at the right place at the right time.

Some of the earliest active cattle breeders were not dirt farmers but politicians. Henry Clay imported the first Herefords to America, and Daniel Webster's Ayrshire herd brought him widespread

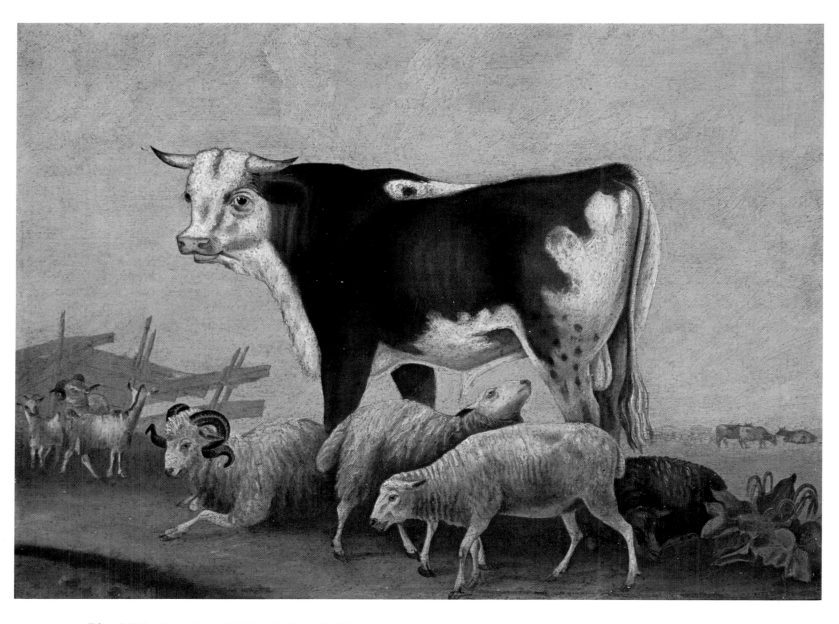

Edward Hicks. James Cornell's Prize Bull. *1846. Oil, 12 × 16¼". Abby Aldrich Rockefeller Folk Art Center, Williamsburg, Va.*

Hereford cattle, identifiable by their white faces and gentle dispositions, proved to be one of the hardiest beef breeds and were therefore well suited to the Pennsylvania farms of Hicks's day. The merino sheep, introduced to the United States in 1793, is still prized in the region for its fine wool.

H. H. Cross. Gordon Glen Stock Farm. *1887. Oil, 22 × 27". Courtesy Kennedy Galleries, Inc., New York*

In a rare departure from hallowed convention, this formal horse portrait includes a plug for a commercial stock farm. Although it would have been frowned upon in England as a lapse of taste, it seems perfectly natural in America.

Overleaf

No trace of their barnyard surroundings mars the aristocratic faces of Mr. and Mrs. Bos taurus, *who posed for these superb portraits with a serene complacency often denied human couples.*

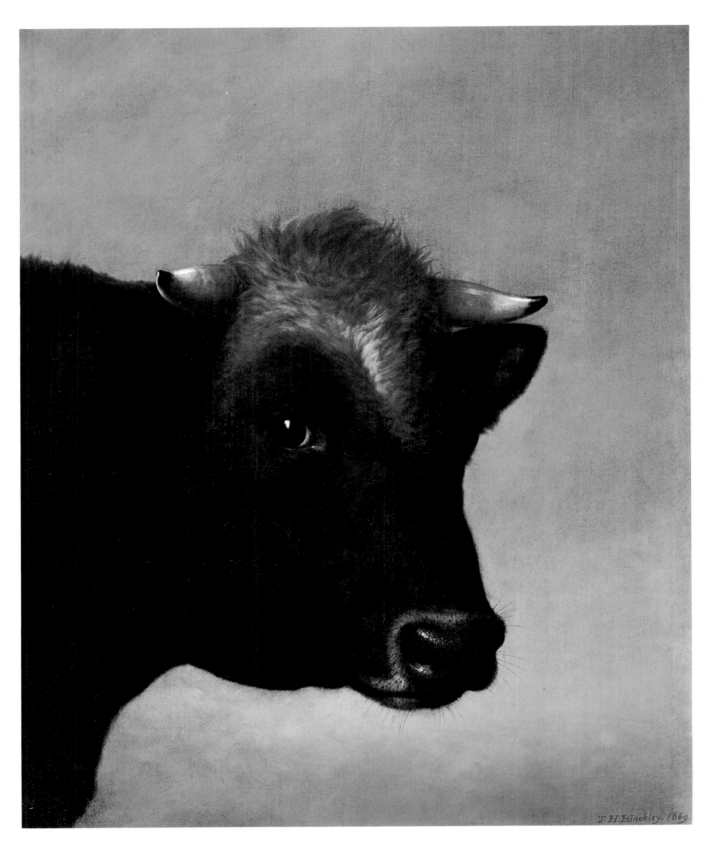

Thomas Hewes Hinckley. Head of a Bull. *1869. Oil, 38 × 30¾″. Private collection, New York*

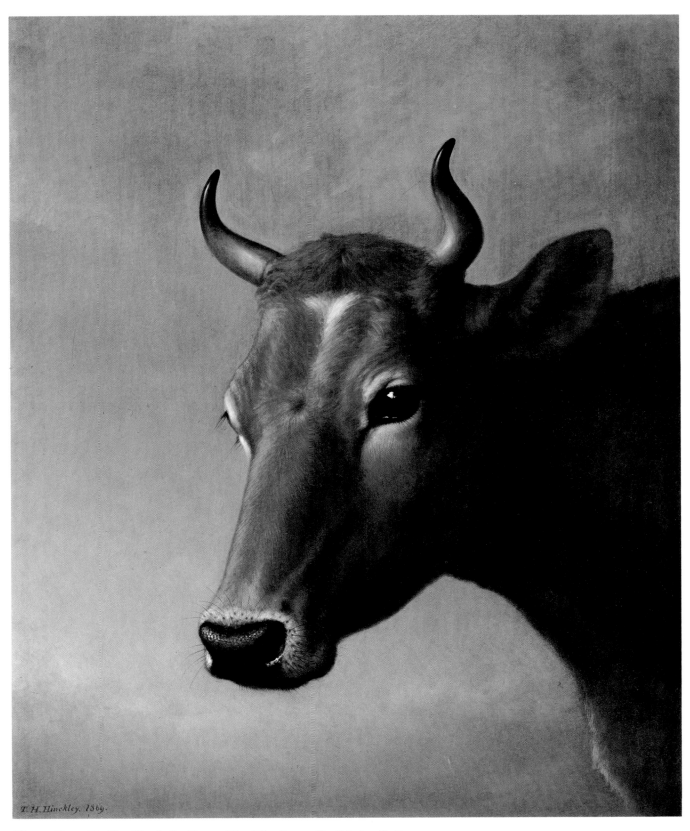

Thomas Hewes Hinckley. Head of a Cow. *1869. Oil, 38 × 30¾". Private collection,*
New York

nonpartisan respect. Webster chose an obscure, almost untrained artist named Thomas Hewes Hinckley to sketch his famous Ayrshires in 1845. Eventually Hinckley became the most successful barnyard portraitist of his time with a large and affluent clientele of landed gentry. His scenes of wild game strongly appealed to their love of hunting, but best of all they liked his portraits of cattle; as the pioneer collector and art critic James Jackson Jarves pointed out, Hinckley could paint animals "with the *animal* left out."

The cow portrait in its sundry forms was an almost obligatory component of the decor of well-furbished American dining rooms and parlors during the Gilded Age. Horse portraits, on the other hand, were commissioned for hanging in tack rooms or, somewhat later, in chambers set aside for strictly masculine activities, as were the enormous quantity of lithographs and engravings of sporting life that emanated from the presses of Currier & Ives and their competitors. Immensely popular artists like A. F. Tait, who, it was said, painted "in a way that almost whets one's appetite for roast duck," and Fanny Palmer produced in their lithographs a polite view of the howling wilderness— the fish, flesh, and fowl already permanently subdued by man, or shortly to be dispatched.

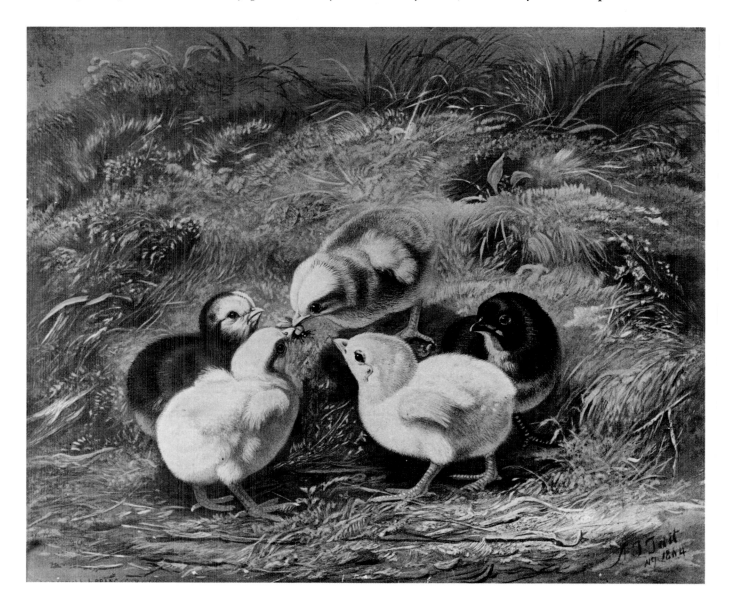

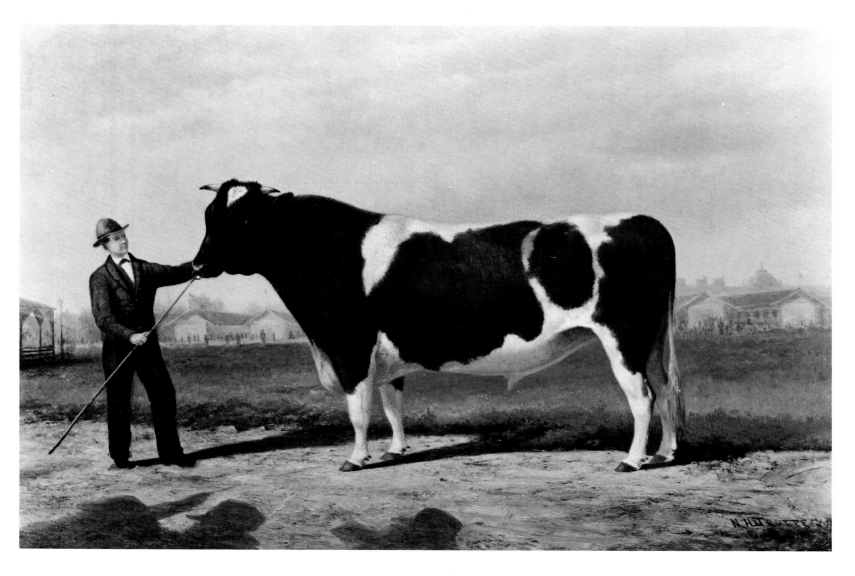

Newbold H. Trotter. Holstein Bull, Crown Prince. *1876. Oil, 20 × 36″. Old Print Shop, Inc., New York*

The pride and joy of modern American dairy farmers, the full-size Holstein-Friesian bull weighs over a ton. This impressive specimen, posing at a fairground, may have been a descendant of the experimental stock brought to America a century before Trotter painted this portrait.

Arthur Fitzwilliam Tait. Chickens I. *1866. Lithograph, 10 × 12½″. Smithsonian Institution, Washington, D.C. Harry T. Peters "America on Stone" Lithography Collection*

A. F. Tait was one of the most popular nineteenth-century designers of lithographs, specializing in game birds and sporting scenes. Today the exact science of poultry raising leaves nothing to chance from hatching time to hatchet time, and the modern farmer would never allow his chickens to feed themselves on stray insects.

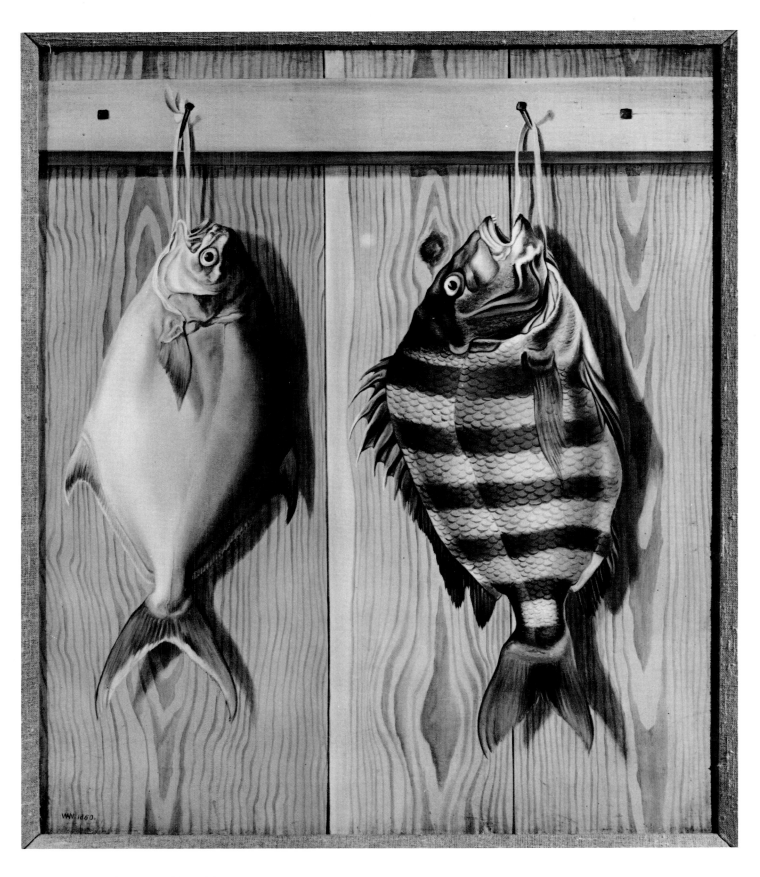

William Aiken Walker. Dollarfish and Sheepshead. *1860. Oil, 24 × 20". Museum of
Fine Arts, Boston. M. and M. Karolik Collection*

154

Fish were no less prestigious subjects than furred or feathered game, and artists went after them with great diligence. S. G. W. Benjamin mentioned in his book *Our American Artists* (Boston, 1879) a gentleman by the name of Walter Brackett, who had "the fascinating custom, which he has pursued for over twenty years, of going into the mountains with his son and camping out, fishing in the roaring brooks, and painting the salmon and speckled trout as they quiver on the end of the line."

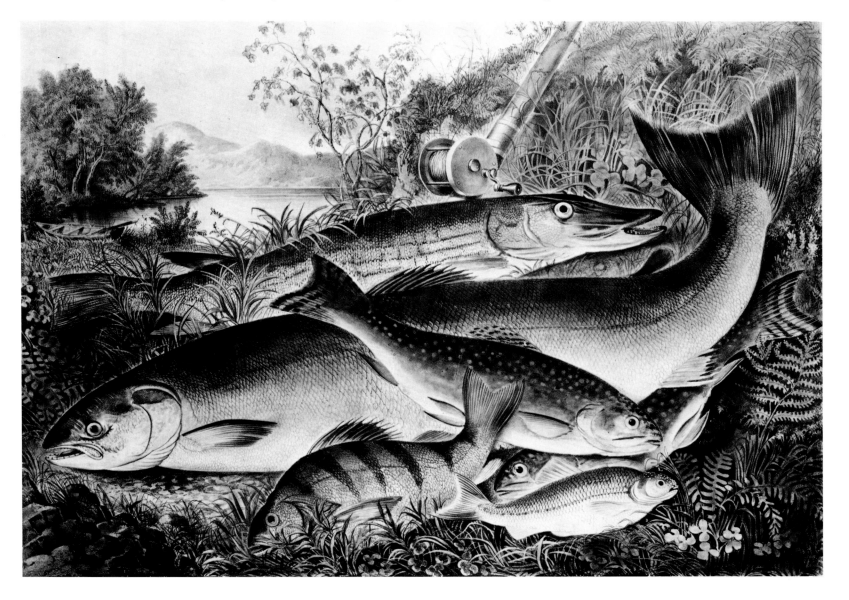

Frances F. Palmer. American Game Fish. 1866. Lithograph, 20 × 27¾". Old Print Shop, Inc., New York

Fish were popular subjects in nineteenth-century American lithography. Fanny Palmer, the versatile designer of some of Currier & Ives's most famous prints, assembled here a catch of America's favorite sporting fish: pike, salmon, trout, and perch.

Nailed to a pine plank, two of the South's most delicious fish make a handsome trompe l'oeil composition. Anyone who has ordered pompano in a New York restaurant will find the earlier common name, dollarfish, an underestimate. The sheepshead, a kind of porgy, has yet to be discovered by restaurateurs.

The horse portrait, like the cow picture, had its origins in Europe. Except for anatomical idiosyncrasies and variations in background, these paintings followed a rigidly traditional pattern in America, as they had in England in the hands of such revered practitioners as John Frederick Herring, George Stubbs, and John Sartorius. A few American artists attempted to duplicate their success but made little progress until they were shown the way by Edward Troye. Troye, who was born in Switzerland, was the first American resident to make a profitable career painting racehorses. He discovered Kentucky in the 1830s and remained there for forty years, working as a kind of Cecil Beaton to the four-footed aristocracy of the bluegrass region. He was much admired for the fidelity of his portraits, which meticulously included even the uncomely veins and tendons of his subjects. To the uninitiated such pictures seem very much alike. To the nineteenth-century lover of thoroughbreds, however, each horse was immediately recognizable by details carefully noted by the artist.

The conception that the history of art can be deduced from a study of horses' tails has been satirically proffered in the past. The problem may seem overly academic, but for reasons now lost, certain tails must have figured quite prominently at one time. The horses in *Prince Imperial* and *Horse with Extra-Long Mane and Tail* both laid claim to the world's longest manes and tails. The first, lithographed in the 1870s, was a Rapunzel of a steed, boasting a mane that must have been at least six feet long. The other, named Oregon Lily, was shown in Chatham County, New York, in the 1890s. There are many unanswerable questions to ponder. What does one do with such a creature? Why was horsehair taken so seriously that artists were paid to paint pictures of it?

In addition to the standing-still horse portrait a second type concentrated on feats of speed. Celebrated trotting horses were shown flying over hill and dale, over track, over snow and ice, across bridges, through forest and field, or scattering terrified bystanders on village thoroughfares. Historic moments in racetrack history, great horses, and famous drivers all received the artist's careful attention. In fact, the horse was nearly always more famous than the artist. The steeds of General Ulysses S. Grant—who was once issued a speeding ticket in Washington, D.C.—were well known through painting and lithography, though the horses of gentlemen of more local repute, such as Captain Shields of Bennington in the painting by William Van Zandt, had their followers too.

The artist who undertook to record such high-speed events had to rely on memory and guesswork. Just where *are* the horse's legs, how are they distributed, at any split second in its flight around the

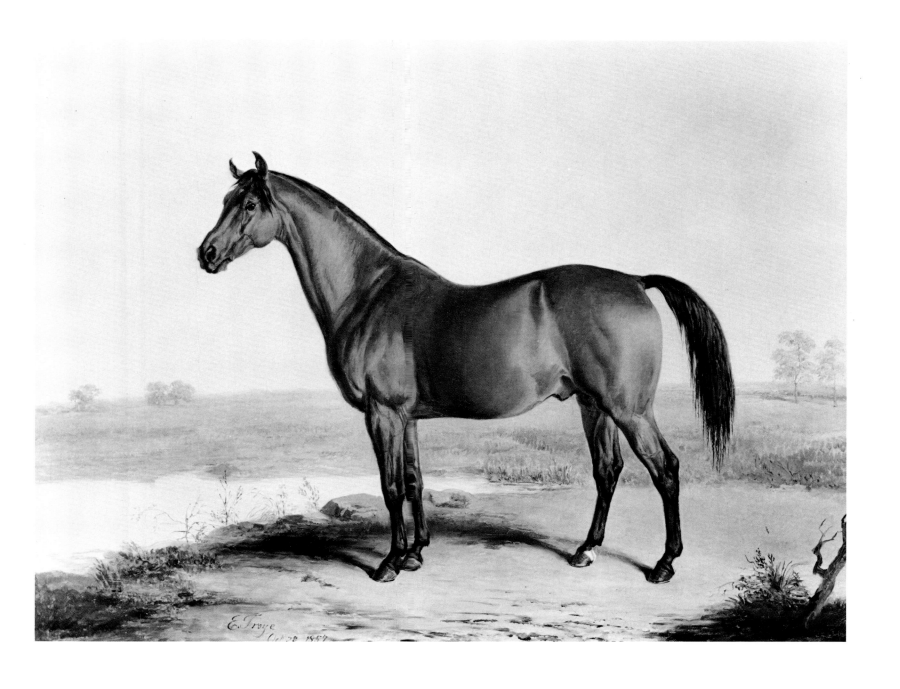

Edward Troye. Renowned Trotter Zero—Saint Louis Fair, 1857. *1857. Oil, 27 ×
36″. Courtesy Kennedy Galleries, Inc., New York*

*The formal horse portrait was one of the strictest art forms in nineteenth-century
America. Except for a few concessions to the local landscape, Edward Troye's
racehorses were almost indistinguishable from those of his famous contemporary
in England, John Frederick Herring.*

Artist unknown. Horse with Extra-Long Mane and Tail. *c. 1895. Oil, 18 × 24".*
New York State Historical Association, Cooperstown

The longest manes and tails are usually found on percherons, incredibly strong,
patient, faithful draft horses. Though prized for its ability to pull ploughs
and to drag mounted artillery through mud, the percheron's excess horsehair
must at times be a considerable handicap.

J. W. McKisson. Prince Imperial. c. 1870–80. Lithograph, 12¼ × 13¾". Smithsonian Institution, Washington, D.C. Harry T. Peters "America on Stone" Lithography Collection

According to the lengthy text accompanying this print, Prince Imperial had the "finest, heaviest and longest mane of any horse in the World, being 8 feet 10½ inches in length." One of the "best Norman Horses ever imported," he won three hundred dollars at the Springfield (Ohio) State Fair in 1870.

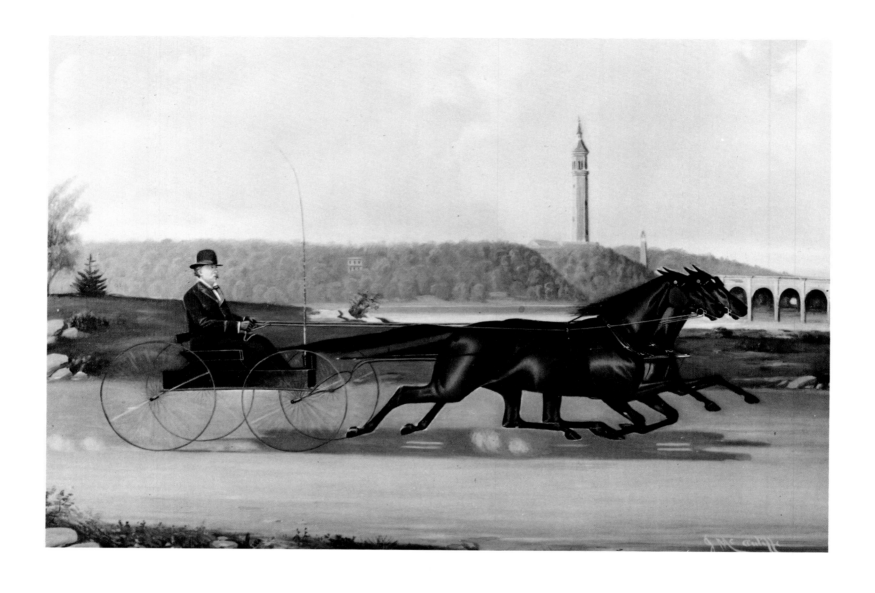

John McAuliffe. Colonel Jim Douglas and His Trotting Mares. *c. 1870. Oil on paper,*
14 × 21". Butler Institute of American Art, Youngstown, Ohio

The colonel and his trotting mares are models of proper racetrack form as they
run through their paces along the banks of the Croton Reservoir in New York.

160

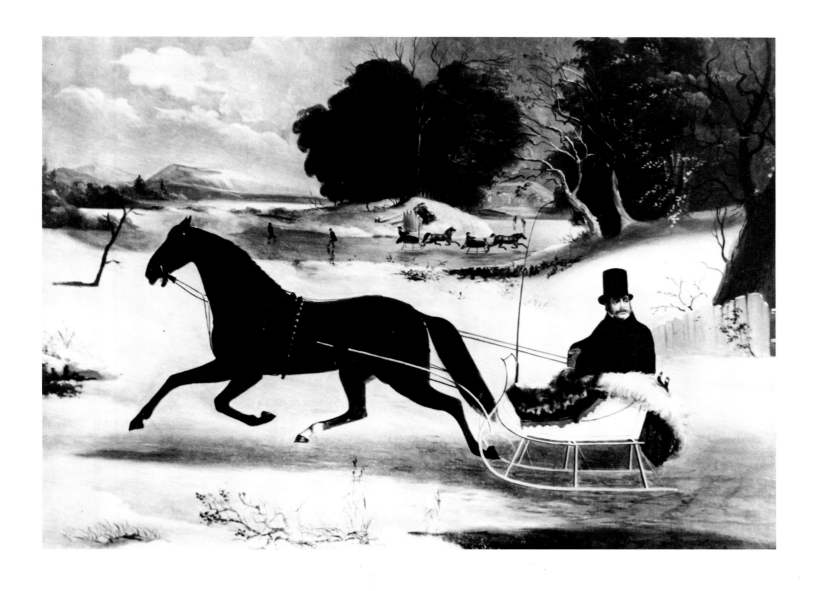

William Van Zandt. Captain H. L. Shields and His Trotter Elsie Colgate. *c. 1868. Oil, 23⅞ × 33⅞". Bennington Museum, Bennington, Vt.*

Captain H. L. Shields, who was a West Point crony of Civil War generals— George McClellan (Union) and both George Pickett and Thomas "Stonewall" Jackson (Confederate)—once challenged Jefferson Davis to a duel but was jailed briefly in 1861 on suspicion of sympathizing with the South. After his army days, he pursued the "good life" as lived in Bennington and Troy, and his handsome rigs and trotters (this one named for a former girlfriend) were a source of pride both to himself and to his neighbors.

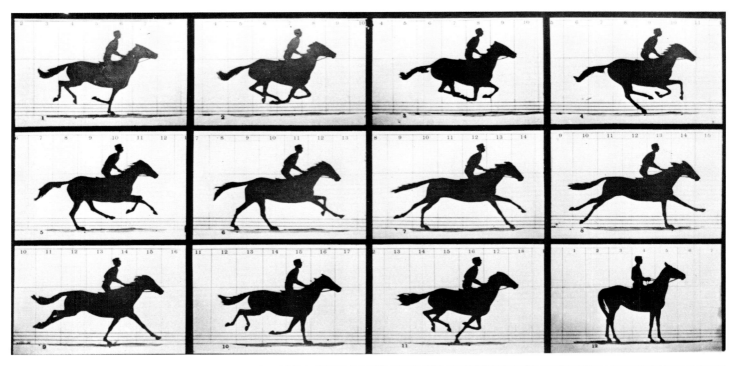

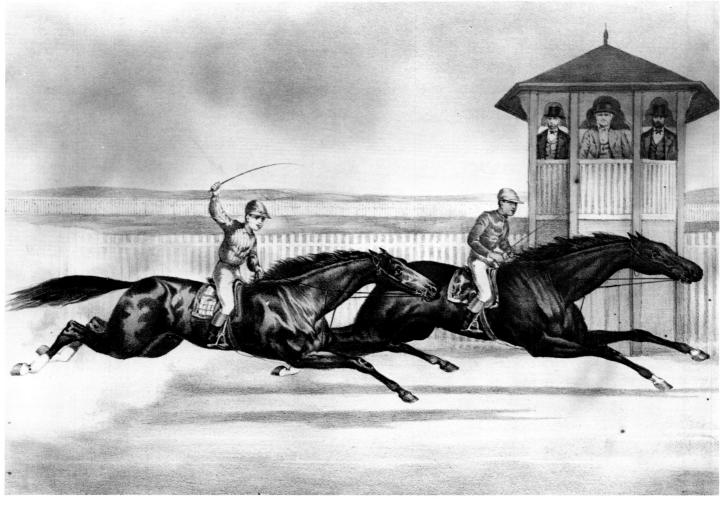

Eadweard Muybridge. The Horse in Motion. *1878. Electrophotograph. George Eastman House, Rochester, N.Y.*

Leland Stanford's mare Sallie Gardner was photographed by a battery of cameras positioned at regular intervals along the Palo Alto racecourse and timed to go off automatically one twenty-fifth of a second apart. The cameras, using a shutter speed of less than two thousandths of a second, made history by establishing a permanent and irrefutable record of the secrets of equine locomotion.

track? Every artist had his own solution to the problem. It was not until the camera was brought into the debate in 1878 that anyone really knew the answers to these questions. And when science finally unlocked the secrets, artist, photographer, and horse owner alike were profoundly surprised.

In the very early years of photography there was little protest from the animal painters. Artists felt quite secure in their belief that art was morally superior to other human endeavors—so much so that no mere mechanical gadget could possibly pose a threat. The point was made that black-and-white impressions on a plate were no substitute for the broad spectrum available to the artist.

In the 1870s that certitude began to weaken. Unquestionably the market for painted human portraits had dropped precariously. Some artists, like Erastus Salisbury Field, had begun to rely on the camera as early as the 1850s for the preliminary steps in their studio work. Photographers had supplanted the indispensable artists traveling with government expeditions, and the dry plate was replacing the engraver's plate in many publications.

Inevitably photography entered the field of animal painting, and when it did, it involved a fascinating cast of characters and stimulated a far-reaching controversy. The cast comprised Leland Stanford (former governor of California and noted railroad builder), his trotting mare Sallie Gardner, and, complete with beard and alias (in his native England he was Edward Muggeridge), a gifted eccentric calling himself Eadweard Muybridge. That a California racetrack was the locus of his research has made the Muybridge legend even more tantalizing. According to the story, the project resulted from a wager between Leland Stanford and a fellow horse fancier in 1872. Stanford maintained that at a certain point in a horse's stride all four hooves are simultaneously in the air. Stanford's fellow bettor was willing to put up a substantial sum (the story varies from five thousand to twenty-five thousand dollars) to have Stanford prove it.

Colorful legend notwithstanding, Stanford must have spent thousands on the experiment. Muybridge set up as many as twenty-four cameras at regular intervals along the track. Then Stanford's trotter Sallie Gardner flew down the track as the carefully timed shutters clicked. Muybridge's research—greatly expanded by a University of Pennsylvania grant, which Thomas Eakins was instrumental in securing—was later continued at length, ultimately including the study of camels lumbering, ostriches cantering, mules bucking, naked men running (including Muybridge himself), and whatever it is that counts for motion among three-toed sloths. All told Muybridge took more than

Artist unknown. Harry Bassett and Longfellow. *1879. Lithograph, 8½ × 12". Smithsonian Institution, Washington, D.C. Harry T. Peters "America on Stone" Lithography Collection*

Eadweard Muybridge's photographic discoveries were not accepted overnight. Harry Bassett and his competitor, Longfellow, continue to sail through the air hobbyhorse fashion in defiance of the laws of animal locomotion.

thirty-five thousand dry-plate photographs of animal locomotion. In the process he devised a way to project the pictures onto a screen so that they appeared to move. For this Muybridge belongs to the small fraternity of inventors of the motion picture. Incidentally, if there actually was a wager, Stanford won it.

In spite of Muybridge's discoveries, most artists continued to let the hooves of their racehorses fall where they might. The human eye, after all, is not a camera. It sees what the mind wills it to see, and nineteenth-century aficionados of the racetrack preferred steeds that looked like flying hobbyhorses. They wanted speed and they wanted action, and the artists obliged.

If the racetrack artists knowingly ignored the findings of science, so too did the political cartoonists of the time. The animal kingdom had ventured into American newspapers as early as 1754, when Benjamin Franklin published his picture of a dismembered serpent in the *Pennsylvania Gazette* over the caption "Join, or Die." In the journalism of the 1830s and 1840s animals came into their own as metaphors for human beings—particularly those whose public malfeasances and private missteps could most readily be alluded to in barnyard terms.

A vote for the most effective political animals in American art would decidedly favor the Tammany Hall tigers of Thomas Nast. Widely circulated in *Harper's Weekly*, they skulked and smirked and gorged themselves on Republican lamb week after week from the 1860s to the 1880s. It is remarkable that New York's Democratic machine managed to survive for so long Nast's relentless and devastating caricatures of Tammany and its policy of "honest graft."

SPIRIT OF THE TIMES.

Artist unknown. Spirit of the Times. 1836. Lithograph, $11\frac{1}{8} \times 19\frac{1}{2}''$. Smithsonian Institution, Washington, D.C. Harry T. Peters "America on Stone" Lithography Collection

When Andrew Jackson took office as seventh president of the United States, the country had been waiting twenty years for settlement of claims against France for an alleged illegal seizure of American ships. Jackson (the eagle), not famous for his diplomacy, pressed the claims with vehemence. Louis Philippe (the cock) resisted with equal vehemence, and into the impasse waded Britain (John Bull) to attempt a compromise.

Thomas Nast. Tammany Tiger. c. 1870. Ink, $14\frac{1}{2} \times 21\frac{1}{2}$ (sight). Addison Gallery of American Art, Phillips Academy, Andover, Mass.

Despite a succession of scandals, Tammany Hall kept its hold on New York's Democratic party until 1895. During almost a century of power the organization had acted with the brazenness of a tiger, as the renowned cartoonist Thomas Nast took pleasure in pointing out. In this informal sketch, which was not intended for publication, the tiger of Tammany Hall seems to be enjoying an unrestrained belly laugh at the public expense. As George Washington Plunkitt, one of Boss Tweed's faithful retainers, liked to brag, "I seen my opportunities and I took 'em."

The aesthetes of late nineteenth century America raised no voice in protest over the cartoonists' use of animals in human roles. But when William Holbrook Beard, a respected member of the National Academy of Design, turned from portraiture to the painting of animal anecdote, he was trounced by the press for lowering his standards. In 1864 he exhibited a suggestive canvas entitled *The Jealous Rabbit* at a Brooklyn artists' reception. The influential art journal *New Path* was outraged. "There may be technical merits in the work in question," grumbled a critic in the February issue, "but they are of no avail to cover sensuality and vulgarity. . . . The public have so much confidence in the artists that they accept anything that is shown to them, and do not stop to think about it, so long as it is the work of a man of reputation."

Nevertheless, over the years Beard acquired a large and devoted following. Vulgar as his satire may have been, the general public thoroughly enjoyed laughing at themselves as they were indirectly portrayed in such works as *Bears on a Bender, The Bears' Picnic,* and *The Bear Dance.* In addition to his self-indulgent bears, Beard's work included more conventional subject matter. G. W. Sheldon, a critic who visited the artist's studio in the late 1870s, was surprised at the breadth of his interests. Sheldon gives an interesting summary of Beard's subjects in *American Painters* (New York, 1879). "He paints woodlands, meadows, and rivers; monkeys, bears, sheep, deer, and rabbits; men, women, and sunburned boys and girls; parlors, kitchens, and bar-rooms; marriages, picnics, and the final destruction of the universe."

Beard's broad sense of humor concealed a genuine understanding of wildlife. In 1893 in his book entitled *Action in Art* he included a definitive and perfectly serious study of squirrels' tail gestures as a form of communication. Moreover, Beard was the only nineteenth-century animal specialist who took an intelligent interest in the animal locomotion studies of Muybridge. "The question is not," he noted in his book, "How does Nature do it? but, How does she *seem* to do it? The first is the question of science, the latter that of art."

The popularity of Beard's storytelling art and the fact that it was regularly exhibited at the prestigious National Academy lent a new respectability to animal genre. In the closing decades of the nineteenth century authors and illustrators also entered the field. It appeared that adults, as well as children, loved a good animal tale, with or without human characters—preferably without, as the success of Joel Chandler Harris's "Uncle Remus" stories throughout the 1880s, 1890s, and early 1900s

John Childs. This Is the House That Jack Built. 1840. Lithograph, 20 × 13⅜".
Smithsonian Institution, Washington, D.C. Harry T. Peters "America on Stone" Lithography
Collection

The failures of thousands of banks and businesses in the late 1830s reached a
climax in 1839 with the collapse of the Bank of the United States. The debacle
was blamed directly on the fiscal policies of Andrew Jackson and his crony
Amos Kendall, whose idea of a sound national treasury turned out to be nothing
but a pipe dream.

William Holbrook Beard. The Bear and the Foxes. *1865. Oil, 14 × 22″. Courtesy
Dana E. Tillou, Buffalo, N.Y.*

*Carried away by the story he is telling and by his audience's rapt and
flattering attention, the bear drones on, unaware that at that very moment the
foxes' accomplices are filching his dinner. William Holbrook Beard, an
astute student of wildlife, was also a sharp observer of human foibles.*

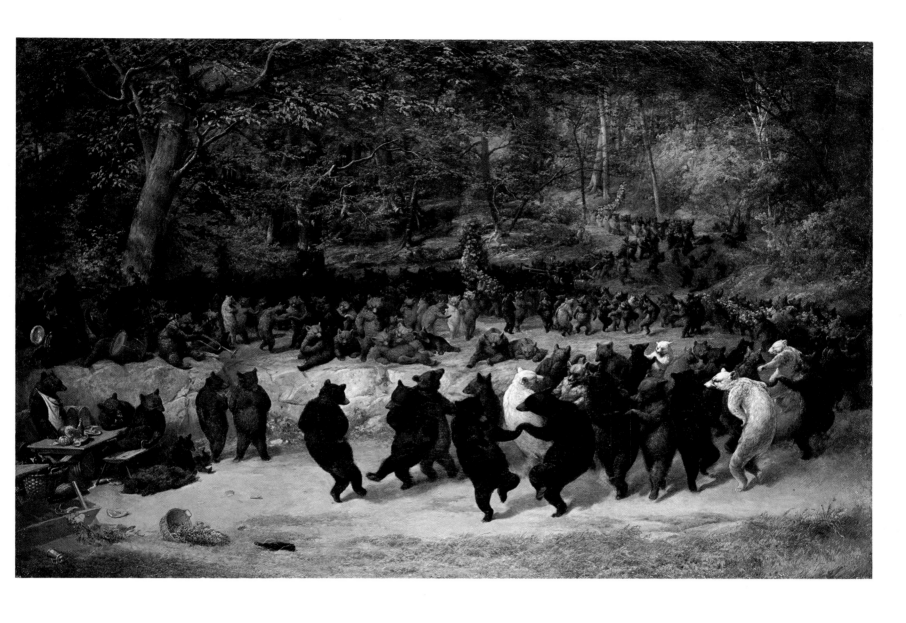

William Holbrook Beard. The Bear Dance, *or* Wall Street Jubilee, *or* The Bears of
Wall Street Celebrating a Drop in the Market. *c. 1885. Oil, 40 × 61" . New-York
Historical Society*

*William Holbrook Beard felt that, unlike other animals, "bears have a smile
that is vaguely a human expression, and is a real indication of humor or fun;
they are great jokers." This nineteenth-century visual joke—explained by any
of the painting's three titles—is that a coup by the bears has been successful and
the market prices of stocks have plummeted to a satisfactory bargain level.*

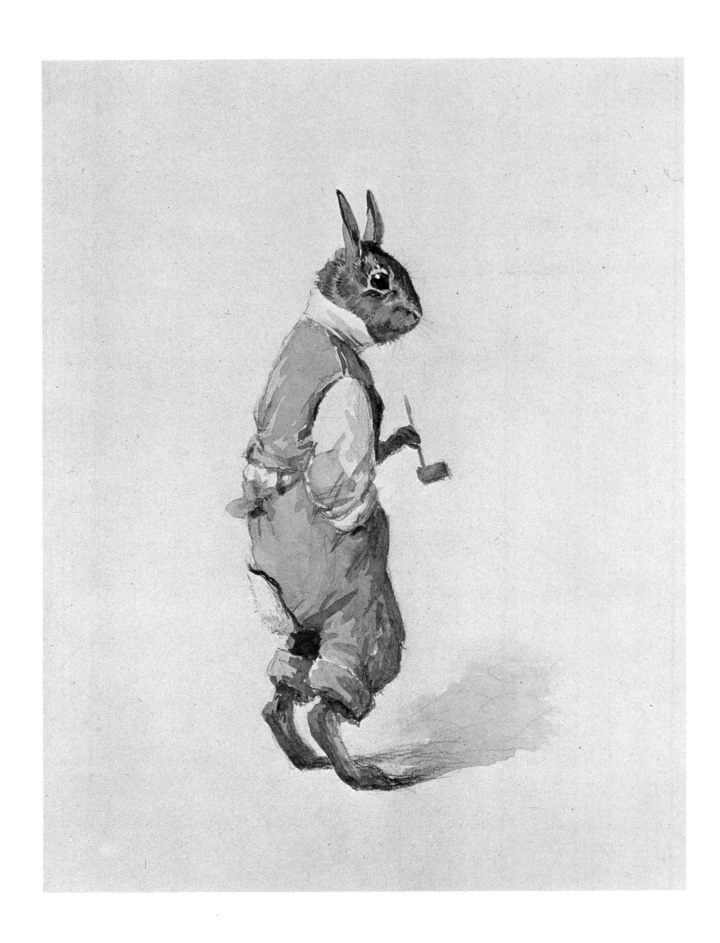

170

clearly demonstrated. Animal storybooks continued to be great favorites in the twentieth century. Harrison Cady's illustrations for Thornton W. Burgess's whimsical animal escapades immortalized the exploits of Peter Rabbit and Reddy Fox for several generations of American children. Jack London's *Call of the Wild* (1903) was one of the best-selling adventure stories in the history of American publishing. This unparalleled narrative of cruelty and courage was decorated—rather than illustrated—in early editions with Charles Livingston Bull's dreamlike paintings in the art nouveau manner.

William Randolph Hearst, never one to pass up a chance to cash in on a popular trend, unveiled in the Sunday edition of the New York *Journal*—on December 12, 1897—the first modern animal comic strip, *Little Tiger*, which had nothing to do with politics, corruption, or daily care; James Swinnerton, its creator, was the first to use talking animals in a humorous comic strip. Hearst's uncanny sense of what the public wanted not only boosted the sales of the *Journal*, it also precipitated a massive invasion of the newspapers by comic-strip creatures. In 1913 George Herriman's *Krazy Kat* was syndicated nationally by King Features. Herriman, a far more talented cartoonist than Swinnerton, was able—at least on Sundays—to bring a little cheer into the grim lives of Woodrow Wilson and his beleaguered cabinet. In the years following World War I, animal comics proliferated in all the dailies (except, of course, the *New York Times* and the *Wall Street Journal*), culminating in the sophisticated denizens of Okefenokee—Pogo and his circle—and America's favorite droopy-eared beagle, Snoopy. By the early 1960s animal comics had become such an integral part of American culture that pop artists brought them into the fashionable Madison Avenue galleries, greatly magnified in both size and price, and offered them as art objects for the serious consideration of connoisseurs.

That animals could be commercially profitable was well understood by the owners of the early menageries that traversed the country from the early 1800s, eventually to be absorbed into full-fledged circuses. In fact the first billboards to mar the American landscape carried advertisements for these crowd-pleasing entertainments. It might be argued in their favor that the monetary proceeds from the flamboyant menagerie and circus posters were used, at least in part, for the care and feeding of the animals. Yet eventually animals ended up pushing merchandise for which they had no use whatsoever: shoe soles, Pullman accommodations, laundry soaps, phonograph records, and cigarettes, to

Arthur Burdett Frost. Br'er Rabbit. c. 1890. Watercolor and pencil, 14¼ × 10¾".
Sterling and Francine Clark Art Institute, Williamstown, Mass.

Br'er Rabbit, the cleverest cottontail in American literature, dressed like a
cracker, but much of his legendary personality can be traced to a distinguished
background in African folklore. Even though Arthur Burdett Frost studied with
Thomas Eakins, he is best remembered for his illustrations of Joel Chandler
Harris's "Uncle Remus" books and other children's stories rather than for his
oil paintings. Frost did not illustrate the first edition of Harris's Uncle
Remus, *but his illustrations are the ones cherished today.*

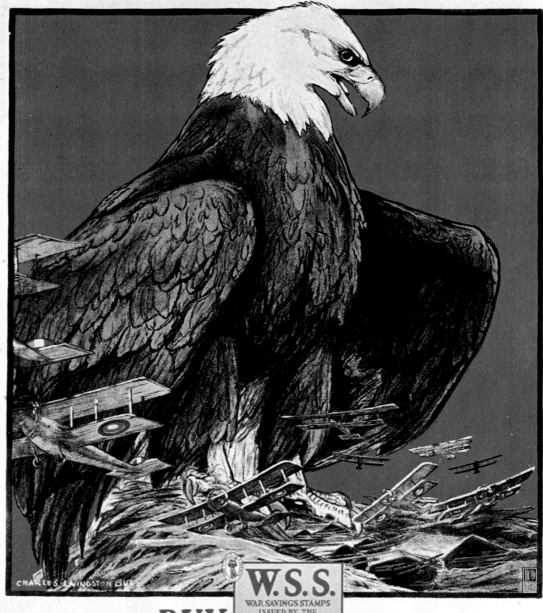

Charles Livingston Bull. Keep Him Free. *c. 1918. Lithograph, 21 × 18¼″. New-York Historical Society*

Charles Livingston Bull's carefully balanced, understated illustrations were graceful ornaments in many animal storybooks at the turn of the century, including Jack London's Call of the Wild. *When the U.S. Treasury Department launched its War Savings Stamps drive in 1917, Bull was recruited as a skilled propagandist for the Allies.*

Harrison Cady. Mr. Possum's Portrait. *1916. Ink and watercolor, $14\frac{1}{2} \times 18''$. New Britain Museum of American Art, New Britain, Conn. Harriet R. Stanley Fund*

Although it is not easy to capture on canvas the idiosyncrasies of shape, motion, and expression in the animal kingdom, this freckled artist has hit upon an ingenious solution to a unique technical problem. Harrison Cady illustrated Thornton W. Burgess's popular Bedtime Story Series. *Later he created the long-lived comic strip* Peter Rabbit.

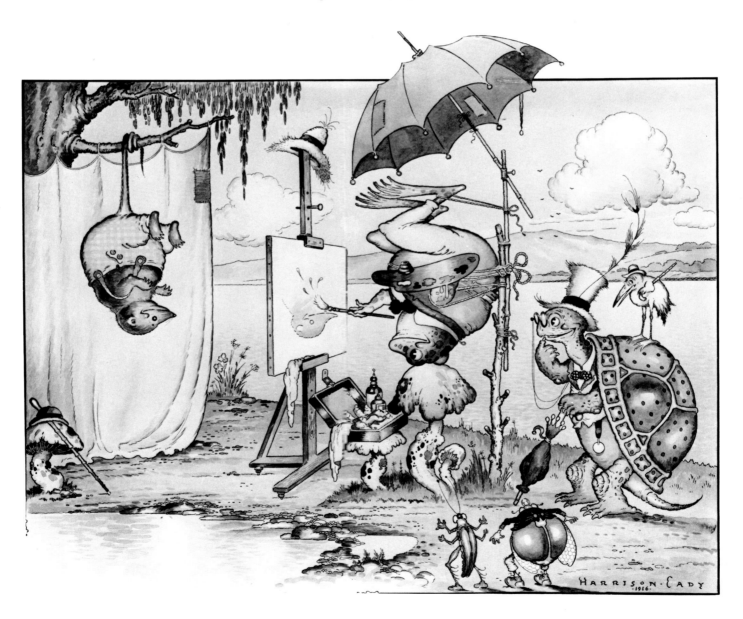

Before he became a full-time writer of nonsense rhymes and pseudo-serious fiction, Gellett Burgess had worked as a draftsman for the Southern Pacific Railway and had taught mechanical drawing. He tried manfully to disassociate himself from his maddeningly memorable jingle about the purple cow, but he was reminded of it wherever he went. Almost every American past middle age can still recite Burgess's wry sequel:

<div style="text-align:center">

Ah, yes, I wrote the "Purple Cow"—
I'm Sorry, now, I wrote it;
But I can tell you Anyhow
I'll kill you if you Quote it!

</div>

Charles M. Schultz. Peanuts. 1969. Newspaper comic strip. © *1969 by United Feature Syndicate, Inc., New York*

The beagle and the common man seem to understand each other in a special way. In the hearts of millions of space-age newspaper readers Snoopy's 1917-vintage daydreams evoke a delectable combination of empathy and nostalgia.

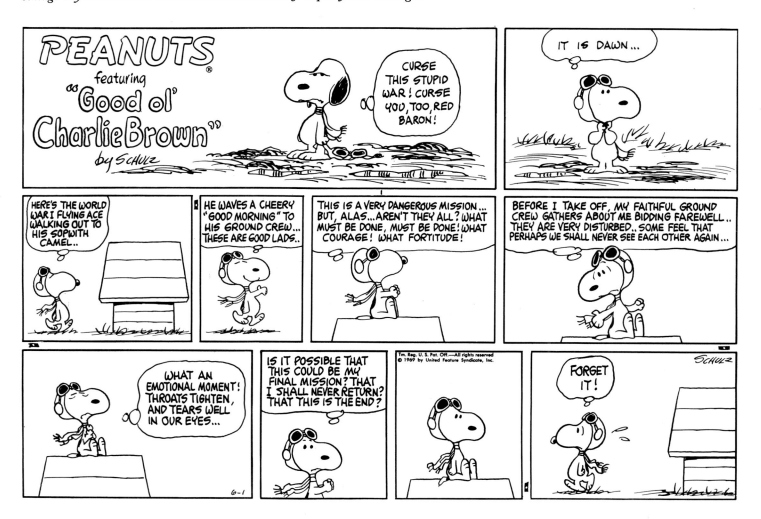

I never saw a Purple Cow

I never hope to see one

But I can tell you anyhow

I'd rather see, than be one!

Gellett Burgess. The Purple Cow. 1894. Watercolor and ink, 10 × 7⅝″. Manuscript in the Huntington Library, San Marino, Calif.

Francis Barraud. His Master's Voice. c. 1898. Advertising trademark. Used with permission of RCA Corporation, New York. Photograph courtesy Culver Pictures, Inc., New York

Francis Barraud, an English artist, painted the original His Master's Voice *in the late 1890s as a sort of mourning piece in memory of his brother. In 1901 the Victor Talking Machine Company acquired the rights to use Barraud's portrait of his brother's dog, Nipper, as its trademark, and ever since April 25, 1903, when he first appeared in a* Saturday Evening Post *advertisement, Nipper has doggedly held his famous pose. By 1909 an ad in* Munsey's Magazine *was boasting, "The Victor dog stands for all that is newest in music. It is on the horn and cabinet of every* Victor, *on every* Victrola, *and on every* Victor *record."*

name only a few of the indignities foisted upon them in the name of free enterprise. The history of advertising is studded with fabulous success stories of promotions based on the public's affection for animals. It has been alleged that after Standard Oil launched its campaign to "Put a Tiger in Your Tank" in the 1960s, Esso and its affiliates nearly doubled their share of the gasoline market.

It goes without saying that the animals that earned the most money in the annals of American art were those of Walter Elias Disney and his small army of artists and animators. Working laboriously, frame by frame, they introduced a whole new range of possibilities to the film industry, they made Saturday afternoons the high point of every child's week, and they profoundly influenced the way at least two generations of urbanized Americans perceived the animal kingdom.

Mickey and Minnie Mouse, Donald and Daisy Duck, Bambi the deer, Flower the skunk, Thumper the rabbit, Goofy the mutt, Pluto the hound, and all the rest immediately became enshrined in the nation's folklore, and even today, despite some inroads by distant competitors like Bugs Bunny and Porky Pig and the Pink Panther, they remain indelible in the memories of almost every American born in the 1930s and 1940s.

The unspoken message of Disney's animated animals was reminiscent of William Holbrook Beard's. The message was twofold: "We animals are absolutely harmless and may even be a bit ridiculous sometimes, *but* we are just as smart and just as vulnerable as you humans." It is no longer fashionable to ascribe human emotions to animals, but this sentiment, instilled in childhood, may have prompted in part the efforts of today's adults to save what remains of the American wilderness.

Fred Achert. Two-Horse Act. *1871. Lithograph, 82 × 76". Courtesy Culver Pictures, Inc., New York*

Advertising posters for the circus provided income for many artists who might not otherwise have found a livelihood. Fred Achert, who lived in the Midwest, designed this poster depicting the type of daring bareback act that was universally popular a century ago.

Charles Huestis, et al. The Association's Celebrated and Extensive Menagerie and Aviary from Their Zoological Institute in the City of New-York. *c. 1835. Woodcut, $111\frac{1}{2} × 76\frac{5}{8}$". American Antiquarian Society, Worcester, Mass.*

The first American zoological park was opened in Philadelphia in 1874. In the years before the opening the public was quite content with traveling menageries, which featured exotic, freakish, and legendary animals imported at great cost for the raucous amusement of a nation that took its own marvelous creatures for granted. In 1835 it cost twenty-five cents to watch the keeper defy death to enter the cages.

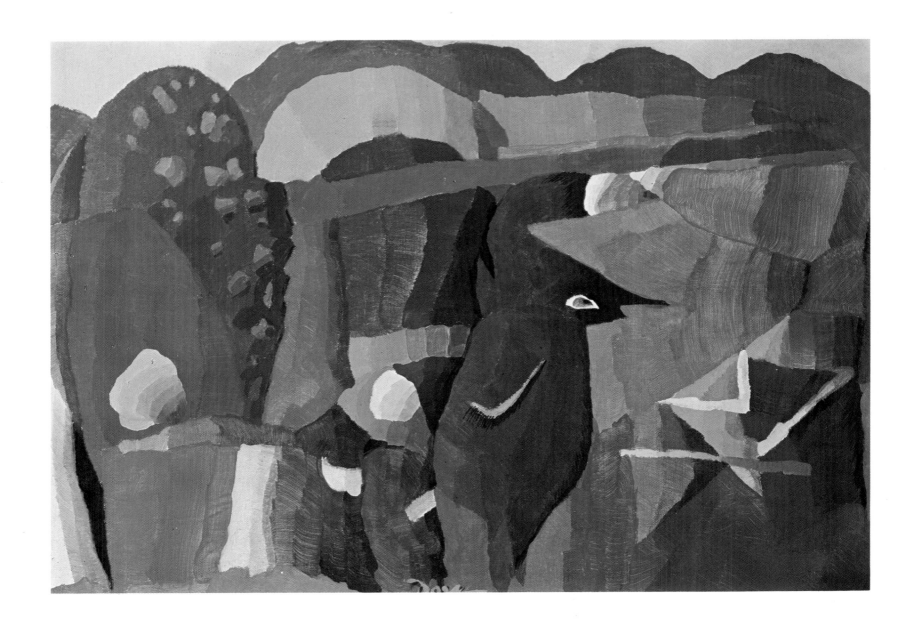

Arthur G. Dove. Red, Olive, and Yellow. *1941. Wax emulsion on canvas, 15 × 21".*
Phillips Collection, Washington, D.C.

A crested woodpecker plays hide-and-seek among Arthur Dove's distinctive
areas of broken color and ambiguous shapes. Like Demuth and Sheeler, Dove
traveled to Paris as a young man and returned with a distinctly foreign artistic
vocabulary, which in Dove's case remained with him until his death in 1946.

In the Asphalt Jungle

There can be no doubt that the nineteenth century was a prosperous era for animals in American art. In the exhibition halls it was a romantic century in which the presence of wildlife lent a sense of solitude and majesty to landscape painting. It was also a scientific century during which America diligently and enthusiastically took stock of its superlative flora and fauna. The tradition of folk art, with its irrepressible devotion to the animal kingdom, reached its height in this century, as did the art of animal portraiture.

It was also a century of wholesale industrialization: factories, mines, and railroads proliferated across the continent, and the first skyscrapers marked America's inexorable pursuit of progress. The West was swiftly being won, and in the process many of the country's native beasts were being sacrificed or forced to find new homes in an unnatural environment. Artistic fashions were changing rapidly and the coming age did not augur well for animal painting. By the turn of the century it must have seemed that the howling wilderness had finally been subdued, both literally and artistically. Yet the dream of a peaceable kingdom too had been shouldered aside by the juggernaut of industrial progress, whose ultimate goal was not moral but material.

Those great foursquare houses, the decoration of which had created such a steady demand for cow and horse pictures, now required refurbishing. Activity and aggressiveness—or the strenuous life (a dream of the industrial age which few but Theodore Roosevelt carried to its limit)—led to the collecting of hunting trophies on a grand scale. Roosevelt's own Long Island country house, Sagamore Hill, was crammed to the rafters with stuffed elk heads, bear rugs, antlers, and innumerable glass-eyed specimens of large and small game of every description; Roosevelt, whose name is now synonymous with conservation, seems in retrospect to have been particularly ruthless in his pursuit of game. These dead animals expressed the mood of the times: far from posing a menace, America's howling wilderness had become the playing field for upper-middle-class sportsmen. These were the same men who had bought or commissioned animal portraits in the past, and the market for such work fell off sharply as trophies took up more and more wall space in their mansions. Paradoxically the turn of the century also marked the beginnings of the first really successful organized attempts at conservation, which are now popularly credited to Theodore Roosevelt himself.

Along with the abrupt changes in interior decoration at the turn of the century, there were significant new trends in the mainstream of American art which ultimately had an adverse effect on the painting of animals. The American public was finally shedding its provincialism. The thriving cosmopolitan magazines brought them in touch with the art—at least the official art—of Europe. Museums were being built throughout the nation and now the work of the masters could be studied firsthand. Well-illustrated volumes of art history and criticism, phrased in high-toned but intelligible language, were readily available in the bookstores. Artists were restless and eager to expand their

George Luks. Lion, Bronx Zoo. *1904. Pencil, 7 × 10″. Addison Gallery of American Art, Phillips Academy, Andover, Mass.*

George Luks, like other artists of the Ash Can School, often went to the zoo to study the human beings. Once in a while he sketched the animals as well. This vigorous example of Luks's draftsmanship was exhibited in the 1913 Armory Show in New York.

Charles Henry Demuth. Fish Series Number 3. *1917. Watercolor, 8 × 9⅞″. Metropolitan Museum of Art, New York. Alfred Stieglitz Collection*

Fish, flesh, and fowl in the twentieth century became increasingly subordinate to the artist's technical preoccupations. In 1917 Charles Demuth was just beginning to explore the medium of watercolor and chose for an étude a particularly appropriate subject, an aquarium. The content of Demuth's small fish watercolors was not so much the fish but the medium itself.

artistic as well as geographical horizons. Transatlantic crossings on fast, comfortable modern steamers came to be a normal part of the American painter's year. No longer was Europe the adventure of a lifetime as it had been for previous generations of artists, and for many painters the ocean voyage turned out to be a one-way trip. Despite the excitement of a young country's coming of age—perhaps for some *because* of this exuberance—American intellectuals, writers, and artists yearned to get away from the philistinism and complacency of a nation bent single-mindedly on economic and industrial progress.

The bold artistic innovations in Europe had an electrifying effect on young American visitors, who were witnessing these developments in the making. The artists reveled in the atmosphere of ferment and freedom and they returned home brimming with new ideas. Those who did not, or could not, stay and paint bought the works of the new masters, brought them across the ocean, and unveiled them to an astonished public at home. The throngs who attended the 1913 Armory Show in New York—and those who merely heard of it—were compelled to pay attention to modern art, even if they did not immediately like it; the new artistic explorations of the twentieth century made indifference impossible.

The National Academy, which for nearly a century had dominated American art, was now viewed as the embodiment of apathy, the enemy of change, and the champion of the obsolete. Before the Armory Show brought matters to a head, efforts had been made to loosen the Academy's stranglehold: as early as 1857 some of the younger artists had joined forces in an attempt to make the Academy more generous toward the medium of watercolor. Rebuffed, they formed their own group in 1866, the American Watercolor Society. Gradually the Academy became even more rigid where subject matter was concerned. Out of frustration groups like The Eight seceded from the art establishment altogether during the opening decade of the twentieth century. This radical group—which comprised Robert Henri, John Sloan, William Glackens, Everett Shinn, George Luks, Ernest Lawson, Arthur B. Davies, and Maurice Prendergast—first exhibited their nonacademic scenes of lowerclass city life at the privately owned Macbeth Gallery in 1908, and in terms of attendance this showing was more successful than most contemporary exhibitions at the National Academy.

After the Armory Show the American art world plunged enthusiastically, if somewhat belatedly, into the heady currents of impressionism, fauvism, cubism, surrealism, dada, and all the other European movements that fascinated the generation of the twenties and thirties. Some of these movements, particularly impressionism, had long ceased to be controversial in Europe, but they could still be subjects for vigorous debate in the United States. As styles and "isms" proliferated, subject matter for a time became almost irrelevant. During this period of experimentation and ferment a concrete image or idea could be conveniently used as a point of departure, but it was the manner of approach and not the subject itself that preoccupied most artists.

Many animals did find their way into the art of this period, but it is interesting to note that they were the same beasts that had been in man's service for centuries—domestic animals such as the dog and cat, the horse, the cow, the pig—serving the artist as self-effacingly as ever. In art no longer was the majestic bison evident, or the flighty pronghorn, the sure-footed wapiti, the sinister timber wolf. These creatures were virtually extinct as subjects for painting—as indeed they were in the American ecology.

Among the artists who continued to work within the figurative tradition, the catchword during the 1930s was regionalism; in an effort to break the monopoly of New York and Paris the regionalists took an inventory of their own neighborhoods in a conscious effort to put on canvas a slice-of-life view

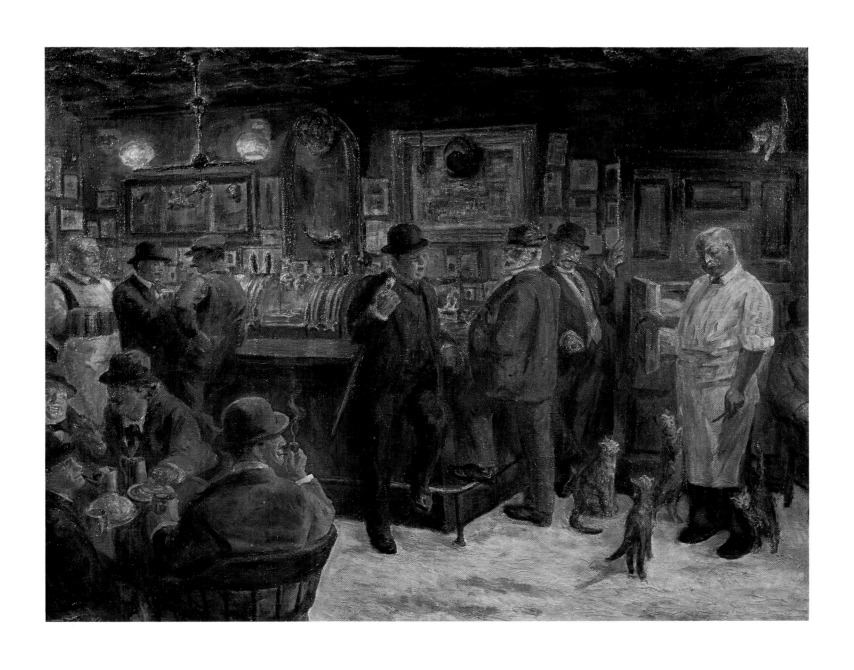

John Sloan. McSorley's Cats. 1928–29. Oil, 35 × 45″. John Sloan Trust, New York

McSorley's Old Ale House on East Seventh Street in New York City has dispensed comfort, conviviality, raw onions, and first-class brew to many generations of grateful patrons since old John McSorley went into business in 1854. Habitués could depend on the excellence of the ale, the absence of women, and the evening ritual of feeding the dozen or more resident cats. John Sloan was devoted to this refuge, and, Prohibition notwithstanding, he painted it no fewer than five times between 1912 and 1930.

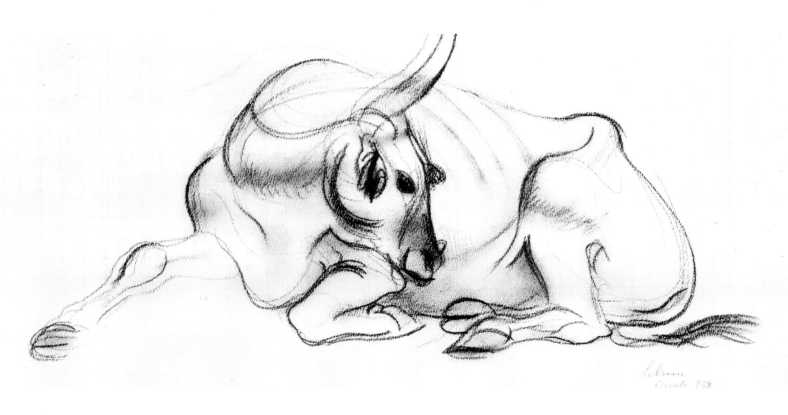

Rico Lebrun. Orvietan Ox. 1932. Charcoal on graph paper, 10¾ × 15¾". Collection Agnes Mongan, Cambridge, Mass.

Few animals are as satisfyingly and abstractly geometrical as the ox. For over four thousand years it has hauled man's burdens, provided his food, and given him an artistic symbol of almost euclidean proportions. Rico Lebrun appropriately chose to sketch this handsome creature on ruled paper.

of the country, from the Maine wharves to the Arizona deserts. If animals wandered into these pictures it was usually with a casual air, but sometimes a roar from the howling wilderness could be heard, as in John Steuart Curry's midwestern *Hogs Killing Rattlesnake.*

During the depths of the Depression all Americans became in a sense wanderers in the wilderness: the familiar pathways were fraught with peril—both economic and social—and there were no new signposts to point the way to deliverance. Artists were frustrated and hungry, and although they knew that the nation's economic paralysis was of man's own doing and not the strategem of some untamed natural power, they were among those most cruelly affected by it. The imposition of the graduated income tax in 1918 had already withdrawn from circulation a significant part of the American artist's income, and art patronage was on the verge of ceasing entirely as the moneyed classes scrambled to save the vestiges of their wealth. For the artists there would soon be respite from other quarters. In May 1933 Franklin Roosevelt received a letter from the painter George Biddle—

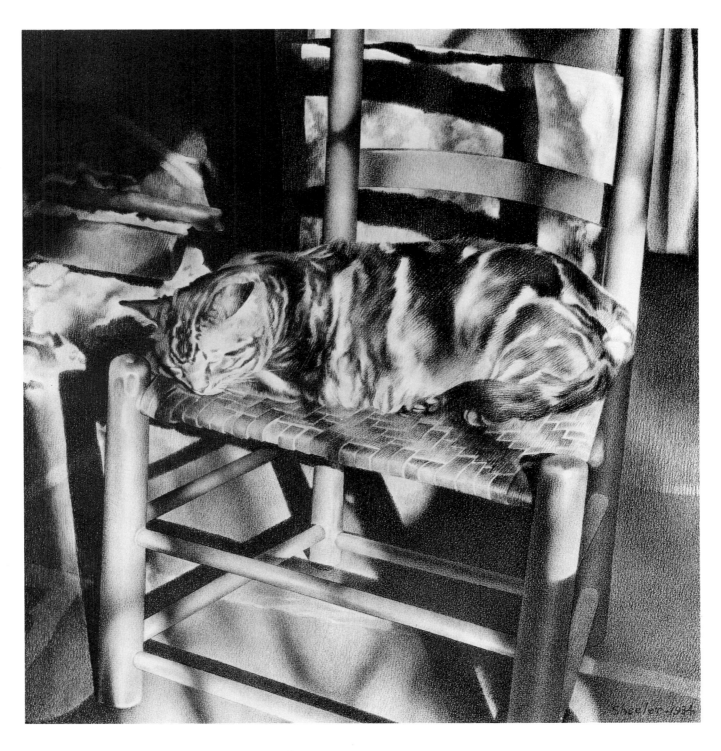

Charles Sheeler. Feline Felicity. *1934. Conte crayon, 22 × 18″. Fogg Art Museum, Harvard University, Cambridge, Mass. Louise E. Bettens Fund Purchase*

That quintessential domestic pet, the tabby cat, has a lineage that can be traced to the sacred cats of Egypt as well as to the dreaded European wildcat. This tranquil scene is not a photograph: besides being a superlative draftsman, Sheeler was also a master photographer, and in some of his works the two media are difficult to tell apart.

Thomas Hart Benton. Cattle Loading, West Texas. *1930. Oil and tempera on canvas board, 18 × 38″. Addison Gallery of American Art, Phillips Academy, Andover, Mass.*

The paintings and murals of Thomas Hart Benton, a vociferous critic of the snobbish and sissified East, celebrated the unsung virtues of the rural Midwest and South. In this painting, uncluttered by his customary rhetoric, Benton has combined all the icons of Texas cattle country in a single composition: the longhorn, the cowboy, the windmill, the freight train, the grain elevator, the tumbleweed, and the ever-present dust.

John Steuart Curry. Hogs Killing Rattlesnake. *1930. Oil, 30⅜ × 38⅜″. Art Institute of Chicago*

Painters of the American scene searched the heartland of America for subjects that would set their work apart from that of Parisian and New York artists. In this tempestuous painting Kansas-born John Steuart Curry captured a midwestern drama of enormous power.

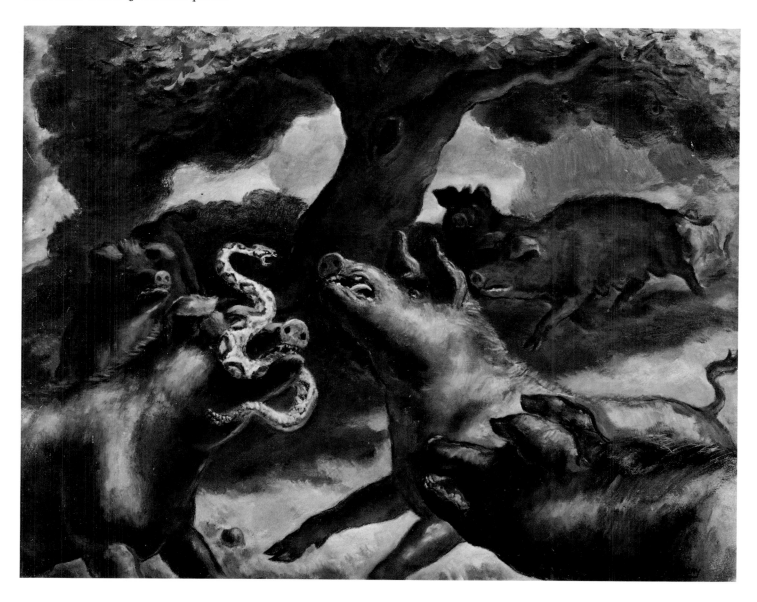

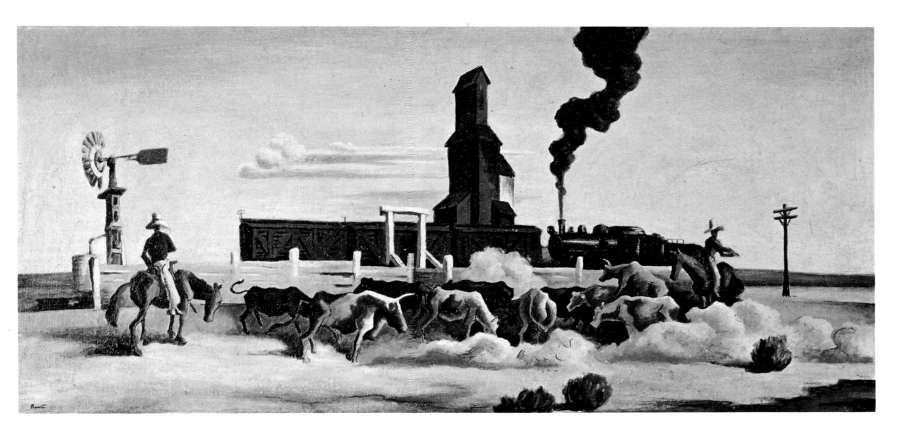

an old Groton schoolmate—which would dramatically involve the federal government in a new role. In effect Biddle was advocating that government assume sweeping obligations as a patron of the arts: "The younger artists of America are conscious as they never have been of the social revolution that our country and civilization are going through; and they would be very eager to express these ideals in a permanent art form if they were given the government's co-operation."

By the end of that year the Public Works of Art Project was in full swing. Under the supervision of the Treasury Department, artists around the country were commissioned to adorn the walls of post offices and other federal buildings with murals designed to inspire the nation's pride and confidence. Thus the state was responsible for an idealized menagerie of New Deal animals: heavily muscled draft horses plowing endless fertile fields, placid cows wandering among golden stalks of heartland corn, Eskimo huskies delivering U.S. mail to the outposts, plump chickens gathering eagerly about the skirts of happy farm women. The mighty American bison was evident once again, towering above the limitless horizon.

This brawny and frankly chauvinistic public art is the art most often associated with the Depression era, even though much of it is now warehoused or destroyed. In the private sector painters like Charles Sheeler kept alive the intimate relationships between artist and animal; *Feline Felicity* is so modest and domestic a scene that it almost belies the stark hard-edged depictions of gleaming machinery and functional architecture for which he is famous.

Alexander Calder's cheerfully stylized circus animals were also created during the nadir of the Depression, as were a host of other beasts apparently untouched by the hard times that brought considerable suffering to the artists themselves. While a deadly cloud of dust devastated the Great Plains, smothering humans and animals impartially, the animals of fantasy endured and prospered.

John B. Flannagan. Dog Curled Up. c. 1935. Crayon, 11¾ × 17⅞". Addison Gallery
of American Art, Phillips Academy, Andover, Mass.

*The supple dog in Flannagan's crayon sketch may be a German shepherd,
although its long tail would indicate otherwise. Dogs of all breeds go to great
lengths to arrange their limbs before a nap, sometimes with peculiarly awkward
and amusing results. No doubt Flannagan in this sketch was toying with an
idea for a piece of sculpture.*

*Alexander Calder's circus animals are anything but ferocious. The tiger gazes
curiously at the audience, the lion lazily yawns, and the lioness waves to a
friend. The trainer is quite safe, despite a lack of bodily protection. Indeed,
he seems to be having difficulty attracting any attention at all from his
grandstanding cats.*

Alexander Calder. Lion Tamer. 1932. Ink, 19½ × 20½". Collection Jean and Howard Lipman, New York

In these grim years James Thurber's dogs, cats, and owls—not to mention the enigmatic seal in the bedroom—provided in the pages of *The New Yorker* a bracing palliative for the nation's afflictions. (Thurber once attempted to "improve" his draftsmanship with elaborate shadings and cross-hatchings but was rescued by his colleague E. B. White with the redeeming advice: "Don't do that. If you ever got good you'd be mediocre.") Thurber's drawings helped the readers of the thirties to get their minds off minor problems like impending bankruptcy; there were more important things to be gloomy about.

The artists who survived the Depression did so because they possessed an unusual share of dedication and talent; they also had unlimited optimism along with a regular government check. Yet for all their perseverance, just as the Depression showed signs of abatement, global war plunged the world into a real howling wilderness, more terrible than any envisaged by even the most tormented Puritan imagination. Industrialization, which most Americans thought had already reached its ultimate level, now raced into high gear. Few remnants of the natural environment were unscarred by the all-out war effort. The massive call to arms meant that the fledgling efforts of the Roosevelt administration to restore the plundered wilderness through public works projects would have to be postponed indefinitely.

Many of the young artists were drafted and some did not return. The older painters, although their lives were disrupted by war, went on as best they could, and many, like the sexagenarian Arthur G. Dove, turned to the animal kingdom as previous beleaguered generations had done—for surcease. But there was no time and little desire to emulate Emerson and Thoreau, who had carefully arranged things so they could have nature all to themselves. It did not seem appropriate in wartime to flee to the transcendental solitude of the deep woods. Many artists—perhaps too many—were frozen at their prewar levels of achievement.

Ominously, as the war worsened, some well-established artists began painting dead animals. Nineteenth-century practitioners of sporting genre had painted dead game and painted it quite attractively, but these wartime carcasses, like the planked fish of Marsden Hartley and the hanging crows of Andrew Wyeth, were not presented as trophies but as literal translations of the traditional French phrase for still life, *nature morte*.

James Thurber. The Owl Who Was God. *1939. Ink and pencil, 10 × 8". Collection Nora Sayre, New York*

Once upon a time the animals of the forest took a vote to determine who would be God, and they elected the owl to the office because he could see in the dark. It turned out to be a poor choice, however, because he could not function at all in the daytime. Thurber's moral: "You can fool too many of the people too much of the time."

Marsden Hartley. Tinker Mackerel. *1942. Oil, 22 × 28″ . Courtesy Bertha Schaefer Gallery, New York*

Marsden Hartley's sightless mackerel were strangely prophetic of the necrophilia that was later to preoccupy many American artists. Hartley was not primarily an animal painter; he simply chose a catch of mackerel for a subject in still life. It is the finality—the deadness—with which he painted them that presaged the hopelessness of some animals painted in the 1960s.

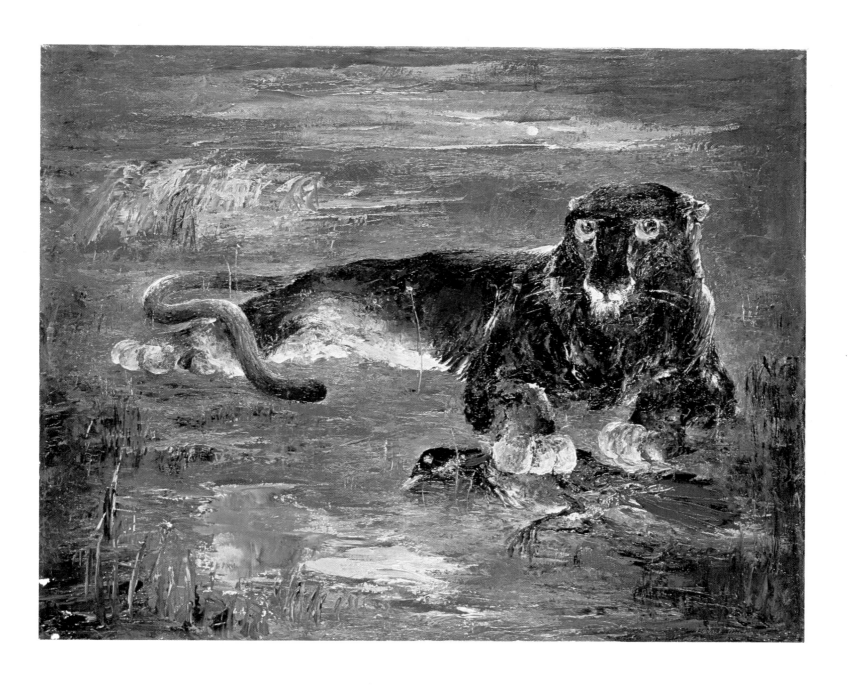

Darrel Austin. The Black Beast. *1941. Oil, 24 × 30″. Smith College Museum of Art, Northampton, Mass.*

Darrel Austin's beasts—and beasts they are—hark back to the smouldering animals of the French romantics. This sleek, heavy cat might have originated in the uncharted jungles of Asia. It might also be a denizen of the haunted underbrush of the human psyche.

Morris Graves. Bird Singing in the Moonlight. *1938–39. Gouache, 26¾ × 30⅛".*
Museum of Modern Art, New York

Supposedly a bird sings only when it wants to attract a mate or establish
territory. Yet there are times when it will let loose a joyous and purely
nonutilitarian song, scientifically inexplicable but perfectly understood by
Morris Graves.

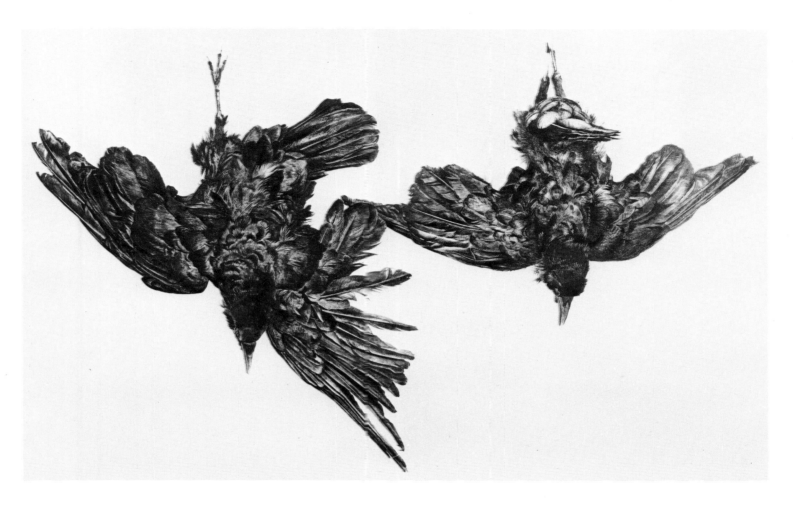

Andrew Wyeth. Crows. 1944. Gouache and ink, 33 × 47". Lyman Allyn Museum, New London, Conn. Frank Loomis Palmer Fund

The natural order of things and the balance of nature are perhaps the essential subject of all of Wyeth's work. Farmers do shoot crows, and Wyeth states the fact with the spare, unemotional vocabulary of the countryman.

Throughout the war years every artist had to shift for himself. Morris Graves continued his thoughtful exploration of animal behavior and discovered a preordained continuity unaffected by politics; sometimes he unearthed a flash of humor as well. At the same time Darrel Austin was painting the predators that have always lurked in the underworld of the American psyche—war or no war—with an uncanny insight, sympathy, and dread.

Jack Levine's eloquence as a spokesman for the nation's social conscience reached its peak during World War II, as did Ben Shahn's; more than ever artists were finding it impossible to remain silent in the presence of injustice. Shahn, searching through the Old Testament for guidance, came across an iconography of beasts that was thousands of years old yet relevant for his time.

At the end of the war, as Charles Burchfield intimated in *The Sphinx and the Milky Way*, Americans welcomed the chance to enjoy again the small sights and soft sounds of familiar woodland wildlife. Although peace did not bring with it a renaissance of landscape or animal painting, artists were not

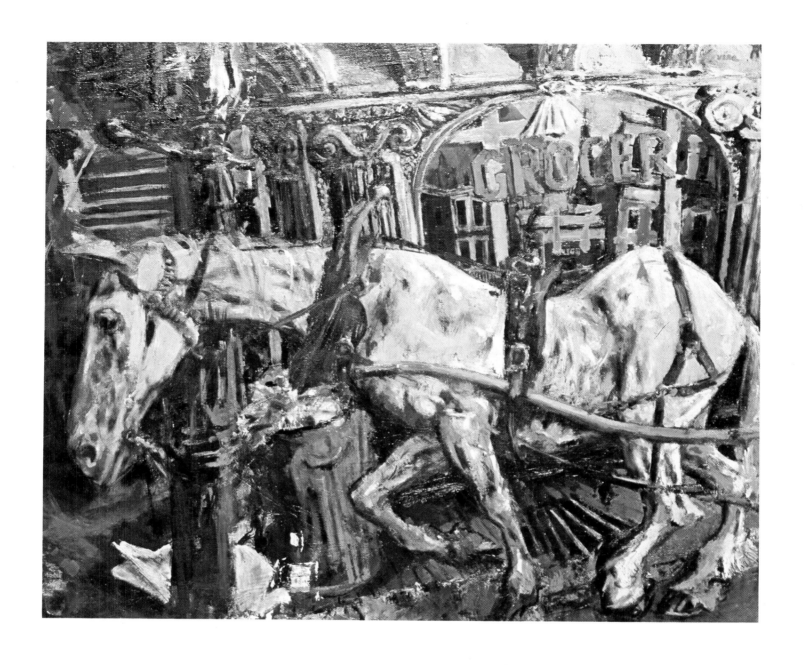

Jack Levine. The White Horse. *1946. Oil, 30 × 36″. Museum of Art, University of Oklahoma, Norman, Okla.*

Understandably animals figure little in the art of social protest, but Jack Levine's spavined cart horse is aimed squarely at the conscience. Although Levine usually directed his satire at the ruling classes, here he painted a close-up of one of the establishment's chronic victims.

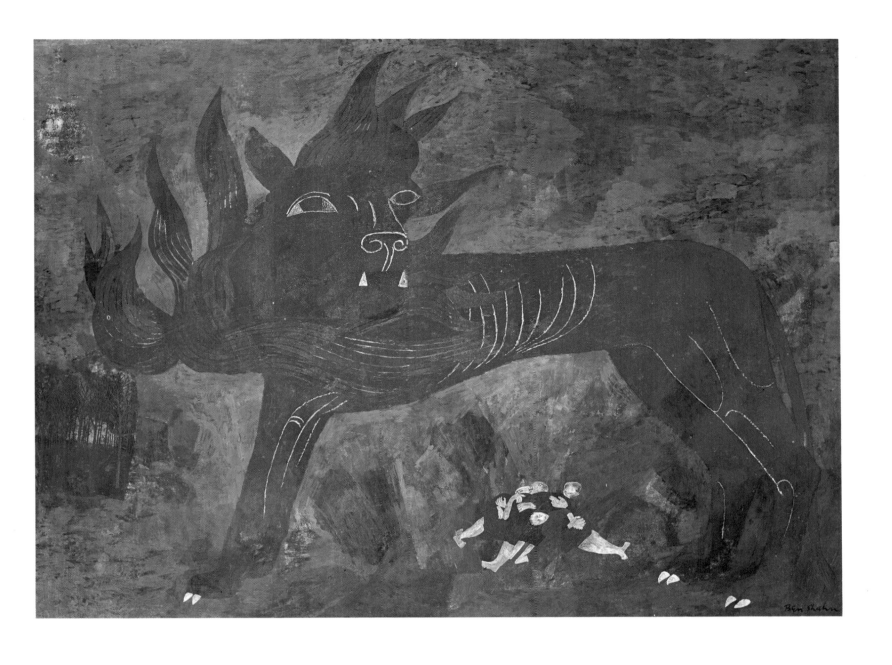

Ben Shahn. Allegory. 1948. Tempera on panel, 36 × 48". Fort Worth Art Museum, Fort Worth, Tex. Gift of W. P. Bomar, Jr., in memory of Jewel Nail Bomar and Andrew Chilton Phillips

In the 1940s Ben Shahn was commissioned to illustrate a magazine story about four black children who died in a 1908 Chicago fire. Searching for an archetypal image to express the agony of all human disasters, he arrived finally at this flame-crowned twentieth-century chimera. In the 1957 Charles Eliot Norton Lectures at Harvard University, Shahn told the audience, "When I at last turned the lion-like beast into a painting, I felt able to imbue it with everything that I had ever felt about a fire. . . . Under its body I placed the four child figures which, to me, hold the sense of all the helpless and the innocent."

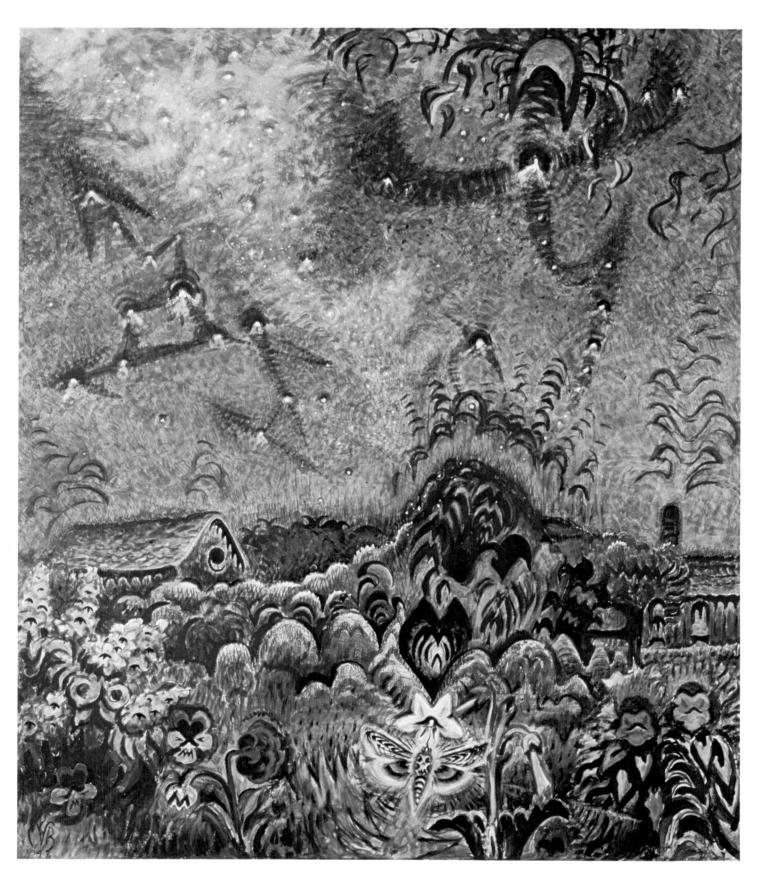

Charles Burchfield. The Sphinx and the Milky Way. *1946. Watercolor, $52\frac{5}{8} \times 44\frac{3}{4}''$.*
Munson-Williams-Proctor Institute, Utica, N.Y.

unaware of the rapid deterioration of the natural environment—which had greatly accelerated, unobserved, during the haste and pressure of the war years—and were beginning to wonder what had happened to Walden Pond.

Of all the artists of the postwar era none was more keenly attuned to the minutiae of nature than Andrew Wyeth. He seemed to have created a new Walden where a large and grateful public could find shelter from the clamor of urban life—and from the artistic uproar of abstract expressionism. It offered silence and peace and a sense of tradition, artistic qualities that would become increasingly hard to come by in the decades that followed.

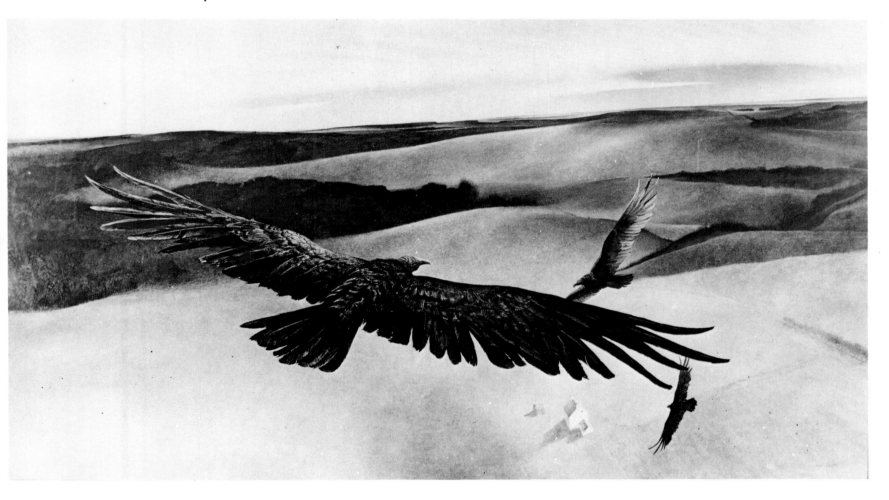

Andrew Wyeth. Soaring. *1951. Tempera on panel, 48 × 87″. Webb Gallery of American Art, Shelburne Museum, Shelburne, Vt.*

Without sermonizing on the significance of life and death, Wyeth simply states things as they are; yet his work is often misunderstood by those who read tragedy into it. Animals stay alive through the death of other animals; what beauty accompanies such rites of passage is the beauty of nature as a whole.

In the foreground of a thrumming, sultry midsummer-night landscape the sphinx moth hovers at the throat of a seductive night-blooming flower. The moth, often thought of as fatally attracted to light, is itself actually a radiant source of illumination in this watercolor, rivaling the intoxicating Milky Way.

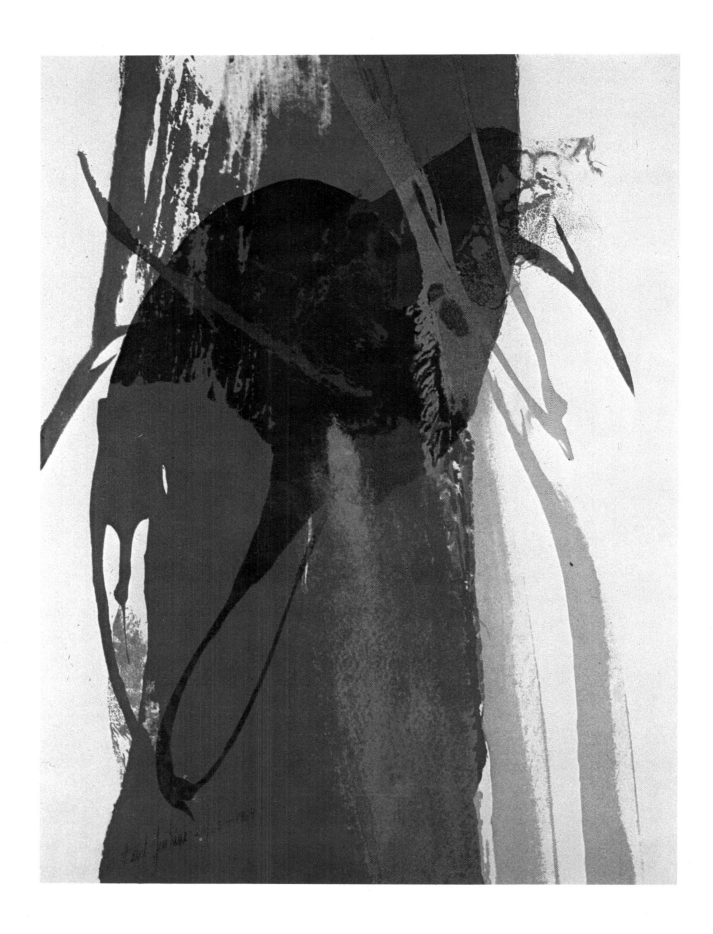

Zoology of the Avant-Garde

Animal imagery survived many shocks during the first half of the twentieth century, but the decade of the 1950s was the most devastating, not only for animals but for traditional subject matter of any kind. After World War II, at a time when the world was struggling to assimilate the grim implications of the atomic bomb, abstract expressionism, the utmost in nonfigurative—or antifigurative—painting, became the most written-about, most controversial upheaval in American art since the Armory Show. Overwhelmed by media coverage extolling the athletic innovations of the New York School, the public was at first utterly baffled. But so vigorously did art critics champion the movement that within a decade abstract expressionism became the official mode of painting, sanctioned by the most prestigious museums and bought at unprecedented prices by a new postwar breed of art collector—the investor.

The popular press and the art magazines almost single-handedly shaped the cataclysmic events of the 1950s and 1960s. In time for every issue there seemed to be some artistic breakthrough to announce. Art was news.

In its repudiation of objective reality abstract expressionism served as an implied protest against bombs, cold wars, used-car lots, canned music, smugness, hypocrisy, and institutional arrogance. In short, it was a protest against the material and spiritual ugliness of the present.

Few artists resisted the landslide, but somehow Milton Avery's unidentified birds breezed steadily onward above the turmoil, and William Baziotes pursued his menagerie of heraldic symbols, while Morris Graves went on studying the instinctive behavior patterns of beasts great and small. Robert Vickrey's tigers still cropped up, unbidden, in unexpected places. These birds and beasts attracted little or no attention from the art critics and magazine copywriters, to whom figurative art did not matter. The older painters, especially those with strong commitments to society like Ben Shahn and Philip Evergood, continued to speak out in artistic language anyone could comprehend. Saul Steinberg's unique menagerie of eccentric fauna—both human and otherwise—strolled the glossy pages of *The New Yorker*, coolly indifferent to the artistic tempest raging in the galleries.

Paul Jenkins. Phenomena Red Parrot I. 1964. Lithograph, 30 × 22″. Courtesy Martha Jackson Gallery, Inc., New York

During the 1950s and 1960s an altogether new menagerie emerged, more or less by accident, in the work of artists whose primary concern was the exploration of color for its own sake. These creatures were metaphors in poured and dripped pigment—states of consciousness rather than zoological actualities.

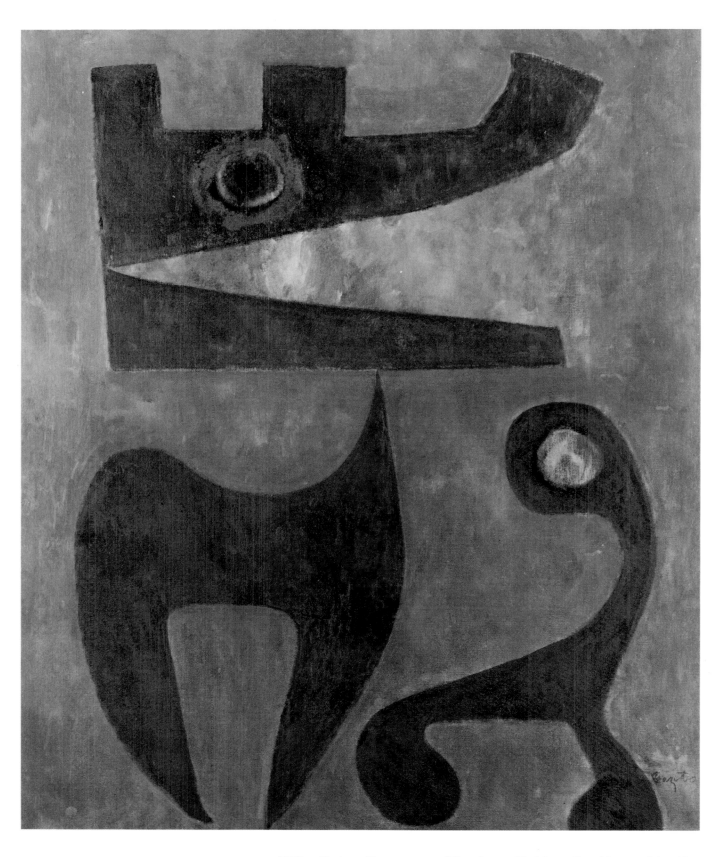

William Baziotes. Dragon. 1950. Oil, 47¾ × 39¾". Metropolitan Museum of Art, New York. Arthur H. Hearn Fund

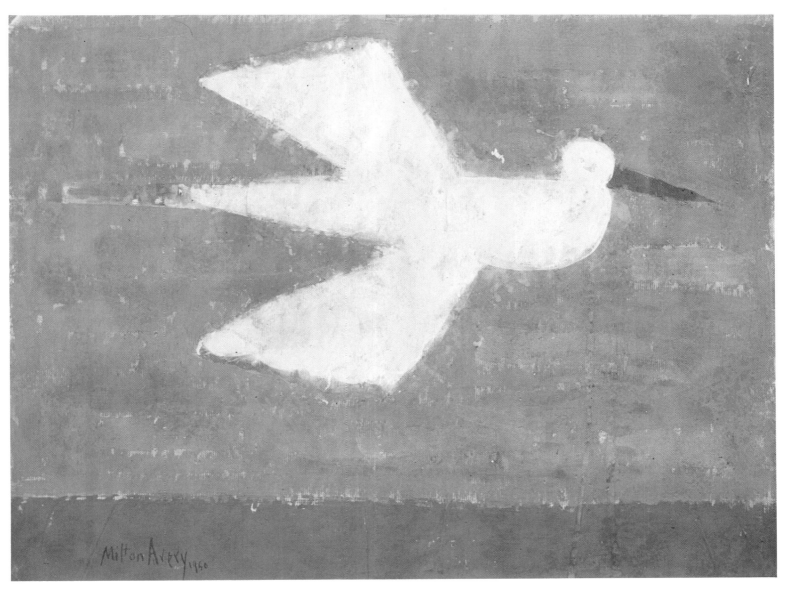

Milton Avery. White Bird. *1950. Gouache, 16 × 21½". University of Arizona Museum of Art, Tucson. Gallagher Memorial Collection*

Across a rosy sky a seagull of indeterminate species flaps contentedly, without haste or wasted motion. Speaking about his distinctly lyrical work, the artist was quoted in 1952 by Art Digest: *"I always take something out of my pictures. . . . The facts do not interest me as much as the essence of nature."*

Baziotes's spare and often wry iconography included a number of emblematic beasts, like this grinning dragon. Baziotes was still in his thirties when abstract expressionism overwhelmed the art world, but he remained a painter of images, albeit enigmatic ones.

Robert Vickrey. Tiger. 1957. Egg tempera on wood, 24 × 37″. Collection Judge and Mrs. Robert W. Sweet, New York

One of Robert Vickrey's menacing tigers was shown on page 30, defending the howling wilderness of the modern city. The same tiger—now a tattered and faded reminder of some long-departed Barnum and Bailey road show—crouches, snarling, in the hush before a country line storm. Vickrey has been tagged a "precise irrationalist," along with John Wilde and other painters who ignored the appeal and success of action painting during the 1950s. A better term might be "psychic realist."

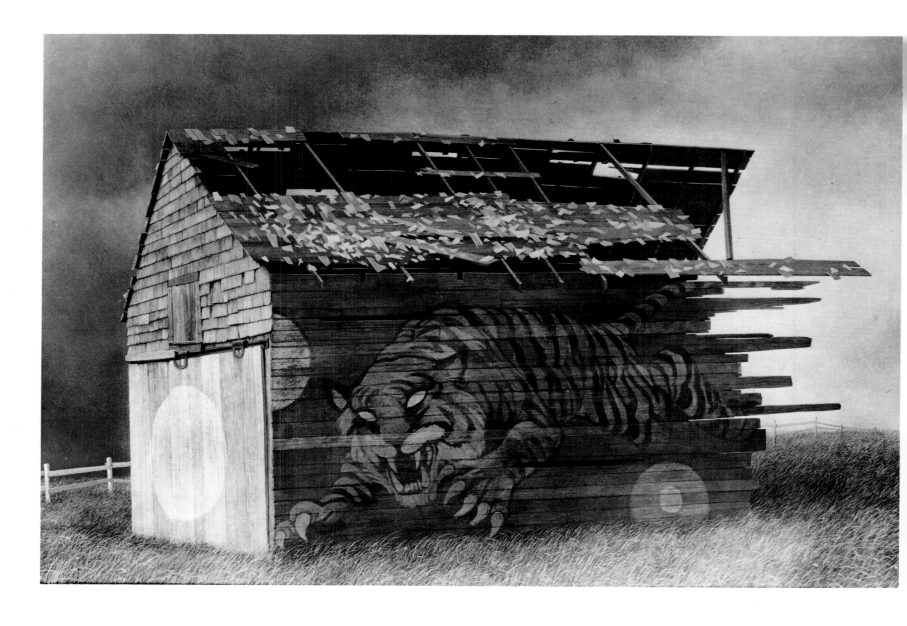

Saul Steinberg. Cat Drawing. 1964. Ink, 18⅝ × 24¾″ (sight). Williams College Museum of Art, Williamstown, Mass.

In his characteristically enigmatic way Steinberg made a cat drawing of a cat, drawing. This talented feline apparently is practicing an advanced penmanship lesson. On the other hand, Steinberg's own calligraphy may have turned into a cat. One can never be sure.

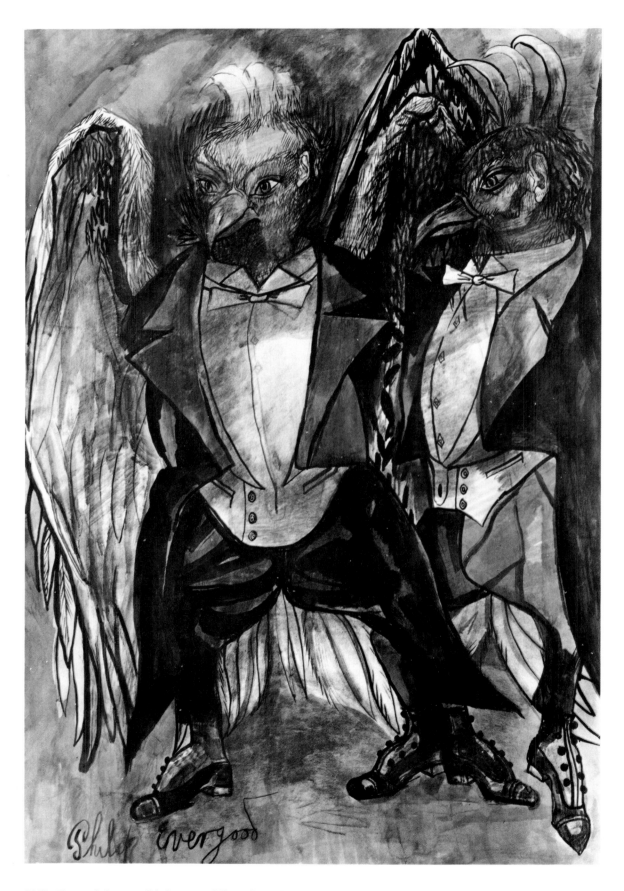

Philip Evergood. Strange Birds. 1954. Watercolor and ink, 38 × 25". Hirshhorn Museum and Sculpture Garden, Washington, D.C.

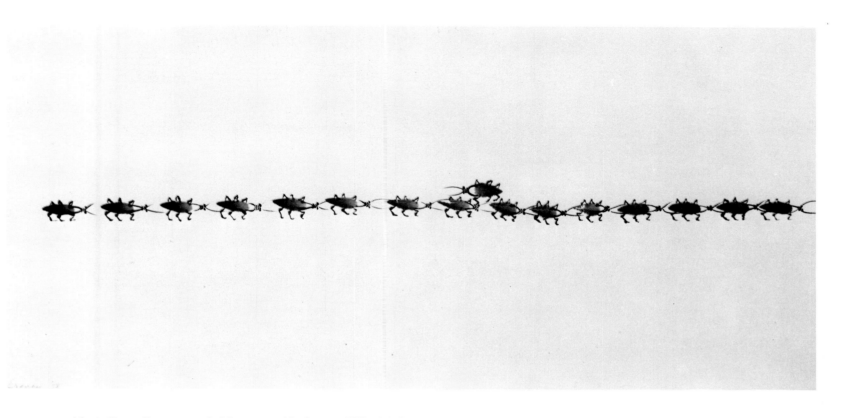

Morris Graves. Insects. 1958. Ink, 10 × 21½". Courtesy Willard Gallery, New York

Entomological etiquette limits the term "bug" to the order Hemiptera. The order comprises insects with flat backs, and although they usually have two pairs of wings, they are terrestrial. Hardly a form of animal life, no matter how small or ignoble, escaped the pen of Morris Graves, who often painted them with the omniscient understatement of an oriental calligrapher.

But these artists had already built solid reputations long before the arrival of abstract expressionism and they could afford to dance to their own tune. Things were not so simple for young painters who by training and temperament were drawn to the representational and the concrete. Formal art training had instilled in them enough self-discipline to be able to paint recognizable objects and to formulate meaningful artistic concepts. Yet throughout the fifties the art dealers and critics and collectors remained transfixed by the abstract expressionist phenomenon. There was only one way for new painters to succeed in the marketplace, and that was to steal the headlines.

It proved to be a brilliant strategy. The young realists of the early sixties quickly won critical attention along with a trendy appellation: pop art. Their subject matter, meticulously chosen from the

These resplendent gentlemen, despite their finery, have not deceived the artist, who sees behind a public image the false vanity of the chicken coop. Philip Evergood was confident that figurative painting would never be outmoded. Yet a bitter observation of his was quoted in Lee Nordness's survey Art: USA: Now *(1962): "What art . . . will last? That is another question entirely. . . . Only the diplomats and the politicians and the military leaders will arrange what is to last."*

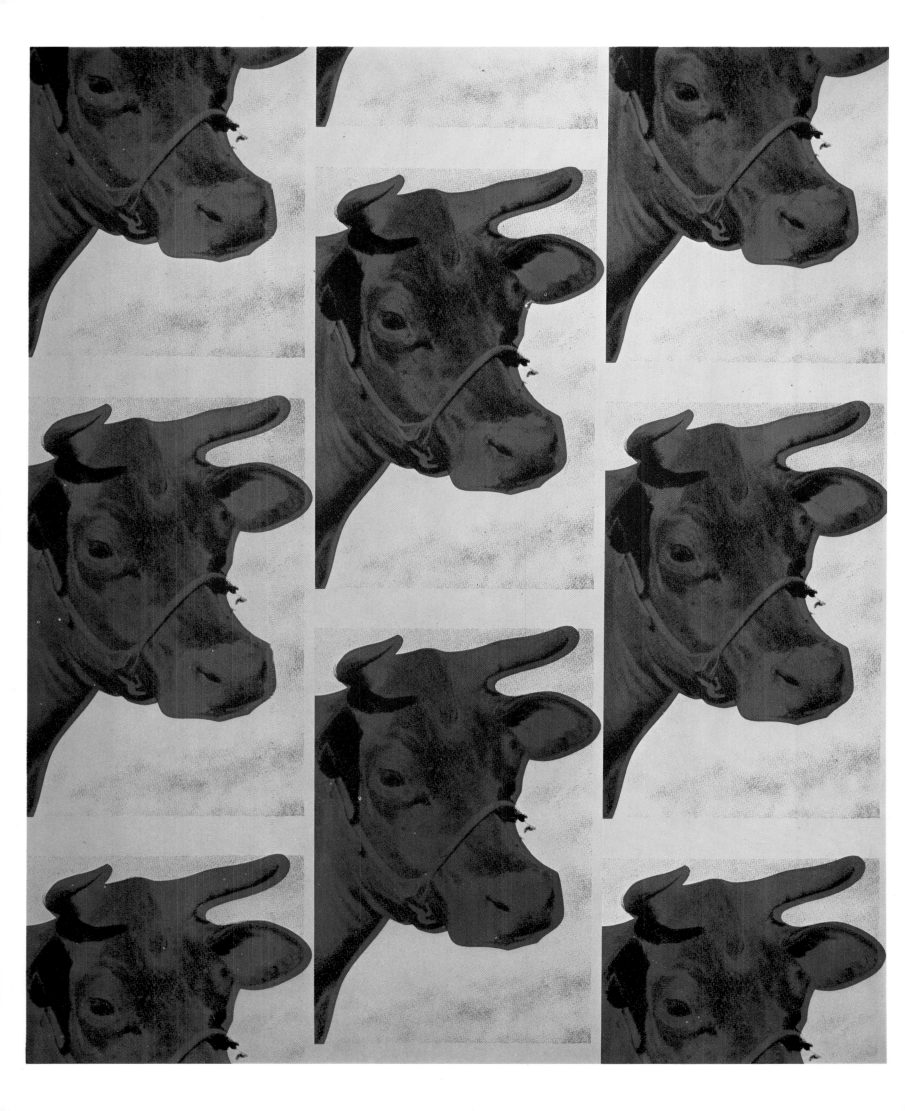

supermarkets, drive-ins, and comic-book racks, was conveyed in an impersonal, almost mechanistic manner. Where abstract expressionism had glorified the artist's every gesture, pop seemed to exist without the intervention of any artist at all. Yet the perpetrators of pop, while self-effacing at the easel, kept the journalists happy with a succession of high-spirited artistic stunts—one of which was Andy Warhol's audacious notion of wallpapering the prestigious Leo Castelli Gallery with contented cows.

Pop introduced an attitude of harmless mischief into the art scene, and the animal was a welcome partner in the fun. By the mid-sixties, however, animals were beginning to assume a more portentous position in American painting, an entirely new role for the animal kingdom which again raised the specter of the howling wilderness. For the first time animals were treated as more than fauna with unfamiliar Latin nomenclature to be anthologized in elephant folios, more than sources of inspiration or points of departure for the primitive or abstract painter. Nor were they any longer filling their accustomed role as accessories to scenic landscape. In fact, their natural backdrops were now missing entirely. Artists began to relegate the animal kingdom to a strange no-man's-land far from the fields and forests and open skies. Apparently for many artists the natural world had already ceased to exist.

The American landscape as perceived by the artists of the 1960s was a chrome-plated, polyurethane, plexiglass, stainless-steel wasteland, and to paint it they resorted, like Perseus slaying the Gorgon, to mirrors and other self-protective devices, as though Main Street, U.S.A. might be more bearable if copied from a photograph—or from a reflection in a dirty window—or if mirrored by the simonized fender of a parked car.

The animal entered this artificial wilderness at its peril. Robert Rauschenberg's tiny warbler, threading its way through the clanging Manhattan cityscape, was a reminder of the precariousness of man's own existence. In such an environment how long might *Homo sapiens* stay off the lengthening list of endangered species? Would the majestic pageant of evolution turn out to be a bitter joke as Thomas Cornell's illustrations for T. H. Huxley implied?

By the end of the 1960s animal painting wore a look of desperate urgency, in the face of what seemed an uncontrollable, irreversible domination of the earth by impersonal technological forces. Joseph Raffael's *Face, Monkey* betrayed the sorrows of the age as candidly as Edward Hicks had summed up the joys of another era. The animals in contemporary American art were condemned to a howling wilderness of man's own making in which life was no longer lived firsthand but merely ticked away on the dials of instruments.

Unlike the animal pictures of a simpler and perhaps more innocent time those of the sixties were creatures of conscience. The great soaring eagles of Leonard Baskin fell ignominiously to earth, possibly the victims of DDT or buckshot. Like all patriotic insignia, they had lost the ability to keep the anguished nation together.

Andy Warhol. Cow Wallpaper. *1966. Silkscreen inks on paper, 44 × 30″ (image size). Courtesy Leo Castelli Gallery, New York*

It is a known fact that dairy cows are acutely sensitive to their surroundings. If soft Muzak piped into the barn can increase the production of milk, perhaps humans too can achieve a measure of bovine contentment by wallpapering their bedchambers with enlarged images of Elsie, the Borden cow. Like other Warhol notions, this belongs to the free-wheeling, ingenuously liberal spirit of pop art.

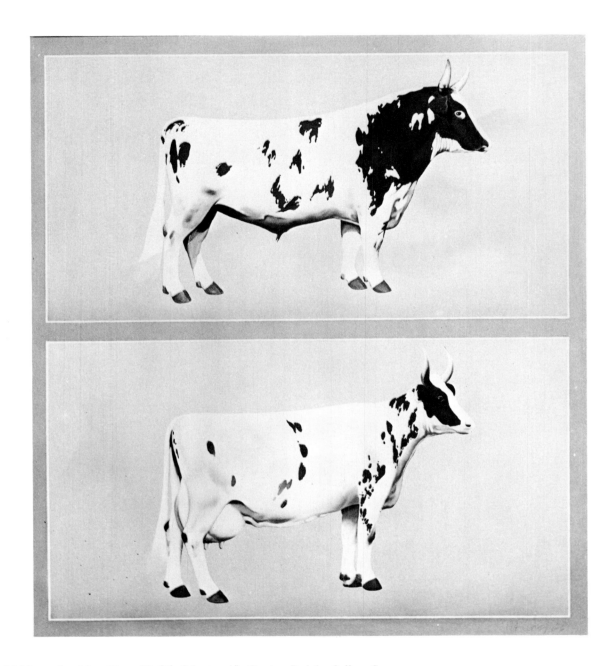

Richard McLean. Ayrshires II. *1966. Oil, 61¼ × 55¼". Courtesy Berkeley Gallery, San Francisco*

Ayrshires have been a popular breed in America since the time of Daniel Webster, who was one of the earliest breeders of cattle. Though exceedingly generous with their milk, they work hard and live long. McLean's fine specimens combine the anatomical expertise of the nineteenth-century livestock portrait with the meticulous draftsmanship associated with twentieth-century photorealism.

No one who has ever been confronted by a snarling police dog can deny how it seems to grow and grow until it takes on the proportions of a comic-book monster. Roy Lichtenstein, like Andy Warhol and other proponents of pop art, attempted to ease the abrupt change away from abstract expressionism by enlarging on themes and images familiar to all Americans.

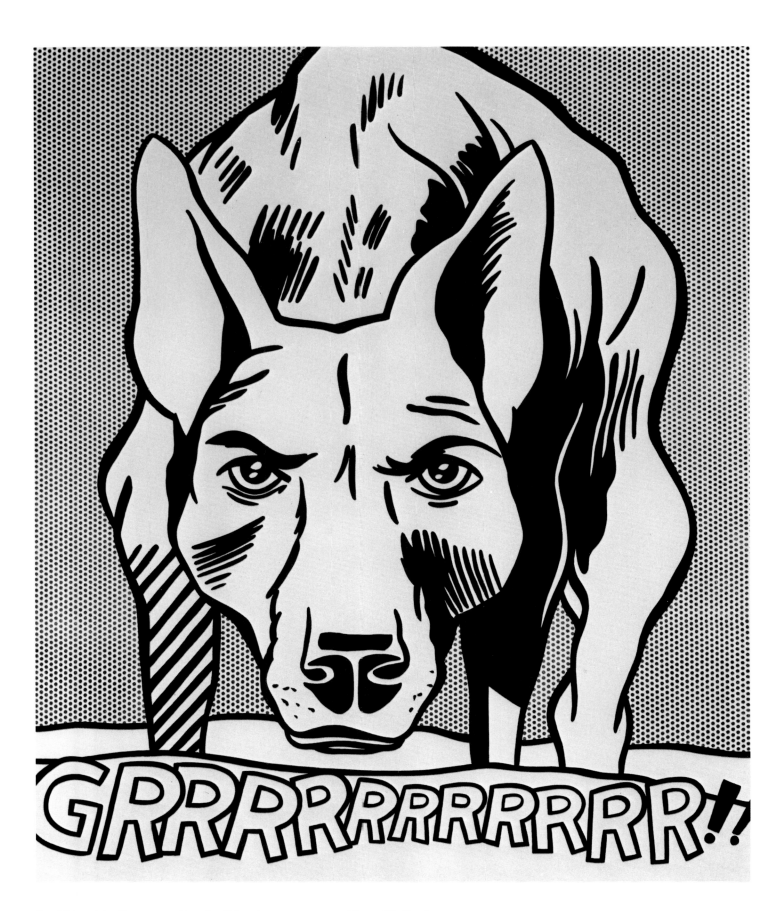

Roy Lichtenstein. Grrrrrrrrrr!! 1965. Oil and magna on canvas, 68 × 56". Courtesy
Leo Castelli Gallery, New York

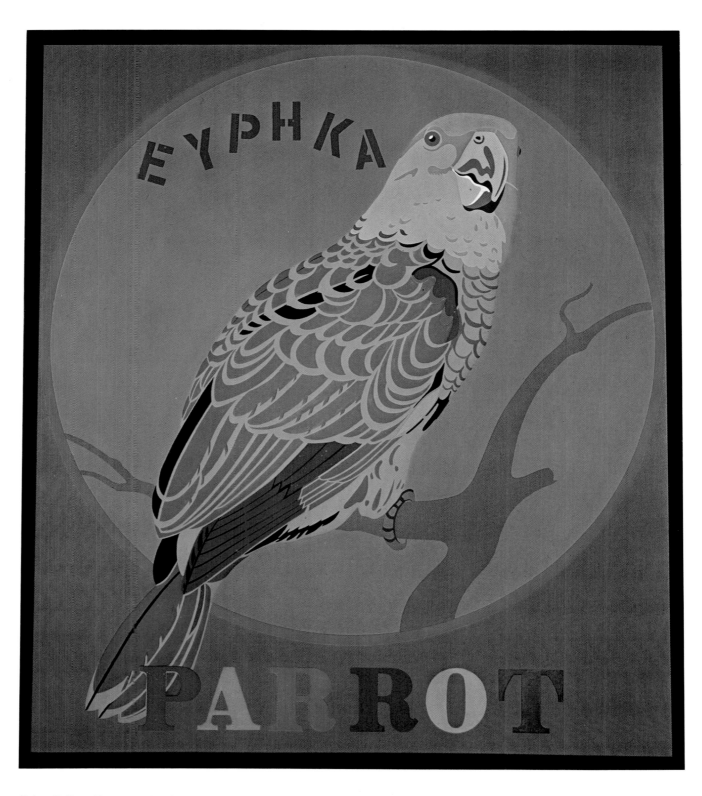

Robert Indiana. Parrot. 1967. Acrylic, 70 × 60″. Collection Professor and Mrs. John A. Garraty, Sag Harbor, N.Y.

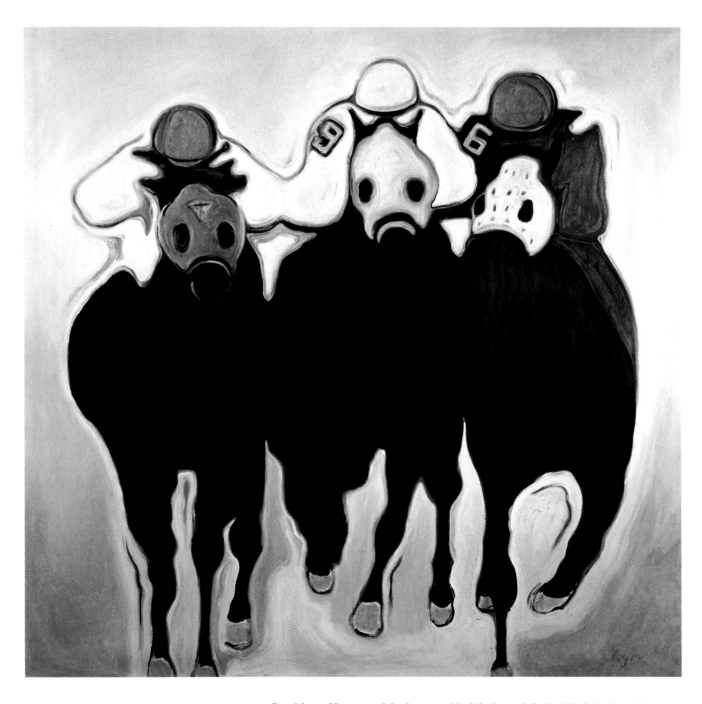

Roy Moyer. Horses and Jockeys. *1966. Oil, 60 × 60". Rockford Art Association, Rockford, Il.*

Traditionally paintings of horse races have always been side-long panoramas of rushing speed. Roy Moyer catches these thundering thoroughbreds head-on, like a camera close-up at the finish line.

Indiana's use of show card lettering became part of the pop iconography in the 1960s, and occasionally his stenciled alphabets were not the painting's subject but the caption. This yellow-headed parrot, native to Central America, seems to be parroting the exclamation immortalized by Archimedes when he ran from his bath naked into the streets on discovering a method for determining the purity of gold: Eureka!

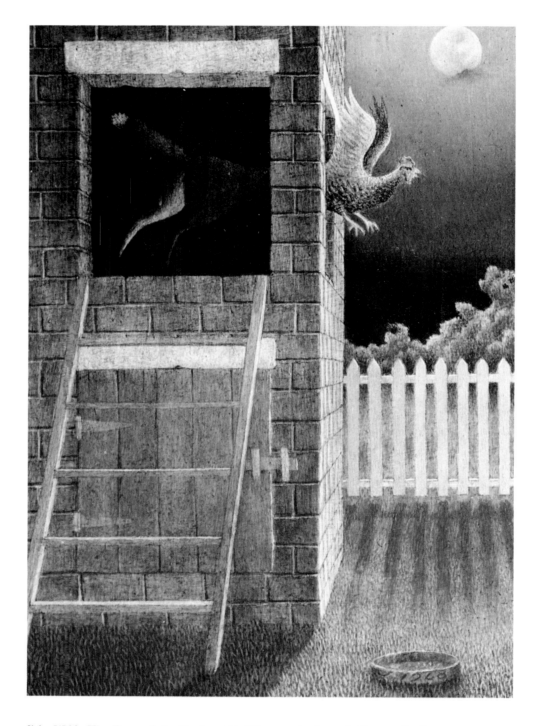

John Wilde. The Fox and the Cock. *1968. Oil on wood, 7¼ × 5″. Courtesy Banfer Gallery, Inc., New York*

As Rachel Carson stated in Silent Spring, *"The predator and the preyed upon exist not alone, but as part of a vast web of life." In John Wilde's conception a metamorphosis takes place, the predator seeming to become one with its prey.*

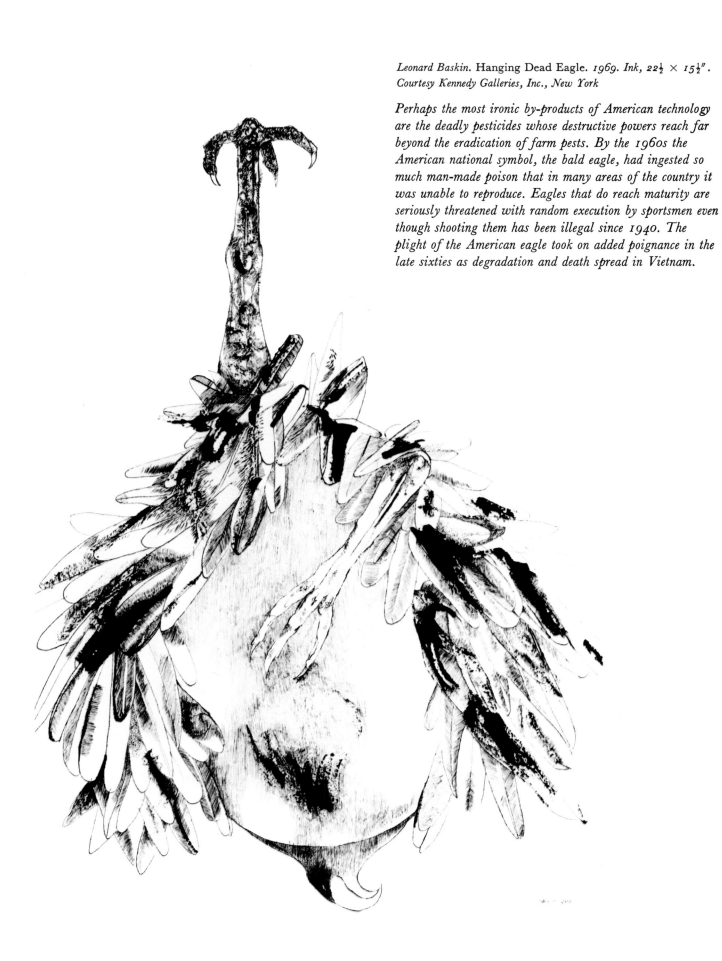

Perhaps the most ironic by-products of American technology are the deadly pesticides whose destructive powers reach far beyond the eradication of farm pests. By the 1960s the American national symbol, the bald eagle, had ingested so much man-made poison that in many areas of the country it was unable to reproduce. Eagles that do reach maturity are seriously threatened with random execution by sportsmen even though shooting them has been illegal since 1940. The plight of the American eagle took on added poignance in the late sixties as degradation and death spread in Vietnam.

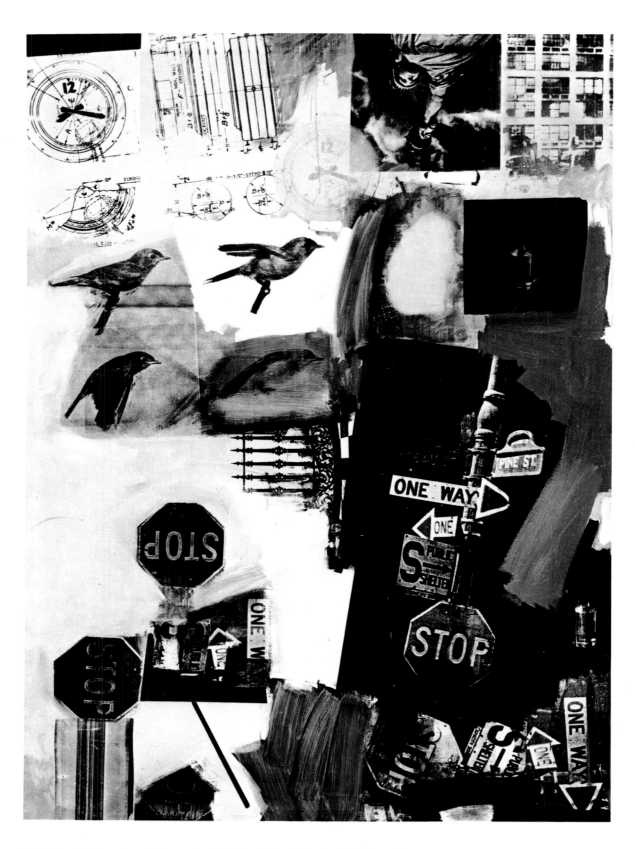

Robert Rauschenberg. Overdrive. 1963. Oil, 84 × 60″. Collection Eric Meyer, Lausanne

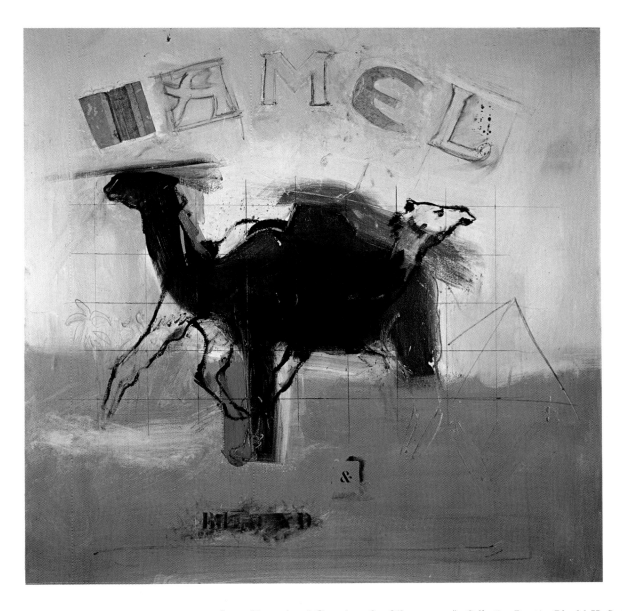

Larry Rivers. Amel-Camel. *1962. Oil, 39 × 39″. Collection Prentice Bloedel II, Seattle*

Larry Rivers's title for the painting refers of course to the famous cigarette camel—which, more precisely, is a dromedary, having one hump instead of two. Camels and dromedaries both got into American history when in 1856 and 1857 the U.S. government imported camels and dromedaries by the boatload, hoping the army could use them in patrolling the southwestern wastelands. It was a favorite scheme of Jefferson Davis (secretary of war, 1853–57), but when the Civil War took him from Washington, the project languished. Legend has it that descendants of the Bactrian and Arabian strains still exist somewhere in the uncharted American deserts.

Maps, landmarks, compass directions, and street signs, upon which beleaguered man depends to get him to his urgent destinations, mean nothing to the courageous warbler, which charts its unerring flyways by the stars and airily ignores the stop signs. Rauschenberg's brilliant commentaries on contemporary life effectively combine the painterly improvisations of the abstract expressionists with short newsreel glimpses of the real world outside the studio.

Thomas Cornell. Three Monkeys. *1959. Etchings. Proofs of illustrations for* The Monkey
by T. H. Huxley. Museum of Modern Art, New York. Gift of Mr. and Mrs. Sylvan Lang

*Thomas Henry Huxley was Charles Darwin's staunchest ally in the nineteenth-
century English scientific community, and he enthusiastically agreed with
Darwin that the "cosmic process" in itself contained no intrinsic morality. But
he did for a time entertain the idea that one day evolution might take a down-
ward turn, at which time dormant negative trends might reassert themselves.*

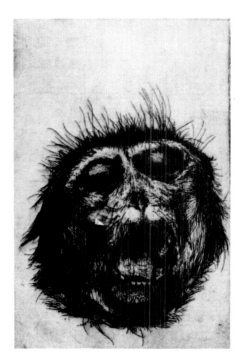

*Joseph Raffael. Face, Monkey. 1968. Oil, dimensions unknown. Courtesy Nancy Hoffman
Gallery, New York*

*The monkey, being the creature most similar to man, has become the preferred
laboratory subject for medical experiments. Rhesus monkeys, imported from
India and Southeast Asia, have also been hurtled by the United States into
outer space in the name of science, their brains and arteries studded with
electrodes and their lungs and limbs wired to machines.*

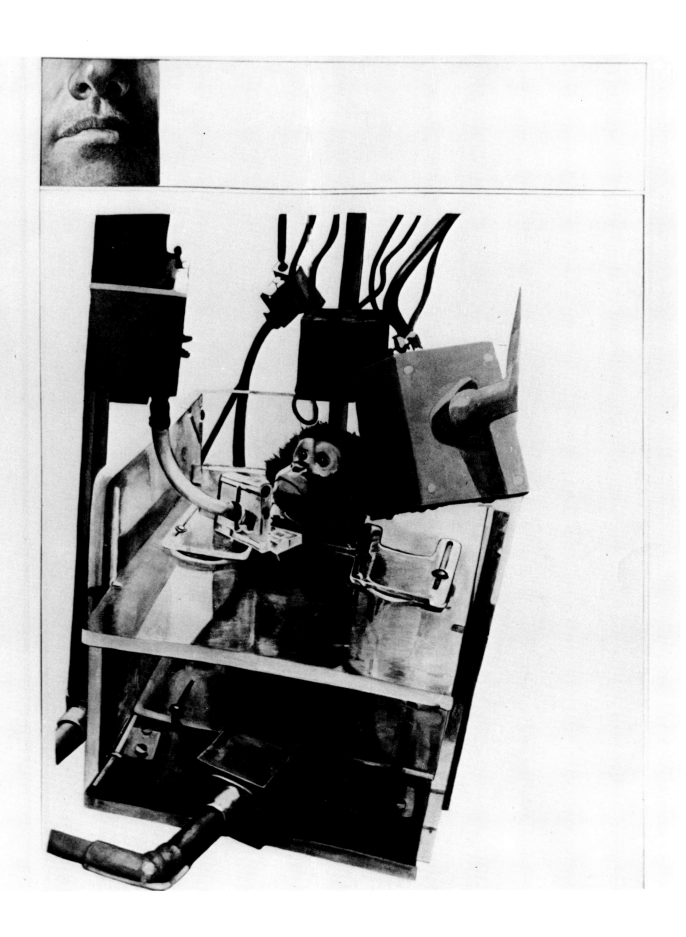

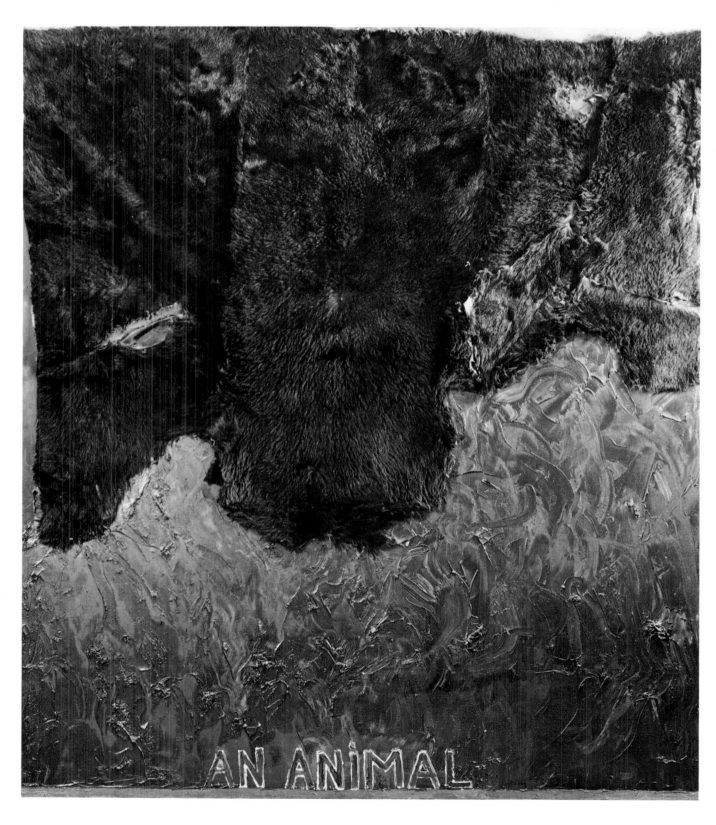

James Dine. An Animal. *1961. Bearskin and oil collage on canvas, 72 × 60″. Collection Mr. and Mrs. Burton Tremaine, New York*

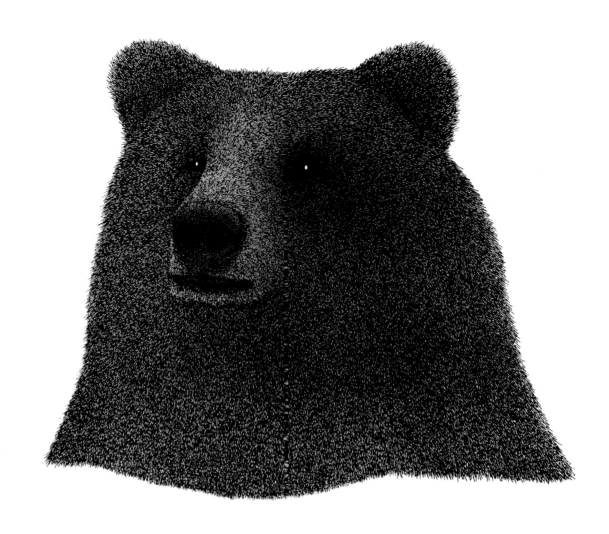

Jonathan Meader [Ascian]. Bear. 1974. Ink, 7 × 7″. Collection the artist, Washington, D.C.

Ascian's bear, like many animals in the art of the 1970s, is not a dreaded denizen of the howling wilderness or a pitiable victim of technology, but simply a fine fellow creature—another passenger along with man on the great planet Earth.

Barely a century after John James Audubon's death, the representation of an animal had already become for many artists little more than an abstraction, remote from real life. Jim Dine's bearskin collage commemorates this loss of rapport between beast and man in a particularly poignant way.

Though objective reality was regaining some of its preabstractionist eminence in American painting, the reality that artists sometimes perceived around them was so dreadful as to be almost unpaintable. In 1968 one respected New York gallery exhibited a canvas on which was displayed a white cat disappearing tail-first down a garbage disposal unit. In an earlier period it would have outraged the art world, but the real world of the late sixties was filled with occurrences incalculably more outrageous. The news coverage of the American colonial war in Vietnam overshadowed all other tragedies, even the disastrous oil spills, the insecticide poisonings, and the polluted rivers, which were taking an enormous toll of wildlife during these war years. Artists seemed at the same time to apprehend for the animal kingdom—even for the planet—a future of sickness and death. In *Silent Spring*— a provocative study of the dangers of insecticides published in 1962—Rachel Carson had predicted the advent of a howling wilderness all the more sinister because it would be a "spring without voices" when "only silence lay over the fields and woods and marsh. . . . No witchcraft, no enemy action had silenced the rebirth of new life in this stricken world. The people had done it themselves."

Nevertheless the birds and beasts of America, with some support from the Endangered Species Preservation Act of 1966 and with the proscription of DDT in 1972, began to show signs of a cautious comeback in the 1970s. In fact, as champions of ecology animals themselves have proved to be more effective lobbyists than human beings: the Everglades was preserved not so much as a playground for man but as a refuge for the American alligator. The California condor, which is extremely rare, did the same for its roosting grounds on the Pacific coast—choice real estate that, but for the precarious plight of the condors, would have been grabbed up by developers. Recently the bureaucratic mechanism of the federal government was stopped dead in its tracks by a small, obscure fish called the snail darter, whose assured extinction caused an entire hydroelectric project to be halted.

Animals are also alive in art—and appear to be well for the time being. Since the mid-seventies there has been a lively resurgence of animal painting along with a reappearance of figurative art in general. Pictures of beasts have been well received by a new generation of gallerygoers who are not easily stampeded by art critics. After four-fifths of a century of decline, subject matter is again widely acceptable, and as compensation for years of ecological and artistic neglect, the bison, the wolf, the bobcat, the eagle, and the whale are enjoying a belated but gratifying prosperity.

As befits products of the Instamatic age, most animals of the seventies are painted with photographic clarity, every hair and whisker receiving the artist's close attention. Some paintings are so exactly rendered as to be suggestive of the plates in zoological encyclopedias. The creatures stand alone

Manon Cleary. Rat IV. 1977. Oil, 35½ × 31½". Collection the artist, Washington, D.C.

The rugged little albino rat, without which America's vast scientific research establishment could not function, spends its precarious life behind bars. Most laboratory rats live and die in anonymity, taken for granted by their exploiters and by their ultimate beneficiaries. Few, if any, have had their portraits painted with such insight and exactitude as this one.

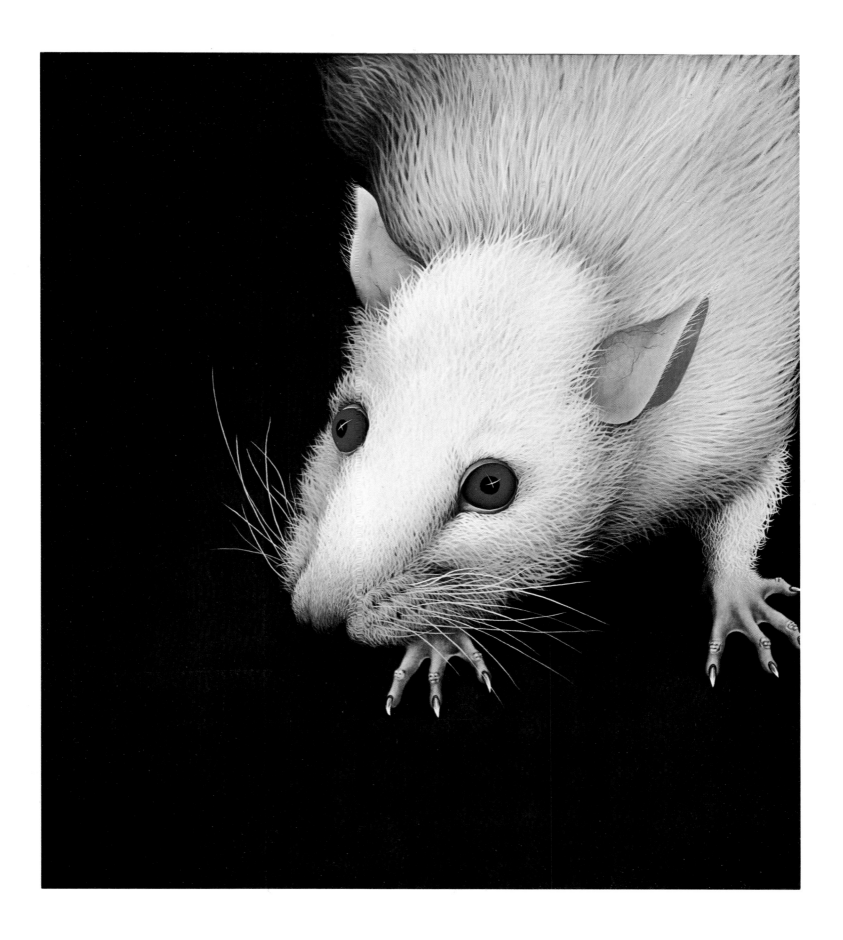

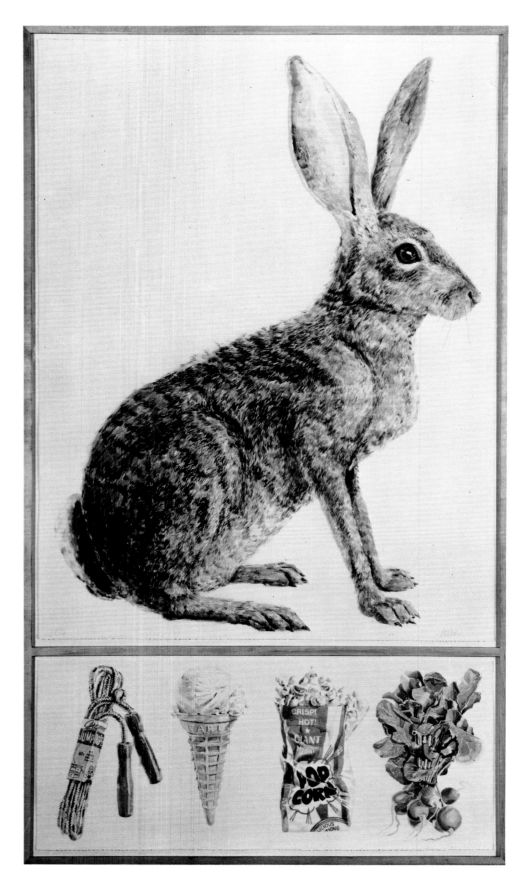

Don Nice. Jack-Rabbit *1976. Watercolor, 75 × 40". Courtesy Nancy Hoffman Gallery, New York*

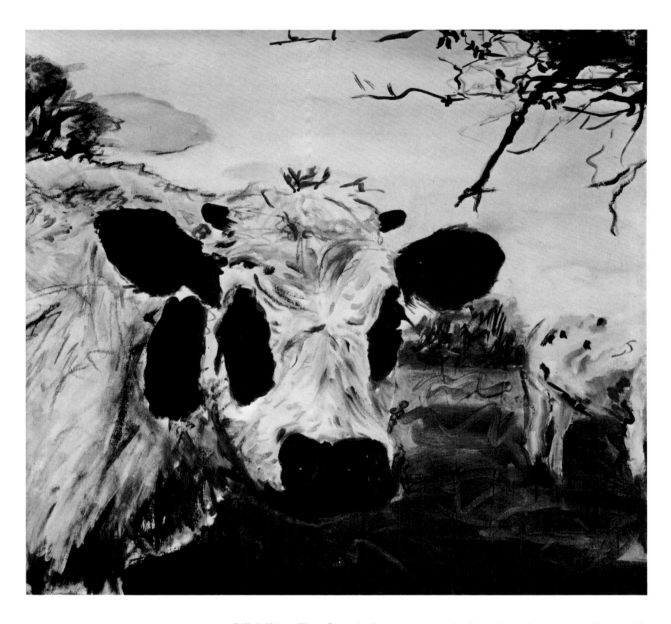

*Bill Sullivan. Two Cows in Pasture. 1977. Acrylic and pastel on canvas, $38\frac{1}{4} \times 41\frac{1}{4}''$.
Collection Mr. and Mrs. Roy R. Neuberger, New York*

*Sullivan's series of pasture scenes coincided with the return in the seventies of
a painterly approach in art, a sensuousness which had lain dormant during
the heyday of superrealism in the previous decade.*

*Don Nice, who began specializing in animal subjects during the sixties,
progressed from huge impersonal representations of tigers and gorilla to
sympathetic but still gigantic portraits of the native fauna. Like most artists of
the seventies, he belongs to a generation without real roots in the American
wilderness. To this generation the animal kingdom seems remote and isolated
from contemporary life. Nice begins to bridge the gulf by supplying pictorial
footnotes to his animal studies, just as medieval artists painted explanatory
predellas below their altarpieces.*

Alex Katz. Rex #2. *1975. Oil, 75 × 90". Courtesy Marlborough Gallery, Inc., New York*

During the 1970s animals grew larger every year. This megapuppy, whose shaggy head alone measures more than seven feet across, would require a very large room to wag his tail in. No wonder many museums post at the entrance a sign that reads, No Dogs Allowed.

Graves spent years studying the anatomy and physiology of the vertebrates. Although she is best known for her camels, sculpted almost life-size out of wool, plastic, steel, and burlap, she is also an astute observer, like Eadweard Muybridge a century earlier, of animal locomotion.

228

Nancy Graves. Diagonal Sequence of Limb Movements in a Newt. *1971. Gouache,*
29 × 20" . Collection the artist, New York

on an otherwise empty page with all reference to environment or natural surroundings carefully silhouetted out. The long estrangement between beast and man seems to have left American artists with a feeling of detachment that leads them to regard animals as specimens to be studied in the zoo or the laboratory rather than in their native habitat. Many of today's animals do not move freely about the wilderness, they pose. Jeanne Owens arranges her animals as carefully as a museum curator setting up a diorama, and Don Nice frames his with scraps from the iconography of human banality—water pistols, tennis shoes, and candy bars. Clearly these artists are attempting to provide their creatures with a context, albeit one that is man-made.

Although an air of scientific objectivity pervades much recent animal painting, there has also been a move toward fantasy and nostalgia, evident in the work of Barbara Bustetter Falk, whose bright colors and flat, undetailed use of acrylics are reminiscent of nineteenth-century folk art brought up to date. There are creatures of legend like Jonathan Meader's paradoxical unicorns rendered with irrefutable photographic authenticity. As always there is a preponderance of big shaggy dogs. Alex Katz, shunning the confinement of magic realism, dashes off his dog portraits with a very broad brush indeed: the head of *Rex #2* measures seven feet from ear to ear. Animal pictures—indeed, paintings in general—reached record-setting dimensions during the seventies. In 1978 Don Nice exhibited a large triptych, *Peaceable Kingdom*, which covered 324 square feet of canvas, paper, and wood.

The revival of animal painting, although coming at a time of increased ecological concern, may be too late to have more than symbolic meaning. The ravages caused by centuries of human indifference will not be repaired by a few artists or even by an aroused electorate. The violence to fragile species and to the natural habitat has already been done. Nevertheless, in the statute books, if not yet in the fields and forests, the foundations of a future peaceable kingdom have been laid. Citizens now have the power to scrutinize environmental impact statements and insist on full disclosure of the truth. Wildlife management policies no longer advocate the heedless eradication of predators, and the scattered survivors on the endangered species list are entitled to the full protection of the law.

Jeanne Owens. Egret Among the Peonies. 1977. Acrylic on board, 30 × 23". Collection the artist, New York

Owens's animal still lifes, back-lighted like exhibits in a museum, are arranged with studied asymmetry and elegance. She provides these habitats with the most important necessities for living: sustenance for both the body and the eye.

Barbara Bustetter Falk. Hollywood. 1976. Acrylic, 20 × 14". Collection Dr. and Mrs. Irving Duke, Woodland Hills, Calif.

Jonathan Meader [Ascian]. Unicorn. 1972. Serigraph, 23 × 23″. Collection the artist, Washington D.C.

The fabled unicorn has fascinated man since the dawn of recorded history. Popular in the art of the Middle Ages and the Renaissance as a symbol of courtly love, chastity, and the resurrection of Christ, its elusive form can still be glimpsed today, if conditions are congenial.

In a nostalgic but not humorless recollection of Hollywood in the glorious 1930s all fantasies are possible: animals are whisked to their appointments in chauffeur-driven limousines, hot dogs come from dog-shaped eateries, and every little girl looks like Shirley Temple.

233

Neil Welliver. Study for Print of Salmon. *1977. Watercolor, 22¼ × 29⅞". Metropolitan Museum of Art, New York. Friends of the Twentieth-Century Art Department gifts and matching funds from the National Endowment for the Arts*

Due to recent vigorous antipollution efforts, the Atlantic salmon is making a significant comeback in northeastern waters. In Welliver's watercolors, intimately attuned to the quiet landscape of rural Maine, some streams are so clear that the fish fairly gleam in the sunlight.

During the seventies Joseph Raffael turned away from an exquisitely rendered but haunted realism (as in Face, Monkey *on page 221) to a soft and voluptuous watercolor style reminiscent of Charles Demuth's early exploration of the medium. He continues to pay homage to the spirit of the animal world, but now his creatures partake freely of nature's riches, even to the point of losing themselves in the seductive embrace of the life-giving landscape.*

Joseph Raffael. Pink Lily with Dragon Fly. *1978. Watercolor, 44 × 33″. Collection Mr. and Mrs. Daniel Fendrick, Chevy Chase, Md.*

A century and a half after Edward Hicks's vision of the potential harmony of man and beast Americans have begun to understand on a deeper level how beautiful and how complex the interdependence of man and beast really is. The age-old cycle of birth, death, decay, quiescence, and rebirth cannot be interrupted for long without irreversible consequences. Although we are committed to urbanization, we have learned that there must be both predators and prey and that there will always be winds howling out of the wilderness, even in the most peaceable of kingdoms.

The artists of today seem optimistic. Neil Welliver's fish-filled streams, where salmon still swim, are as clear as any of Winslow Homer's, and Joseph Raffael, whose animals of a decade ago were studies in suffering and human manipulation, now finds pleasure in sketching the free-spirited dragonfly. Don Nice has begun to introduce distant glimpses of the American landscape into his assemblages of native fauna, and while the animals have not yet actually entered these habitats, they are drawing closer.

In the medieval bestiaries all creatures had a purpose on earth. They were emissaries of God, assigned to implement His divine plan for terrestrial harmony and to serve as reminders that man must not neglect his own obligations as caretaker of the earth and keeper of the peace. The art of the animal, the oldest art on earth, has taken many turns since Stone Age man first scratched the outlines of the ibex and the bison and the woolly mammoth on the walls of his caves, but it remains a powerful and persistent metaphor for life itself and for man's continuing dialogue with nature.

Don Nice. American Totem Bobcat. *1978. Acrylic on canvas and watercolor on paper, 114½ × 68½". Courtesy Nancy Hoffman Gallery, New York*

The long estrangement between man and beast still haunts the efforts of many American artists to reach a rapprochement with nature. The increasingly rare bobcat poses in this painting in sterile isolation against a bare backdrop, literally fenced off from a patch of attractive wilderness that seems to lie just beyond reach.

IN APPRECIATION

Wherever I turned for help and guidance during the writing of this book, I found people—and even institutions—with a warm and lively regard for animals in general and for paintings of animals in particular. Because of their ready enthusiasm for the topic, they were moved to volunteer the kind of imaginative and selfless cooperation that researchers dream about but seldom have the good fortune to experience.

First I must thank Jean Lipman who, as editor of *Art in America,* perceived that an informal examination of animal imagery in American art might prove enlightening as well as entertaining, and allocated to me generous space in the magazine's July–August 1970 issue in which to explore the subject.

In the ensuing years the list of benefactors and supporters has grown exponentially as the pages of raw and rewritten manuscript proliferated. Almost ninety institutions and individuals graciously provided photographic material for the finished work—only to be rewarded by a blizzard of paperwork and a terse acknowledgment in the captions. It is not possible here to thank all of them properly and individually. Yet for their extraordinary exertions I would like to single out for special mention the Abby Aldrich Rockefeller Folk Art Center, the Addison Gallery of American Art, the American Museum of Natural History, Hirschl & Adler Galleries, Kennedy Galleries, the Library of Congress (particularly the Prints and Photographs Division), the National Collection of Fine Arts, the New-York Historical Society, the Smithsonian Institution's Division of Domestic Life, the Whitney Museum of American Art, and the Henry Francis du Pont Winterthur Museum.

Even with the generous help of many of the nation's great museums, I could not hope to cover

the whole field without those volunteer scouts who from time to time sent word of obscure, unpublished animal paintings in small museums and local historical societies or those who furnished the names of talented young artists I might not have encountered otherwise. Some of their suggestions turned out to be exciting finds. I am particularly grateful for the sleuthing of Jo Ann Lewis, Martina Norelli, Barbara Sessions, Rosamond Sheldon, and the late Hermann Warner Williams, Jr.

To identify by name the birds, beasts, and fish portrayed—often very imaginatively—in American art, I soon realized help was needed. Fortunately four fearless naturalists came to the rescue: Roxie Laybourne (birds), John Paradiso (beasts), Andrew McErlean (fish), and especially John Trott, whose knowledge of wildlife knows no bounds. Altogether they brought so much expertise to the problem that I'm sure it is safe to say that any errors in attribution are the artists' fault, not theirs.

Many hands helped with the often wearisome work of manuscript preparation. Reginald Gay of Abrams proved to be a most diligent and conscientious editor, and I am grateful for the long hours he lavished on this project. Before him others toiled with me over the constantly changing text: Mario Amaya, Anthony Bower, Mary Mix Foley, Rosamond Haverstock, Kitty Kelley, Francis Kloeppel, and Marcia McDonald. Each of them contributed in some vital way to the final arrangement of words on paper.

Dan, Julia, John, and Gwendolyn Haverstock ran innumerable important missions to libraries and post offices at my behest, and to them I will always be grateful.

Finally, it was my cousin, Nora Sayre, who, by putting me in touch with the one and only Maxine Groffsky, made everything possible. Thank you, Maxine, and thank you, Nora.

MARY SAYRE HAVERSTOCK

BIBLIOGRAPHY

The interested reader will find that the eventful history of American art has been extensively chronicled in print and that there is no shortage of outstanding books on all aspects of American wildlife. But few and far between are full-length treatments of the intricate relationships between artist and animal, between man and beast, between art and the environment. Hans Huth's *Nature and the American*, published in 1957, is still one of the best. Also highly recommended are three more-recent volumes that explore with care and respect the lives and works of America's artist-naturalists: Joseph Kastner's *A Species of Eternity*, Martina R. Norelli's *American Wildlife Painting*, and Hal Borland's *History of Wildlife in America*.

The selected bibliography that follows is divided into two sections, proceeding from the general to the specific. Included in the first section are some useful art surveys that provide an overview of the whole pageant of American creativity from the beginning to the contemporary scene; other titles in this section treat with similar thoroughness the nation's natural history. The works cited in the second section are somewhat narrower in scope; in one way or another they touch intelligently on the concerns, ideas, yearnings, and accomplishments of individual American artists who have over the years looked to the animal kingdom for inspiration or income or scientific data—or simply for entertainment.

GENERAL SURVEYS

Alloway, Lawrence. *American Pop Art*. New York: Macmillan Publishing Company/Whitney Museum of American Art, 1974.

Baur, John I. H. *American Painting in the Nineteenth Century: Main Trends and Movements*. New York: Praeger Publishers, 1953.

————. "Trends in American Painting, 1815 to 1865." Introduction to *M. and M. Karolik Collection of American Paintings, 1815–1865*. Cambridge, Mass.: Harvard University Press, 1949.

Benjamin, S. G. W. *Our American Artists*. Boston: D. Lothrop and Company, 1879; Second Series, 1881. Reprint. First and Second Series in 1 vol. New York: Garland Publishers, 1977.

Borland, Hal. *The History of Wildlife in America*. Washington, D.C.: National Wildlife Federation, 1975.

Brooks, Van Wyck. *The Dream of Arcadia: American Writers and Artists in Italy, 1760–1915*. New York: E. P. Dutton and Company, 1958.

————. *New England: Indian Summer, 1865–1915*. New York: E. P. Dutton and Company, 1950.

————. *The World of Washington Irving*. New York: E. P. Dutton and Company, 1950.

Brown, Milton W. *American Art to 1900: Painting, Sculpture, Architecture*. New York: Harry N. Abrams, 1977.

————. *American Painting from the Armory Show to the Depression*. Princeton, N. J.: Princeton University Press, 1955.

————. *The Story of the Armory Show*. Greenwich, Conn.: New York Graphic Society, 1963.

Canaday, John. *Embattled Critic: Views on Modern Art.* New York: Farrar, Straus and Cudahy, 1962.

Clark, Eliot. *History of the National Academy of Design, 1825–1953.* New York: Columbia University Press, 1954.

Clark, Kenneth M. *Animals and Men: Their Relationship As Reflected in Western Art from Prehistory to the Present.* New York: William Morrow and Company, 1977.

Cumming, William Patterson, R. A. Skelton, and David B. Quinn. *The Discovery of North America.* New York: American Heritage Press, 1972.

Dance, S. Peter. *The Art of Natural History: Animal Illustrators and Their Work.* Woodstock, N.Y.: Overlook Press, 1978.

Dorra, Henri. *The American Muse.* New York: Viking Press, 1961.

Dunlap, William. *A History of the Rise and Progress of the Arts of Design in the United States.* 2 vols. New York: G. P. Scott and Company, 1834. Reprint. 2 vols in 3. New introduction by James Thomas Flexner. Newly edited by Rita Weiss. New York: Dover Publications, 1969.

Flexner, James Thomas. *The Light of Distant Skies, 1760–1835.* New York: Harcourt, Brace and Company, 1954.

————. *That Wilder Image: The Painting of America's Native School from Thomas Cole to Winslow Homer.* Boston: Little, Brown and Company, 1962.

Ford, Alice. *Pictorial Folk Art, New England to California.* New York: Studio Publications, 1949.

Frankenstein, Alfred V. *After the Hunt: William Harnett and Other American Still Life Painters, 1870–1900.* Rev. ed. Berkeley: University of California Press, 1969.

Gardner, Albert Ten Eyck. Introduction to *101 Masterpieces of American Primitive Painting from the Collection of Edgar William and Bernice Chrysler Garbisch.* New York: American Federation of Art, 1962.

Honour, Hugh. *The New Golden Land: European Images of America from the Discoveries to the Present Time.* New York: Pantheon Books, 1975.

Huth, Hans. *Nature and the American: Three Centuries of Changing Attitudes.* Berkeley: University of California Press, 1957.

Janis, Sidney. *Abstract and Surrealist Art in America.* New York: Reynal and Hitchcock, 1944.

Jarves, James Jackson. *The Art-Idea.* New York: Hurd and Houghton, 1864. Reprint. Edited by Benjamin Rowland, Jr. Cambridge, Mass.: Harvard University Press, Belknap Press, 1960.

Kastner, Joseph. *A Species of Eternity.* New York: Alfred A. Knopf, 1977.

Klinger, Francis. *Animals in Art and Thought to the End of the Middle Ages.* Cambridge, Mass.: MIT Press, 1971.

Larkin, Oliver W. *Art and Life in America.* Rev. ed. New York: Holt, Rinehart and Winston, 1960.

Lassiter, Barbara Babcock. *American Wilderness: The Hudson River School of Painting.* Garden City, N.Y.: Doubleday and Company, 1978.

Lichten, Frances. *Folk Art of Rural Pennsylvania.* New York: Charles Scribner's Sons, 1964.

Lipman, Jean. *American Primitive Painting.* New York: Oxford University Press, 1942. Reprint. New York: Dover Publications, 1972.

Lipman, Jean, and Alice Winchester. *The Flowering of American Folk Art, 1776–1876.* New York: Viking Press/Whitney Museum of American Art, 1974.

Little, Nina Fletcher. *The Abby Aldrich Rockefeller Folk Art Collection: A Descriptive Catalogue.* Boston: Little, Brown and Company, 1957.

Lorant, Stefan, ed. *The New World: The First Pictures of America, Made by John White and Jacques Le Moyne and Engraved by Theodore de Bry, with Contemporary Narratives of the French Settlements in Florida, 1562–1565, and the English Colonies in Virginia, 1585–1590.* Rev. ed. New York: Duell, Sloan and Pearce, 1965.

Lynes, Russell. *The Art-Makers of Nineteenth-Century America.* New York: Atheneum, 1970.

Matthiessen, Peter. *Wildlife in America.* New York: Viking Press, 1959.

McCausland, Elizabeth, and Hermann Warner Williams, Jr. *American Processional, 1492–1900.* Washington, D.C.: Corcoran Gallery of Art, 1950.

McCracken, Harold. *Portrait of the Old West*. New York: McGraw-Hill Book Company, 1952.

Miller, Perry. *Errand into the Wilderness*. Cambridge, Mass.: Harvard University Press, 1956.

Mumford, Lewis. *The Brown Decades: A Study of the Arts in America, 1865–1895*. New York: Harcourt, Brace and Company, 1931. Reprint. Rev. ed. New York: Dover Publications, 1971.

Nordness, Lee, ed. *Art: USA: Now*. 2 vols. New York: Viking Press, 1963.

Norelli, Martina R. *American Wildlife Painting*. New York: Watson-Guptill Publications, 1975.

Perlman, Bernard B. *The Immortal Eight: American Painting from Eakins to the Armory Show, 1870–1913*. Introduction by Mrs. John Sloan. New York: Exposition Press, 1962.

Peters, Harry T. *America on Stone: The Other Printmakers to the American People . . .* Garden City, N.Y.: Doubleday, Doran and Company, 1931. Reprint. New York: Arno Press, 1976.

————. *Currier & Ives: Printmakers to the American People*. Garden City, N.Y.: Doubleday, Doran and Company, 1942.

Purcell, Ralph. *Government and Art: A Study of American Experience*. Washington, D.C.: Public Affairs Press, 1956.

Rathbone, Perry T., ed. *Westward the Way: The Character and Development of the Louisiana Territory As Seen by Artists and Writers of the Nineteenth Century*. Saint Louis, Mo.: City Art Museum, 1954.

Richardson, Edgar P. *American Romantic Painting*. Edited by Robert Freud. New York: E. Weyhe, 1944.

————. *Painting in America from 1502 to the Present*. New York: Thomas Y. Crowell Company, 1965.

Rose, Barbara. *American Art Since 1900: A Critical History*. Rev. ed. New York: Praeger Publishers, 1975.

Rowsome, Frank, Jr. *They Laughed When I Sat Down: An Informal History of Advertising in Words and Pictures*. New York: McGraw-Hill Book Company, 1959.

Saarinen, Aline B. *The Proud Possessors: The Lives, Times, and Tastes of Some Adventurous American Art Collectors*. New York: Random House, 1958.

Sandler, Irving. *The New York School: The Painters and Sculptors of the Fifties*. New York: Harper and Row, 1978.

Shepard, Paul. *Man in the Landscape: A Historic View of the Aesthetics of Nature*. New York: Alfred A. Knopf, 1967.

Soby, James T., and Dorothy C. Miller. *Romantic Painting in America*. New York: Museum of Modern Art, 1969.

Taylor, Joshua C. *America As Art*. Washington, D.C.: Smithsonian Institution Press, 1976.

Trefethen, James B. *An American Crusade for Wildlife*. New York: Winchester Press, 1975.

Tuckerman, Henry T. *Book of the Artists: American Artist Life, Comprising Biographical and Critical Sketches of American Artists, Preceded by an Historical Account of the Rise and Progress of Art in America*. New York: G. P. Putnam and Son, 1867. Reprint. New York: James F. Carr, 1966.

Virch, Claus. *The Artist and the Animal*. New York: M. Knoedler and Company, 1968.

Welker, Robert Henry. *Birds and Men: American Birds in Science, Art, Literature, and Conservation, 1800–1900*. Cambridge, Mass.: Harvard University Press, Belknap Press, 1955.

Welsh, Peter C. *Track and Road: The American Trotting Horse, a Visual Record, 1820 to 1900*. Washington, D.C.: Smithsonian Institution Press, 1967.

White, T. H. *The Bestiary: A Book of Beasts, Being a Translation from a Latin Bestiary of the Twelfth Century*. New York: G. P. Putnam's Sons, 1954; Capricorn Books, 1960.

Young, Mahonri Sharp. *The Eight: The Realist Revolt in American Painting*. New York: Watson-Guptill Publications, 1973.

INDIVIDUAL ARTISTS

Many of the beasts in American art were painted anonymously. Others were wrought by artists who still await, and richly deserve, full-length biographical treatment. Following are some of the most thorough and readable monographs that have been written about—or occasionally by—American animal painters.

Audubon, Maria R. *Audubon and His Journals*. With zoological and other notes by Elliott Coues. 2 vols. New York: Charles Scribner's Sons, 1897. Reprint. New York: Dover Publications, 1960.

Baigell, Matthew. *Thomas Hart Benton*. New York: Harry N. Abrams, 1974.

Baur, John I. H. *Charles Burchfield*. New York: Macmillan Publishing Company/Whitney Museum of American Art, 1956.

———. *Philip Evergood*. New York: Praeger Publishers/Whitney Museum of American Art, 1960.

Beard, William Holbrook. *Action in Art*. New York: Cassell Publishing, 1893.

Brigham, Clarence S. *Paul Revere's Engravings*. Rev. ed. New York: Atheneum, 1969.

Boynton, Mary Fuertes, ed. *Louis Agassiz Fuertes: His Life Briefly Told and His Correspondence*. New York: Oxford University Press, 1956.

Cantwell, Robert. *Alexander Wilson: Naturalist and Pioneer*. Philadelphia: J. B. Lippincott Company, 1961.

Catesby, Mark. *The Natural History of Carolina, Florida, and the Bahama Islands*. London: Printed at the expence of the author, 1731–43. Reprint. Introduction by George Firth. Notes by Joseph Ewan. Savannah, Ga.: Beehive Press, 1974.

Catlin, George. *Letters and Notes on the Manners, Customs, and Condition of the North American Indians*. 2nd ed. 2 vols. New York: Wiley and Putnam, 1842. Reprint. New York: Dover Publications, 1973.

Chancellor, John. *Audubon: A Biography*. New York: Viking Press, 1978.

Corn, Wanda M. *The Art of Andrew Wyeth*. With contributions by Brian O'Doherty, Richard Meryman, and E. P. Richardson. Greenwich, Conn.: New York Graphic Society, 1973.

Cortissoz, Royal. *John La Farge: A Memoir and a Study*. Boston: Houghton Mifflin Company, 1911.

Cruickshank, Helen Gere, ed. *John and William Bartram's America: Selections from the Writings of the Philadelphia Naturalists*. New York: Devin-Adair Company, 1957.

Ewan, Joseph, ed. *William Bartram, Botanical and Zoological Drawings, 1773–1780*. Reproduced from the Fothergill Album in the British Museum (Natural History). Philadelphia: American Philosophical Society, 1968.

Farnham, Emily. *Charles Demuth: Behind a Laughing Mask*. Norman, Okla.: University of Oklahoma Press, 1971.

Fisher, Jonathan. *Scripture Animals: A Natural History of the Living Creatures Named in the Bible*. Portland, Maine: W. Hyde, 1834. Reprint. With a Foreword by Mary Ellen Chase. Princeton, N.J.: Pyne Press, 1972.

Ford, Alice. *Audubon's Animals: The Quadrupeds of North America*. New York: Studio Publications, 1951.

———. *Audubon's Butterflies, Moths, and Other Studies*. New York: Studio Publications, 1952.

———. *Edward Hicks, Painter of the Peaceable Kingdom*. Philadelphia: University of Pennsylvania Press, 1952.

———. *John James Audubon*. Norman, Okla.: University of Oklahoma Press, 1964.

Frick, George Frederick, and Raymond Phineas Stearns. *Mark Catesby, the Colonial Audubon*. Urbana, Ill.: University of Illinois Press, 1961.

Gardner, Albert Ten Eyck. *Winslow Homer, American Artist: His World and His Work*. New York: Clarkson N. Potter, 1961.

Getlein, Frank. *Jack Levine*. New York: Harry N. Abrams, 1966.

Goodrich, Lloyd. *Albert P. Ryder*. New York: George Braziller, 1959.

––––––. *Ralph Albert Blakelock Centenary Exhibition*. New York: Whitney Museum of American Art, 1947.

––––––. *Thomas Eakins: His Life and Work*. New York: Whitney Museum of American Art, 1933. Reprint. New York: AMS Press, 1970.

Hendricks, Gordon. *Albert Bierstadt: Painter of the American West*. New York: Harry N. Abrams/Amon Carter Museum of Western Art, 1974.

––––––. *The Life and Work of Thomas Eakins*. New York: Grossman Publishers, 1974.

––––––. *Winslow Homer*. New York: Harry N. Abrams, 1979.

Hoopes, Donelson F. *The Private World of John Singer Sargent*. Washington, D.C.: Corcoran Gallery of Art, 1964.

Hulton, Paul. *The Watercolor Drawings of John White*. Washington, D.C.: National Gallery of Art, 1965.

Knowlton, Helen M. *Art Life of William Morris Hunt*. Boston: Little, Brown and Company, 1899. Reprint. New York: Benjamin Blom Publications, 1971.

Marcham, Frederick George, ed. *Louis Agassiz Fuertes and the Singular Beauty of Birds*. New York: Harper and Row, 1971.

McCausland, Elizabeth. *Marsden Hartley*. Minneapolis: University of Minnesota Press, 1952.

McCracken, Harold. *Frederic Remington: Artist of the Old West*. With a bibliographic checklist of Remington pictures and books. Philadelphia: J. B. Lippincott Company, 1947.

––––––. *George Catlin and the Old Frontier*. New York: Dial Press, 1959.

Mount, Charles Merrill. *John Singer Sargent: A Biography*. New York: W. W. Norton and Company, 1955. Reprint. New York: Kraus Reprint Company, 1969.

O'Connor, Francis Valentine, and Eugene Victor Thaw, eds. *Jackson Pollock: A Catalogue Raisonné of Paintings, Drawings, and Other Works*. 4 vols. New Haven, Conn.: Yale University Press, 1978.

Peattie, Donald Culross, ed. *Audubon's America: The Narratives and Experiences of John James Audubon*. Boston: Houghton Mifflin Company, 1940.

Pennell, Elizabeth R., and Joseph Pennell. *The Life of James McNeill Whistler*. 2 vols. London: William Heinemann; New York: J. B. Lippincott Company, 1908. Reprint. New York: AMS Press, 1973.

Poesch, Jessie. *Titian Ramsay Peale, 1799–1885, and His Journals of the Wilkes Expedition*. Philadelphia: American Philosophical Society, 1961.

Prown, Jules David. *John Singleton Copley*. 2 vols. Cambridge, Mass.: Harvard University Press, 1966.

Purrington, Philip F. *Four Years A-whaling: Charles S. Raleigh, Illustrator*. Barre, Mass.: Barre Publishers, 1972.

Ritchie, Andrew C. *Charles Demuth*. New York: Museum of Modern Art, 1950.

Robertson, Bryan. *Jackson Pollock*. New York: Harry N. Abrams, 1960.

St. John, Bruce, ed. *John Sloan's New York Scene: From the Diaries, Notes, and Correspondence, 1906–1913*. New York: Harper and Row, 1965.

Sellers, Charles Coleman. *Charles Willson Peale*. New York: Charles Scribner's Sons, 1969.

Shahn, Ben. *The Shape of Content*. Charles Eliot Norton Lecture Series. Cambridge, Mass.: Harvard University Press, 1957.

Shahn, Bernarda Bryson. *Ben Shahn*. New York: Harry N. Abrams, 1972.

Stebbins, Theodore E., Jr. *The Life and Works of Martin Johnson Heade*. New Haven, Conn.: Yale University Press, 1975.

Thayer, Gerald H. *Concealing-Coloration in the Animal Kingdom: An Exposition of the Laws of Disguise Through Color and Pattern, Being a Summary of Abbott H. Thayer's Discoveries*. New York: Macmillan Publishing Company, 1909.

Truettner, William H. *The Natural Man Observed: A Study of Catlin's Indian Gallery*. Washington, D.C.: Smithsonian Institution Press, 1979.

Weintraub, Stanley. *Whistler: A Biography*. New York: Weybright and Talley, 1974.

White, Nelson C. *Abbott H. Thayer: Painter and Naturalist*. Hartford, Conn.: Connecticut Printers, 1951.

INDEX

All numbers in this index refer to page numbers; those in italic type denote illustrations.

PHOTO CREDITS

The author and publisher wish to thank the museums, libraries, galleries, and private collectors for permitting the reproduction of paintings, drawings, prints, and other art objects in their collections. Photographs have been supplied by the owners or custodians of the works of art except for the following, whose courtesy is gratefully acknowledged.

Andover Art Studio, Andover, Mass.: 108, 164, 190; Oliver Baker, New York: 209; E. Irving Blomstrann, New Britain, Conn.: 73, 93, 173; Joel Breger, Wheaton, Md.: 223, 225, 233; Brenwasser, New York: 89, 149, 153; Rudolph Burckhardt, New York: 213; Geoffrey Clements, New York: 216; Culver Pictures, Inc., New York: 176; George Cushing, Boston: 21; Bevan Davies, New York: 226; Eeva-Inkeri, New York (courtesy Kornblee Gallery, New York): 227; Fogg Art Museum, Cambridge, Mass.: 186; Greenberg-May Prod., Inc., Buffalo, N.Y.: 168; Hirschl and Adler Galleries, Inc., New York: 32, 150, 151; Michael Katz, New York: 192; M. Knoedler and Company, Inc., New York: 125; Kraushaar Galleries, New York: 185; Le Bel's Studio, Canajoharie, N.Y.: 25, 119; Leo Castelli Gallery, New York: 218; Robert Mates, New York (courtesy Marlborough Gallery, New York): 228; Edward Meneeley, New York: 194; Midtown Galleries, New York: 30, 206, 215; Ann Munchow, Aachen, Germany: 229; John D. Murray, Andover, Mass.: 95, 182; Eric Pollitzer, Hempstead, N.Y. (courtesy Brooke Alexander Gallery, New York): 234; Frank Rollins, Cooperstown, N.Y.: 144; Walter Rosenblum, New York: 217; Soichi Sunami: 17, 220; Stable Gallery, New York: 221; John Tennant, Washington, D.C. (courtesy Fendrick Gallery, Washington, D.C.): 235; Whitney Museum of American Art, New York: 222.